BEING CULTURED

in defence of discrimination

ANGUS KENNEDY

SOCIETAS
essays in political
& cultural criticism

imprint-academic.com

Published in the UK by
Imprint Academic, PO Box 200, Exeter EX5 5YX, UK

Distributed in the USA by
Ingram Book Company,
One Ingram Blvd., La Vergne, TN 37086, USA

ISBN 9781845405700

A CIP catalogue record for this book is available from the
British Library and US Library of Congress

For my mother and my father,
Authors of my beginning.

What calls me is that lifted, rough-tongued bell
(Art, if you like) whose individual sound
Insists I too am individual.
It speaks; I hear; others may hear as well.

—Philip Larkin
Reasons for Attendance

Civilization is not by any means an easy thing to attain to. There are only two ways by which man can reach it. One is by being cultured, the other by being corrupt.

—Oscar Wilde
The Picture of Dorian Gray

Contents

Acknowledgements

A number of friends have provided advice and assistance without which I could not have managed to conceive of this book, let alone write it. In particular I would like to thank Tim Black, Claire Fox, Jim Panton and Laura Susjin for their effort and patience in reading early drafts, and for all their insightful comments and opinions. The end result is immeasurably improved wherever I followed their suggestions.

I am grateful to Douglas Berrie and Martin Wynne for their indulgence of me over the years in too many things—not least the annual art tours—but especially in entertaining discussions about opera when perhaps they would have not.

Tiffany Jenkins, Dolan Cummings, Wendy Earle and everyone at the Institute of Ideas Arts & Society Forum have provided invaluable examples and ideas as well as a genuine space of freedom in which to try out my thoughts on culture at their expense. Professor Joe Friggieri for making me realise we can still talk of Beauty. Above all, and throughout, Claire Fox has been a Pole star, constant to all my twists and turns, my ups and downs, and, as such, naturally bears no responsibility for wherever I may have ended up.

The intellectual debt I owe to a certain tradition of thought I only have space to outline in thumbnail even though it is total: Cicero, Kant, Hegel, Marx, Sartre, Hannah Arendt, Christopher Lasch, Daniel Bell, and, more recently, Harold Bloom, Frank Furedi and Roger Scruton. Thanks too to Keith Sutherland and Jeff Scott for entertaining the original idea and everyone at Imprint Academic for making it real.

Thanks are not enough for Gae, whose insistent and trenchant refusal to be bluffed with philosophical verbiage and

cavalier argumentation was one of my toughest obstacles, but whose daily encouragement proved my biggest support. If my text has become more readable as a result it is all down to her.

Finally, a special thank you to Claudia, whose entry into this world five years ago was the emergence of a perspective on my life that it very much wanted and in whose eyes I hope the existence of this essay is some small justification for all the time I have been reading in my study and not reading to you. I promise to make up for that and hope in the future you may write something for me.

A.E.K.
West Sussex, 2013.

Introduction

Culture plays a larger and larger part in our lives. Plays, exhibitions, films, books, experiences, performances and box sets: weekly culture listings groan under what is new, must-read, and have-to-see. Successive governments push culture as a fundamental part of education. Culture is instrumentalised in the pursuit of policy and social objectives. Arts organisations, cultural institutions and their mandarins work to increase access to audiences they see as excluded in some way. Culture seems to be everywhere and ever more important. There are more and more cultures on offer: African, Latin American, Chinese, Iranian, Australian... We might imagine ourselves living through a second Renaissance. And yet... we never seem to hear someone say they *are* cultured. The dominant idea of culture today is profoundly uncomfortable with the simple reality that one person might be more cultured than another. Let alone one culture better than the next: Western culture in particular. There is deep discomfort with the very idea of 'high culture' itself (high and low being seen as, at best, one these days, a cultural fusion). Even the *attempt* to argue that something might be better than something else is met with accusations of undeserved cultural authority, of an elitism that has somehow had its day: that smacks of an abuse of power and influence, resulting in the inevitable call to 'check your privilege'. As a result, in the cultural sphere, we do not know whose authority – or whose opinion – is worthwhile. This lack of authority is often celebrated as the variety of multiculturalism and the spice of diversity. In this context, while culture may be ubiquitous, more accessible than ever before, it is, however,

without heart or soul, weighed out by the pound, its spirit gone. Culture may be total but it is flat and shallow.

Being Cultured

'Being', 'culture', 'discrimination': each word demands many more books and far subtler thinkers than I. To that extent, this is a rash book. My original intention was to restrict it to a critique of the prevalent instrumentalist approach to the arts. How theatre, say, is increasingly treated as a means to an end (such as a feeling of wellbeing or civic enthusiasm in the audience). This process is well documented and has been widely discussed: the overt politicisation of arts funding under New Labour even provoked something of a backlash in the last decade.[1] Yet the attempt to weigh and measure, to make the arts wash their face, continues. The latest project by the UK's Arts & Humanities Research Council, which promises to 'define a framework for identifying and evaluating the different components of cultural value', is just the most recent example of an ongoing trend to attempt the quantification of the unquantifiable: to confuse value with cost, goodness with benefit, and to retreat from idealism to crude pragmatism.[2] Against the demand that the arts justify themselves as being useful, I wanted to make an argument for the value of the arts in and of themselves — an intrinsic defence — and, at the same time, put forward an undoubtedly unpopular — and deliberately provocative — argument for cultural elitism. By which I mean an argument for standards: a defence of aesthetic judgements such as *this* is beautiful and, equally important, but often much harder, *that* is ugly.

Every time I tried to limit my scope in this way, however, I found that I was unhappy with just making an impassioned

[1] See, for example, Tusa (2007), pp. 165ff.

[2] The AHRC Cultural Value Project, http://www.ahrc.ac.uk/Funded-Research/Funded-themes-and-programmes/Cultural-Value-Project/Documents/Cultural_Value_ Project.pdf

defence of art for art's sake. I became increasingly uncomfortable with what can be a superficial formalism with no reference to the content of art. Art for art's sake can, after all, sit comfortably with a relativist, post-modern, approach to the valuation of culture: it's good because it's art, or because it problematises the concept of art, or just because I like it, and that's the end of argument. For me the heart of the issue is that we should try and become better at knowing and judging what is beautiful and what is not, what is good and what is not: what truth; and what lies. There is, I shall argue, a *moral* content to art: at least in the sense that aesthetic judgements — discriminating between what is beautiful and what is less so — are more than just a matter of saying what I *like*. They express the idea that you *ought* to like it too: *because* it is beautiful and true and, if my reason can apprehend that, then so should yours. Which is equally to express the belief that a world in which we were all better at discerning the beautiful would be a more reasonable world. Culture is not like science but expresses our accumulated knowledge of how humans should be and what that is like: it is a reflection to us of our own humanity; we are both the object and subject of art.

As a result I kept sliding into an exploration of the extent to which art can be said to be *morally* instrumental. Not in the sense of teaching lessons for living, but at least to the extent that the arts — in their production and reception — represent what Sartre, in his examination of how literature works, called a 'gift of freedom... an appeal to freedom'.[3] I found that attempts to exercise one's freedom to discriminate — even the very use of the phrase 'good taste' — are met with hostility and scorn: that discrimination is seen as a throwback to a less enlightened time. That what is valued is a culture that is total rather than discriminate: without limit or border, value or distinction. And I thought that something important had been lost: namely any wider social validation and support for the individual project of

[3] Sartre (1950), pp. 35ff.

trying to be cultured. If anything today we look to acculturate the individual *into* society: to restrict, rather than enhance, his freedom. That may be an excuse for my intemperance with the terms of the discussion of culture today and, to the degree that comes across in this book, I do not apologise, though I do for my failure to resist the attempt to tackle the all-too-broad question of the totality of culture on the one hand and the possibilities still open to us in terms of the free, aesthetic, moral subject on the other.

The question that came to occupy me more and more was to what extent we can still rely on existing cultural institutions. There is never any turning back the clock, but could we stop the rot and usher in a cultural renaissance? Or are things—in a world of robot saints and X-Factor pop—just too far gone? In the face of the dissolution of culture into multi-culture and fashionable non-judgementalism, must we start to look to new ways to conserve our cultural tradition? In short, for example, can we hope to bring about a turn to beauty in the Arts Council England? Or, would we do better to close it down and let the arts run free? I'm still torn on that question: all I can hope to do here is lay clear the parameters of what is at stake. Finally, I should apologise too for the extent to which the polemical nature and length of this book—as well as my own limitations—have restricted me from developing much more than an assertion of, rather than a detailed argument for, my position on the theory and practice of a more positive approach to aesthetics.

Classical Beginnings

Virgil's *Georgics*—at first sight a Roman agricultural manual in hexameter verse—ends with Orpheus the musician and poet who could once charm all living things with his music, now grief-stricken at losing his wife Eurydice: not once, but twice. As he leads her up, on the very threshold of the Underworld, desperate to see her face and overcome with passion, he breaks his promise not to look back: only to see her vanish forever. Orpheus wanders the world weeping, bereft, alone in the

Thracian wilds, his music stripped of its ability to charm nature. At last he is torn limb from limb by ecstatic worshippers of Dionysus, the ravaging Bacchantes:

> But even then that head, plucked from the marble-pale
> Neck, and rolling down mid-stream on the river Hebrus —
> That voice, that cold, cold tongue cried out 'Eurydice!'
> Cried 'Poor Eurydice!' as the soul of the singer fled,
> And the banks of the river echoed, echoed 'Eurydice!'[4]

Poetry, Virgil tells us, can resonate after death and human culture may improve on nature: make a river sing, make sculpture from marble, make a better world for us to live in. And for others. And for those that will come after us.

I thought Virgil was a good place to start not only because our culture owes so much to the Romans — although of course it does — but because I have begun to notice some cultural commentators express the view that, in the future, maybe no one will read Virgil anymore, or listen to Beethoven and, what is more, that we should be relaxed about it or welcome the change: we will have new traditions. I think it is an opinion born of an inability to defend or understand the value of culture: resulting in a feeling that it does not matter what might be lost. It is all relative after all and who is to say Virgil is a better poet than Maya Angelou? Or the rapper Plan B, for that matter.

The pressing question is not whether or not we will read Virgil in the future but why is it we still read him now? It is a question that Karl Marx posed in the *Grundrisse*: just why is it that the art of the Greeks and that of Shakespeare 'still afford us artistic pleasure and that in a certain respect they count as a norm and as an unattainable model'?[5] Is there something

4 Virgil (1983), p. 126.
5 It is a question also raised in Hume's essay 'Of the Standard of Taste' (1757): 'The same HOMER, who pleased at ATHENS and ROME two thousand years ago, is still admired at PARIS and at LONDON. All the

objective about great culture that can explain why tastes are not historically specific? Marx's answer was why 'should not the historic childhood of humanity, its most beautiful unfolding, as a stage never to return, exercise an eternal charm?' Why not indeed, but Marx's difficulty was that he understood the flourishing of Greek art to be 'bound up with certain forms of social development' which were gone and never to return. But why then do we, at such a different level of social development, with such different economies, and politics, still enjoy *Oedipus Rex* and *Twelfth Night*? In what sense, furthermore, do we hold them up 'as a norm and as an unattainable model'? Marx's answer that still we find charm in childish naïveté and that our culture reproduces 'its truth at a higher stage' has never been particularly convincing.[6] Just what is a 'higher stage' of truth? Are some artistic truths more 'truthy' than others? Just what *has* reproduced the truth of Homer, or Shakespeare for that matter, at a higher stage? It is evidence of Marx's questioning intellect that he saw the challenge that the apparently ahistorical nature of culture and the uniqueness of the Western cultural tradition posed to a materialist conception of historical progress, and testament to his honesty that he raised it at the end of his introduction to his great unfinished work on political economy.

American sociologist Daniel Bell's *The Cultural Contradictions of Capitalism* gives an answer to Marx's question by distinguishing the techno-economic and the cultural spheres. The former does indeed grow on a linear basis: its progress measured in the increased productivity of society and humanity's growing independence from and mastery over nature. But culture — the activity of the leisure time afforded us by this productivity — is not a cumulative evolution but rather a:

> *ricorso* to the primordial questions which confront all men in all times and places and which derive from the finiteness of the

changes of climate, government, religion, and language, have not been able to obscure his glory.'

6 Marx (1973), p. 111.

human condition and the tension generated by the aspiration, constantly, to reach *beyond*. These are the existential questions which confront all human beings in the consciousness of history: how one meets death, the nature of loyalty and obligation, the character of tragedy, the meaning of courage, and the redemptiveness of love or communion... The principle of culture is thus that of a constant returning—not in its forms, but in its concerns—to the essential modalities that derive from the finitude of human existence.[7]

And it is, Bell notes, unfashionably enough, *religion* that 'relates man to something beyond himself'.[8]

It is our nature to lose what we love, and to die. Such is the human condition. But we also bear witness to our existence in the form of our culture: what we leave behind us—our legacy and gift to future generations. The strange truth is that while it is our nature to be mortal, yet there is nothing natural about culture. Here is a possible way to approach Marx's insightful question. It is not that culture is an ahistorical and eternal set of answers to an innate human nature. Nor is it a transient super-structure determined by the socio-economic base at a given moment. Rather perhaps it is precisely because culture is *historical*, which is to say, not natural but man-made, that we value it. Maybe we value it as part of the evolving story of human history: a story in which we find ourselves the makers of that history. As Hegel knew, it is freedom that is the motor of history and it is freedom too—that measure by which man is not a creature of instinct but is self-reflective and *self*-determining—that underpins the story of culture. When Marx speaks of Greek culture as 'the historic childhood of humanity, its most beautiful unfolding', I read him as meaning that the beginning of the history of human freedom and of culture in the Western tradition is related to our narration of that story of human freedom.

7 Bell (1996), p. 166.
8 Bell (1996), p. 166.

And when freedom is threatened, as it is today in particular by those who see the individual as a threat to the security of society, we can do worse than put a hand back for a rope to grab: in times of crisis, as someone once said, we are well advised to look back to the ancients as a source of renewal.

Culture: now, then, and next

The book opens with an unavoidable attempt to define my terms and to examine reasons why it is important to hang on, insofar as we can, to a sense of culture as being something active and, secondly, as denoting something that our best selves should pursue: that is high culture as being, broadly, the arts; specifically, the music, dance, literature, drama, philosophy, painting, architecture and sculpture of the Western tradition. A tradition that I see as uniquely grounded in an understanding and exploration of human freedom and, to that extent, as being a universal tradition that, whatever the contingency of its birth, now belongs to us all.

The book is in two parts. The first sets out what I think is wrong with the way in which we tend to view culture today. Why is there such hostility to the exercise of discrimination today? Why has exercising the freedom to choose *this* and not *that* become evidence of intolerance, of an unacceptable level of judgementalism? Why are the arts increasingly obsessed with being relevant to our experience, determined to drag us through the 'real' at the expense of any idealism? I will set out the idea of a 'total culture' — increasingly the world in which we live — a term for what is left when nothing is left out, when the arts are measured by their inclusivity, not valued for their exclusivity. I take that point forward into the way in which we imagine the audiences for culture when culture is seen as inclusive: the way the public is mobilised as a stage-army argument for why all must have art; and examine the way in which culture is thought to have powerful positive effects on those that experience it and the use of such instrumental arguments to justify arts funding.

In the second part I try to make a positive case for making a project of culturing the self. While contemporary society may

appear frozen in the here and now, in fear of the future and estranged from the past, out of touch with tradition, it remains the case that there is nothing natural about this situation. I look at the hardest argument: that there is nothing natural, nor objective, about culture. This was something that was long understood but it is an understanding very much under attack today: often in the name of evolutionary biology and psychology. Yet science can only take us so far: taking its leave precisely when we arrive at questions of meaning. I take that starting point—our subjectivity, our freedom to make sense of the world, our perspective—and argue that we could do worse today than try and refresh our memories as to how some great thinkers have understood our freedom to choose. How is it that we have understood judgement in the past? In conclusion I examine the relationship between the individual and society, the possibility of shared judgements, and the development of discriminating communities of taste: freedom to discriminate being the foundational possibility of society as such.

Throughout I have tried to resist a temptation which comes all too easily: one of nostalgia for a supposed 'golden age' of the arts—as if, once upon a time, the arts were free and so were we, basking in truth and beauty as revelations of our spiritual freedom. Such a time, as I am reminded in discussion on these topics all too often—usually by those who look to excuse the less than satisfactory state of culture today—never really existed. In the Renaissance, rulers like the Medicis had no restraint when it came to bending the arts to their will, and employing them to celebrate their power. Virgil enjoyed the patronage of the emperor Augustus. To a degree it has always been thus: the ideas that matter have always been the creation of the few, just as the arts have largely been enjoyed by social and intellectual elites. What matters, however, is whether or not those ideas, those works of art, are any *good*. If they are, then we should—and can—all pursue them. We are free to pursue culture: though it is true too that freedom has always been a struggle.

Finally, I have found, in the course of researching and writing this book, of dragging my family around the Sussex coast—and from the Guggenheim to the Santa Maria delle Grazie—that I have fallen a little bit more in love with this human world of ours: what we have made of it so far, what we have inherited and have a duty to conserve, and the prospects for what may be made tomorrow. I do not believe the arts *necessarily* have any positive effect on one: having them rammed down one's throat will only reliably produce feelings of revulsion. I certainly do not believe we cannot live without them: millions have for thousands of years, and still do, and through choice at that. It is a mark of decadence to imagine that a fulfilling life *must* involve Proust and Prokofiev. I do however think it is possible to make oneself a little more civilised through making the attempt to be cultured. The impulse can only come from within but, when it does, it helps to have guides and helping hands around: a canon and a tradition to refer to—love it or hate it, contest it, add to it, subtract from it as you will—and make the journey easier. There is no virtue in reinventing the wheel after all, and Virgil was certainly a great help to Dante in more difficult circumstances than even those we face today:

> Placing his hand on mine, smiling at me
>> in such a way that I was reassured,
>> he led me in, into those mysteries.[9]

There is no shortage of guides available. I watched Kenneth Clark's *Civilisation* again this year—I think you can buy the four-disc box set for under £15—which, among everything else that it is, also provides a good object lesson in the virtues of tolerance as one has to learn to consider his insights at face value without the easy recourse of dismissing them straight off because of contemporary prejudice about his suits and strange pronunciations. The Institute of Ideas, where I work, runs a four-day summer school, modestly called The Academy, and a

[9] Dante (1971), p. 90.

Great Books lecture series, for those who feel that they do not know enough about what has been thought and said, and who are not afraid to take the risk of admitting it. After all, the greatest single difficulty we all face as individuals is simply one of getting started, of taking the plunge.

> Sometimes we have to do a thing in order to find out the reason for it. Sometimes our actions are questions, not answers. — John le Carré, *A Perfect Spy*.

What is Culture?

To walk staunchly by the best light one has. — Matthew Arnold, *Culture and Anarchy.*

Barbarism is strength without sensitivity; decadence is sensitivity without strength. — John Armstrong, *In Search of Civilization.*

Culture and Autonomy

Culture and freedom go together. The arts need time and freedom to make and to appreciate. One needs leisure to cultivate oneself with books, music, the theatre, film and friends. High culture wilts in totalitarian societies and has blossomed at those moments in history when freedom was most valued. Great works of art reflect the freedom and personality of individual human beings. One of the things we value most in the Western tradition is originality: when artists are bold enough to break ground with tradition, outrage social sensibilities, offer fresh perspectives on our world. Sometimes this culture of freedom pits individuals against society and sometimes society feels there is only so much freedom it can take. Art for art's sake arguments defend artistic freedom while more utilitarian arguments push the social value of the arts, even, as so often today, their value in terms of contributing to something as everyday and basely material as the economy.

Matthew Arnold's famous *Culture and Anarchy* remains a key reference point in discussions about the value of culture to the individual and to society. Arnold is either attacked as a Victorian elitist wishing to educate the working classes to keep them well behaved and to stop society sliding into anarchy or

even despotism, or he is held up as the standard bearer for a lost ideal of culture as 'the best which has been thought and said': a much-needed defender of high culture at a time when pretty much the only standard we have is a refusal to judge or to discriminate. Both positions are largely correct but both miss something very important about Arnold: his fear of individual freedom and his faith in the state. He thought that anarchy results from too much freedom: from the freedom for individuals to do whatever they want. Raymond Williams notes this in his book *Culture and Society*, quoting Arnold: 'Freedom... is a very good horse to ride, but to ride somewhere.'[1] This is freedom not held up as an end in itself, but rather as *directed* freedom. The direction for Arnold was, of course, towards culture as

> being a pursuit of our total perfection by means of getting to know, on all the matters which most concern us, the best which has been thought and said in the world.[2]

Education of the working classes was the way to stave off individual license and social anarchy. A tension is apparent: between an ideal of *freedom* to study and pursue culture for one's own benefit; and the *use* of culture to temper the freedom of individuals, to shape them into social norms, an orderly mass.

Arnold shows us another tension as well. On one hand there is his faith in reason and his passionate desire for social and institutional reform, which led him to value our knowledge of culture as 'turning a stream of fresh and free thoughts upon our stock notions and habits'. Culture for him was something open to change and its values were relative. While some of it might be 'the best', he had to admit that it might lose its position over time: such is the price of allowing free thought and criticism. On the other hand to this abstract faith, he knew there was no actual class in society so reasonable nor so interested in culture

[1] Williams (1961), p. 127.
[2] Arnold (2006), p. 5.

as to see it in its own interest to realise Arnold's ideas. The aristocracy (Barbarians) wanted to keep things the way they were. The middle classes (Philistines) wanted to be wealthy. The working classes (the Populace) wanted to be Philistines or to rob, steal and destroy. How could there be any hope for culture?

In two places he thought. Firstly, in a 'remnant' of individuals from each of the three main classes: people who were not determined by their class situation — through whatever accident — and loved culture for its own sake. Secondly, and more reliably — although with a certain fear of the consequences for individual liberty and an awareness of the dangers of Jacobinism — he found it in the state. Only there was there, as Williams argues, an 'agent of general perfection', with the power and authority to use culture to organise society.[3] In the end, Arnold, a classic liberal, was forced, despite his faith in individual reason and free thinking, to come down on the side of society — against the individual — and the use of the state as an engine of culture to shape and direct the people into an organised and harmonious whole. If freedom had to be sacrificed so the 'sweetness and light' of culture could lift as many from darkness as possible, so be it. Since Arnold's time the role of the state and of politics in culture, in education, and in museums — as in every walk of life — has steadily increased.

Culture in a State

Arnold felt he had little choice. Culture in his time — Western high culture — had lost the unquestioned authority it enjoyed before the 19th century. Enlightenment radicals like Diderot and d'Holbach, in their complete repudiation of monarchy and aristocracy, embraced

> [a] conscious and systematic effort to erase completely the institutions and consciousness of the past and replace these

[3] Williams (1961), p. 128.

across the board with the principles of liberty, equality, and fraternity.[4]

Nor were the values of industrial revolution and empire those of aristocratic connoisseurship: Lord Palmerston was no Robert Walpole. Arnold was doing his best to save culture from irrelevance and destruction and he could only do so, he thought, by putting it at the service of society. He was perceptive to see that there must be limits. Freedom without any limits—at least the limit of self-discipline—is indeed anarchy and culture without standards undistinguished and meaningless. But tell people where to ride their horses to and they are not free. Use culture as a tool and it is no longer an idea we can ride towards: no longer an end but a means. The key point is that directed freedom is not freedom unless it is *self*-directed. Culture employed to make us better expresses a degree of paternalism that runs counter to the idea that we might make *ourselves* better through its study and pursuit. The only other way Arnold might have argued would be to say that those 'remnants' of each class—the unusual ones—actually form a model for leaving culture up to individuals. That is the only reliable way for people to become more cultured: if they study and pursue it freely rather than because the state makes them. He could have welcomed the emergence of the masses into society as something that would revitalise culture, but they terrified him and he lacked faith that they would or could come to culture on their own. His lack of faith in the pulling power of culture—and his decision to use it instrumentally to combat anarchy—was a fatal misstep since it was an admission that culture was not enough on its own: not enough in itself and for itself as Hegel would say; lacking sufficient spirit to express itself. Culture was fatally wounded through the success of Arnold's idea that it should be used as a *tool* in the interests of society.

[4] Israel (2010), p. 224.

Unable to see the masses as anything but a dark mass, neither was he able to see the trees for the wood: to see the Populace as made up of individuals and free ones at that. The free individual is the basis of culture in two senses: firstly, as a producer of culture; secondly, as its suitor. Arnold failed, understandably no doubt, to write the book he could have done: *Culture and Autonomy*. That would have resolved his problem since the autonomous individual, while free, submits himself to his own laws. Won't we all go in different directions? No, because when we act to improve ourselves, strive toward our best selves, we do act in our own interest, but that, while it is of course a self-interest, is equally a shareable interest. The point about *self*-interest is that it is precisely not *other*-interest: that is, if I act in what *I* determine, for myself, to be my interest, then it is not something determined for me by the powers that may be. That is, I act in freedom. As do you. On the basis of the shared freedom of self-determination rests the possibility of consensus and agreement. Culture is one way of bettering oneself. It is also, and importantly so, something that helps us recognise our own human freedom and acts as a reminder that some things are better than others.

It is of course true that relatively few people are committed to the study and pursuit of high culture. Some, equally, might like fine art but not classical music, nor opera, nor ballet. Some do not like the arts at all but are passionate about sport. In some ways it is remarkable that people actually retain so much love for the high points of the Western tradition as they do given the almost complete loss of cultural authority it has suffered over the last hundred and more years. Though those whom one might think would be its staunchest defenders seem to find it rather embarrassing at best. BBC art's editor Will Gompertz recently declined to express any opinion on what art he thought was good and what was bad, but it is precisely strongly-argued value judgements — and authoritative guides — that can make

the arts so attractive.[5] The trend, however, has long been in the other direction. Towards science and the state; not the arts and the individual. For democratisation and anything-goes relativism; not elitism and judgement, nor good taste. There has been an explosion in identity politics, attacks on the 'orientalism' of Western thinking, on the dead white men and supposed phallocentricity of the Western canon. The 'counter-culture' has sought to shatter and overturn the allegedly rigid and exclusive hierarchies of culture. So thoroughgoing has been this trend that it is increasingly rare to talk of art for art's sake, let alone of truth and beauty, and certainly not Truth, or Beauty. And it may even seem odd to talk today of culture at all, rather than *cultures*. Even when high culture does not come with a sneer, there is a tendency to elide or deny any distinction between 'high' and 'low' or 'popular' culture. The ultimate no-no today is to talk about being cultured or to say that someone has better taste or is more discriminating. Statements like that of the philosopher Roger Scruton to the effect that all 'civilizations have a culture, but not all cultures achieve equal heights' should be matter of fact but are taken as unforgivably elitist, if not racist. Culture would seem to be no more than just whatever we like and we refuse to be told that what we happen to like is not always the best we could.

The irony of the state of culture today is that society fears the individual expression of judgement every bit as much as Arnold did in the 19th century and is just as determined to inflict its own vision of culture on the 'masses', and to defend such instrumentalism—through an entirely circular argument—as what the masses want. Art, we are told, must relate to people's experience and people like what they know. Even the burgeoning heritage industry in the UK strives for such contemporary 'relevance': in 2013 the National Trust took over television's Big Brother house, arguing:

5 Tiffany Jenkins, 'The good, the bad and the non-judgemental', *Scotsman*, 26 October 2012.

> [T]he fact that the garden is not the parterre at Cliveden but is more like the AstroTurfed gardening section of a DIY store actually makes it more relevant, or at least more comprehensible, to modern society. The great houses of our past reflected the tastes of the day, and so does the Big Brother house.[6]

The defenders of the arts have again adopted instrumentality as a cover for their own loss of faith in the power of culture: lacking the courage to stand up for their own tastes, they presume to act in what they imagine to be to your taste. Threatened with irrelevance and government cutbacks, they have made the case for how very useful the arts are: in providing jobs for 'creatives', turning young people away from crime, making us all happier and better citizens. Arnold would recognise the arguments if not the value of much of contemporary culture. In such circumstances, a defence of individual discrimination is more vital than maybe ever before: as a statement of our common freedom as individuals. Of our being in a shared world and our shared ability to choose that world. If we do not mount such a defence our cultural tradition will continue to lose significance since, while the state can do many things, one thing it cannot do is give meaning to anything. Meaning is not generated in committee rooms. Only individuals and private associations of individuals have that power because only they have the freedom to judge and to argue.

Culture as Taboo

Culture, I suspect, is a word that is used more and more but, little by little, no longer means what it used to. Unlike a word such as 'civilisation' which is simply, slowly, falling out of everyday use. We might talk about 'Mayan civilisation' more than we used to but, since the Second World War, the phrase 'Western civilisation' has been in steady decline except when

6 'Big Brother House to open as "National Trust"', http://www. nationaltrust.org.uk/article-1355802647316/

wheeled out in the context of an apologetic exercise or to opine, *a la* Gandhi, that it might be a good idea. After 9/11 Silvio Berlusconi asserted:

> [T]he superiority of our civilisation, a system that has guaranteed well-being, respect for human rights and—in contrast with Islamic countries—respect for religious and political rights, a system that has as its value understanding of diversity and tolerance.[7]

The immediate reaction by the European Union was to denounce his remarks, warning they could have 'dangerous' consequences. They did not say he was wrong: just to keep quiet about it. One wonders if they would have said the same to the Trinidadian historian C.L.R. James, who famously said he denounced European colonialism but respected 'the learning and profound discoveries of Western civilisation'.[8]

'Taste' is another example of a word becoming off limits. We talk of course about how food tastes—and we elevate food to an art form (a mark of decadence since ancient Rome)—but less and less about good or bad taste in art or books or music. Cultural theorists decry good taste as a fig leaf for the naked power of social elites: an underhand claiming of intrinsic value for what, they argue, is nothing more than just what certain types of people have liked through history.[9] Thus, British artist Grayson Perry thinks taste—far from being a matter of choice—is 'inextricably woven into our system of social class... one's social class determines one's taste'.[10] There is an element of truth in this—cultural elites have indeed always sought to distance themselves from the tastes of the many and to hand tradition down to their own—but what is missing from such critiques is

7 'EU deplores "dangerous" Islam jibe', *BBC News*, 27 September 2001.
8 James (1980), p. 179.
9 Notably Pierre Bourdieu (1984) but widely since then and cf. the discussion of his theory in chapter two.
10 Grayson Perry, 'Taste is woven into our class system', *Telegraph*, 15 June 2013.

any consideration as to whether or not they may have been *right*. Or wrong. The real irony is that, historically, taste has had nothing fixed about it: taste, as we understand the concept, was born in a time of exploration, risk-taking and experimentation through arguments about taste between Hume, Kant, Herder and Burke. What is great in the Western tradition is neither objectively beautiful nor just a matter of subjective fancy: instead, as Scruton puts it, 'a tradition is the residue of critical conflicts'; the longer those conflicts have been settled, so much greater the confidence we can have in the value of the works concerned.[11] Today, however, rather than rising to the critical challenge that canonical works pose us, it appears we are embarrassed by them and would rather downplay their greatness: keep quiet about it, at least in public.

Culture itself, in the absence of discrimination, may be everywhere but no one can easily say what it means: to the extent that it is an expression of how society feels about itself, then society is going through an existential crisis. It was once a broadly accepted idea that high culture was

> the accumulation of art, literature, and humane reflection that has stood the 'test of time' and established a continuing tradition of reference and allusion among educated people.[12]

Today it is immediately open to question and deconstruction. What we are at risk of losing, as high culture becomes taboo, is the ability to judge works of art in terms of their beauty and truth. This is not just a loss of the ability to love them but also of the understanding that the beauty and truth we speak of in the arts is *human* beauty and truth. High culture expresses the best of the human spirit: human self-consciousness and self-reflection and, in the end, human freedom. Today we seem to be more comfortable with the idea of finding beauty and truth in *nature*, untouched by human hands or sullied by so-called

[11] Scruton (2007), p. 4.
[12] Scruton (2007), p. 2.

civilisation, particularly of the Western variety. Man today is more often seen as a polluter, a greedy mouth to feed, than a creator, more brute than divine, and few are comfortable with the historical reality that the Western tradition—and its superiority in culture—was based on our freeing ourselves from nature earlier and more successfully than others. Some may feel that freedom won at this price, at the expense of nature, was not worth the candle. And yet one of the high points of Enlightenment thought was the idea that through affording humans more freedom to exercise their reason they would mature and learn to live in tolerance with each other, become grown-up enough to challenge and be challenged with respect to their stock notions and their judgements. Freedom and reason were opposite ends of the pole to nature and instinct. As philosopher Tzvetan Todorov puts it, there was a double movement put in play by the Enlightenment:

> A negative movement of liberation from norms imposed from the outside and a positive movement of construction of new norms of our own devising. The good citizen, Rousseau wrote, knows how to 'act according to the maxims of his own judgement'.[13]

The slow erosion of what words mean is not something that is easy to arrest and often attempts to do so are inspired by nothing more than nostalgia or irritation with change. With a word like culture, there are a lot of things we might welcome about its evolving usage. The end of the 'culture of deference' for example: the unthinking or enforced acceptance of the tastes of others, our presumed betters. But if we want to try and conserve what we can—and this book is addressed to those that would—of the tradition of culture we have inherited, then part of what is involved is the effort to understand culture better. One first step then is to try and sketch out what the word means and the role it has played in our intellectual development. What follows now

[13] Todorov (2006), p. 41.

is limited and partial and leaps hither and thither across history much as genius appears but infrequently and without warning. For more adequate outlines of what is one of the most complicated concepts in the English language, Williams' *Keywords* gives a fair treatment as does the aforementioned *Culture and Society*. In his footsteps, see Terry Eagleton's *The Idea of Culture*. Scruton has written extensively on this subject but *Modern Culture* and *Culture Counts* are particularly relevant here. I also recommend German political theorist Hannah Arendt's essay 'The Crisis in Culture' in *Between Past and Future* to which I owe the insight that to understand where we are sometimes we must look back to where we came from.

The Eternal City

Culture has its roots in Rome.[14] In a straightforward way, that our word 'culture' has its etymology in the Latin verb *colere*, meaning, at first, to cultivate in the sense of agri-culture: to till, tend and look after nature, the land, fields and gardens. Somewhere that has been tended in this way is, by dint of your labour, somewhere that will provide you the necessities of life, and so *colere* also comes to mean to inhabit, to persist or dwell in a place. If you cultivate nature around you, then you make it somewhere fit to live in. At the very beginning, then, 'culture' carries a two-fold sense within it: an active one of caring for the world, improving it for your own benefit; and a passive one, a more objective sense, of *being* in that world. The ability to improve on and be in this world is something to give thanks for — after all the fruits of nature are something of a miracle — and the Roman concept of culture also covered that of 'cult': care for the gods, their honour, reverence and worship. Once you have a place of your own, food on the table, and gods to watch over you, then, with luck, in the good years, you may have a little spare time, some freedom, some leisure in which you can turn to the cultivation of your body — the adornment

[14] I develop here on Arendt's exposition (1968), pp. 208ff.

and beautification of your physical appearance, your *nature* —
and, so, by an easy extension, *colere* comes to mean the care of
what dwells inside that body: your spirit, *soul* or consciousness.
You can care for yourself by making yourself better through
cultivating, for example, friendship, justice and tolerance: *bonos
mores*, good behaviour. In short, culture has a moral dimension:
it becomes a question of what *sort* of person you choose, in your
freedom, to make of yourself; and, therefore, what sort of per-
son you appear to be to others, as an object of *their* judgement. It
also becomes, as I have tried to indicate, a conscious activity, an
act of free will or what the ancients tended to talk about in terms
of virtue: the perfecting of nature, being good.

In all this the Romans were quite different from the 'cultured
Greeks' who, 'it seems, had no word for culture'. For them
culture

> was something natural if it existed at all — something of which
> they were unconscious, something as instinctive as their lan-
> guage or the complexion of their skins.[15]

Something which, being natural, would have died with their
civilization — consider its rapid decline into the dead ends of
academic Hellenism with its Oriental scale and pompous
drama[16] — had it not been preserved by the Romans who paid
the Greeks the greatest and most original of all possible compli-
ments: setting them up as the foundations and underpinnings of
their own culture; as an enduring touchstone of greatness; and
as — just consider Virgil's *Aeneid*, a complete refashioning of
heroic epic some 700 years after Homer — a springboard for the
conscious creation of new art.

[15] Read (1963), *To Hell with Culture*, pp. 10–11.
[16] Hellenism is the period after the death of Alexander in 323 BC: in it, as
 Gombrich notes (1995), p. 108, the 'styles and inventions of Greek art
 were applied on the scale, and to the traditions, of the Oriental
 kingdoms'.

A New Model of a Man

Cicero—the Roman orator, republican politician and political theorist, lawyer, philosopher, linguist, collector of antiquities and poet: the world's first Renaissance man—wrote many letters to his friend Atticus in Athens, entreating him to buy Greek statues and art to decorate Cicero's Tuscan villa. He wanted them to adorn his *gymnasium,* itself built on Greek models and a place where body and mind both got a workout.[17] Like Virgil, Cicero reached back into a past treated as a resource for contemporary life, taking what he liked, discarding what he did not consider beautiful and morally fitting. He was a man of taste and discrimination, of good judgement. And it was Cicero who was the first we know of to use culture in this moral sense. As Arendt observed, he

> speaks of *excolere animum,* of cultivating the mind, and of *cultura animi* in the same sense in which we speak even today of a cultured mind, only that we are no longer aware of the full metaphorical content of this usage.[18]

Cicero can also stand for the role Rome played in preserving the culture of Greece and using it to underpin and elevate its own. Cicero's great labour at the end of his life in taking Greek philosophy and political theory into Latin, not just through his provision of a Latin vocabulary (*humanitas, qualitas, quantitas, essentia,* etc.) but through his personal statement that *these* were works of great value, that *Plato* mattered, led to the establishment of a tradition, an intellectual inheritance that was to be handed down, through the Christian fathers and onto the Renaissance.

For the aristocratic elites of late Republican Rome, Cicero was a man who had 'bought his own furniture' (to reprise Alan Clark's famous put down of Michael Heseltine). He was a self-

17 Neudecker (1988), p. 14.
18 Arendt (1968), p. 208. In a footnote she quotes Cicero as saying philosophy is the cultivation of the soul: *cultura autem animi philosophia est.*

fashioned new man, a *novus homo*: for some a grubby *parvenu*. The noble families of Rome, exhausted with imperial plunder and self-conscious under the disapproving stares of the funeral masks of stern ancestors on their walls, were not wrong to see something novel and dangerous about the way in which Cicero had created himself: if his personal and private virtues – rather than noble birth – could take him to the Consul's curule chair, then on what basis was their rule over Rome legitimate, or secure? While they debated that question in civil war, Cicero's nemesis, Julius Caesar, did posterity the great favour of shutting Cicero out of public life, leaving him time to reflect: 'it was through my books that I was addressing the Senate and the people. I took the view that philosophy was a substitute for political activity.'[19] Cicero wrote in a new way – for his private consolation – with doubts about whether or not it would be of any use in terms of educating his contemporaries but in the conviction that, in doing philosophy, and in exercising disinterested judgement on the world as it appears, doing something that we might also recognise as aesthetics, he was engaged in 'the freest, *liberalissimum*, of all pursuits'.[20] Cicero's conception then of what it was to be a good person, his *humanitas*, presumed a self-conscious free will shaping a character fit for public life, and ready to receive the judgement of others. The exercise of personal judgement with the guidance of an internalised traditional authority – reading the right sort of things, the greats – will teach you to know what to read and what not to: looking at the beautiful and shunning the profane will sharpen your ability to discriminate. Taste, that most subjective, most personal, and freest of our faculties

[19] Cicero, *De Divinatione*, II 7.
[20] Arendt (1968), p. 216.

> de-barbarizes the world of the beautiful by not being over-
> whelmed by it; it takes care of the beautiful in its own 'personal'
> way and thus produces a 'culture.'[21]

It was characteristic of Caesar to recognise the greatness of
Cicero while drawing attention to his own exploits at the same
time: 'it is more important to have greatly extended the bound-
aries of the Roman genius than the borders of the Roman
empire.'[22] Caesar's foundation of empire and its spread of
civilisation made the city of Rome the centre of the world and
made the whole world a city.[23] And what survived — even after
the reality of its fall and the ensuing Dark Ages — through the
ideal of this eternal city, the place to which we trace back all our
values, was the Ciceronian vision of free and equal citizens
living in the city, being in the world, being cultured.

Man Renascent

It is Petrarch, the 'Father of Humanism', and his famed ascent of
Mount Ventoux in 1336 that is sometimes chosen to introduce
accounts of the Renaissance.[24] In emulation of King Philip V of
Macedon — the only other to have attempted it — Petrarch
ascended the summit apparently for the sheer fun of it: but at
the top of the mountain he gazed out on the view, and although
he recognised the aesthetic beauty of nature, the landscape
spread before him like a picture, in the same moment he became
acutely aware of the greater importance of inner truth, of care
for his soul. Suddenly that lofty summit 'seemed scarcely a cubit
high compared with the range of human contemplation'. The
story is a key example of what the great Swiss historian Jacob
Burckhardt called the discovery of the world and of man in the
Renaissance: 'man became a spiritual individual and recognised

21 Arendt (1968), p. 221.
22 Pliny, *Natural History*, 7.117.
23 Mumford (1961), p. 239, where Mumford quotes the 5th-century poet
 Rutilius Namatianus: 'a city of the far-flung earth you made.'
24 See, for instance, Cronin (1967), p. 139.

himself as such.'[25] It is also a good example of the Ciceronian sense of culture: it is one thing to care for nature, it is another to care for the self. What happened on that summit was that Petrarch discovered perspective. He stood on the top of the world and looked down on it, as might God. His subjectivity could take in, as it were, the whole world as its object. In the same instant he became aware that it was *him* who so perceived the world and that he was not in it: 'we look about us for what is to be found only within.' Man cannot find himself in the natural world but his unique subjectivity makes it an object he can both find, and make, beautiful.

Petrarch's discovery, in 1345, of Cicero's letters to his friend Atticus represents another key facet of the Renaissance: its use of the tradition inherited from Cicero—of the classics of literature (*bonae litterae*)—to serve as an ancient authority for the contemporary exercise of freedom of thought by humanist scholars. Cicero's arguments in defence of Roman republican freedom against the tyrant Caesar were used as justification for the political freedom of city-states like Florence, searching for models to legitimise their independence from both Pope and Emperor.[26] Cicero was also revealed, in his works and letters, to be a deeply *human* man with all his warmth and flaws which made it easier to relate to him and also gave support to the goal of 'standing out' as your own man in a world—of Italian mercantile cities—where ambition and talent could get you to the top. Men like Petrarch, Coluccio Salutati (Chancellor of the Florentine Republic from 1374) and, famously, Machiavelli mined the letters and works of Cicero and other ancients for advice and solutions to contemporary problems. These early humanists

> spoke with their ancient forebears, wrote letters to them, read them in the evenings as friends to be relied on when their con-

[25] See Burckhardt (1990), p.9, and chapter four.
[26] On the creation of a 'Florentine Cicero', see Witt (2000), p. 205.

temporaries could not be, and insisted they shared the same values.[27]

It was Coluccio who added Cicero's *Letters to his Friends* to his library of some 800 volumes and set about mastering and surpassing the great Roman's prose style, believing he could go further than mere imitation of antiquity and produce something new. And it was Coluccio's archaeology of the historical foundation of Florence — deriving its origin from the Roman Republic rather than the Roman Empire — which was a key support for the freedom of its citizen-body: he and his friends termed themselves 'the new Romans'.[28] And this reading of the 'old Romans' was also — in Bertrand Russell's words — a further 'step towards emancipation, since the ancients disagreed with each other, and individual judgement was required to decide which of them to follow'.[29] The Renaissance became aware of its *historical* distance from the ancients and gained a perspective on them, although they were still treated as directly relevant to contemporary concerns. Thus if Florence was successful that must be because it was a free republic and the model for this was found in an explanation of Roman good fortune as resting on Roman freedom and virtue.[30] If base-born men came to positions of power and wealth — rather than feudal knights — it must be because, as could be read in Horace, 'true nobility is nothing but virtue'. Roman ideals explained the material reality of Florence's situation.

That flowering of the human spirit that was the Renaissance was able, through the Romans, to reach back to the Greeks, to read Plato in the original and rework him for its own time. Artists were also to look at Greek sculpture — like the *Laocoön* so

27 Coleman (2000), p. 234.
28 Cronin (1967), pp. 43–44.
29 Russell (1946), p. 483.
30 Cf. Sallust (2010), p. 13: 'once liberty was attained, it is incredible to recount how great the state became in a short time. So strong was the desire for glory that came over them.'

beloved of Lessing and Winckelmann—and use that as a spur for the creation of monuments and symbols of their own freedom. Donatello's amazing *David*—the subject *par excellence* of Republican freedom—in Florence being one example; Michelangelo's *David* is, of course, the other. Florentine polymath Leon Battista Alberti made use of classical forms in the architecture of the façade of the Palazzo Rucellai in Florence: he would have been aware of the Greek 'orders' because they were reproduced in the tiers of the Colosseum in Rome where he studied and in fact wrote a book on architecture, *De Re Aedificatoria*, itself based on his reading of the Roman architect and engineer Vitruvius' *De architectura*. Renaissance thinkers drew on Ciceronian roots for their conception of *virtù*:

> Alberti, equates *virtù* with man's will, and believes it 'capable of scaling and possessing every sublime and excellent peak', while Poggio, in his dialogue *De Nobilitate* defines nobility exclusively in terms of active personal *virtù* and points with scorn to such a kingdom as Naples, where the barons believe that nobility consists in superior birth and will not even farm.[31]

Alberti thought we learn everything from a study of nature and some argue the real breakthrough of the Renaissance was in a turn from the study of God to a study of nature.[32] From theology to science. In a way this is true, but the turn was to a study of *human* nature or of how the world appeared to *man*. Alberti, after all, thought it was mathematics that underpinned both art and science: their unity being the exercise of human reason since neither is to be found in nature. He also thought painting and architecture should create harmonious and *beautiful* forms: again, not, he thought, to be found in nature, but brought to it by man. In this he was following in the example of

[31] Cronin (1967), p. 57.
[32] For example, 'At the dawn of magnificence', *Economist*, 29 March 2013: 'The movement placed man, rather than God, at the centre of the universe. Nature, more than heaven, was to be the proper subject for an artist.'

Petrarch—to look within—and so too was Leonardo da Vinci in his restless desire to understand everything: his anatomical studies, his interest in grotesques, his fascination for machines and how things work. All these aspects of him, I suggest, find their synthesis in his theorisation of painting as nature perfected. In fact Leonardo is not best described as a naturalist. He depicts humanity in the world, in nature, yet does not do so *naturally*, but in a highly idealised, artificial and, in fact, *super*natural way. Walter Pater, the essayist and critic, described Leonardo's view that 'art, if it was to be something in the world, must be weighted with more of the meaning of nature and purpose of humanity' and spoke of his portraits as 'faces of a modelling more skilful than has been seen before or since, embodied with a reality which almost amounts to illusion on dark air'.[33]

The Light Within

Although the political freedom of cities like Florence was untimely and extinguished soon enough, and although Italian humanists retreated from the cities to their villas and the court of Lorenzo the Magnificent established itself in Cicero's beloved Tuscan hills, thinkers like Marsilio Ficino, founder of the Florentine Academy, translator of all of Plato into Latin, and his student Pico della Mirandola still operated in a framework that had man at its centre and celebrated his creative powers and dignity. Their philosophy was moulded more by Plato's humanistic spirit than anything before it, as Mirandola's statement in his *Oration on the Dignity of Man* demonstrates:

> Philosophy herself has taught me to weigh things rather by my own conscience than by the judgement of others, and to consider not so much whether I should be badly spoken of as whether I myself should say or do anything bad.[34]

[33] Pater (1986), p. 63.
[34] Mirandola (1965), p. 18.

This is a direct echo of Socrates — that horsefly on the Athenian body politic — in Plato's dialogue *Gorgias*, where he says:

> [I]n my opinion it's preferable for me to be a musician with an out-of-tune lyre or a choir leader with a cacophonous choir, and it's preferable for almost everyone in the world to find my beliefs misguided and wrong, rather than for just one person — me — to contradict and clash with myself.[35]

With this, at the very beginning of the Western tradition of thinking about our thinking, of philosophy in other words, we find Socrates putting forward the idea that, in Arendt's formulation: 'even though I am one, I am not simply one, I have a self and I am related to this self as my own self.'[36] Socrates established that we have a duty of care to our selves before we do to others: it is more important for me to agree with me than with you. Thus Mirandola, like Cicero, committed himself to the 'cultivation of the mind' and struggled to raise himself up to God rather than descend to the beasts. Individuals were free to decide: to you 'alone is given a growth and a development depending on thine own free will. Thou bearest in thee the germs of a universal life.'

The slow spread of the idea that the only person who could decide what was right for himself *was* himself — that authority over oneself must be located in one's own freedom — can not only be traced through the Reformation (and the reaction against it) and into the philosophy of the Enlightenment, but observed too in the growing status of artists, and the importance of the arts and culture to society more generally. It is as if the more the individual human being is taken seriously, the more do we value those works of beauty he might produce and the more we value beautiful representations of the human. This includes not just portraiture but landscape (a human view), poems and novels (the life of the human mind), drama (humans

35 Plato (1994), p. 64.
36 Arendt (2003), p. 90.

playing humans), architecture (homes for humans) and music (how it feels to be human).

The Enlightenment has been termed by historian Jonathan Israel 'a revolution of the mind'. The nature of this revolution consisted fundamentally in a belief that man could turn to face the future as a possibility rather than look behind him to the past as a guide to action. In politics this way of thinking inspired actual revolutions in both America and France. In terms of culture too there was a split or rupture in what was understood by the term. The Great Earthquake of Lisbon in 1755 is as convenient an historical hook to hang this change on as any insofar as it shook the faith of many in the ability of reason alone to shape a world fit for human beings.[37] Maybe there were forces we could not control after all. Kant, in particular, was so disturbed by the event as to write three essays trying to find scientific explanations for the tragedy, laying the basis for scientific geography and seismology in the process. Although he continued to write and think in the spirit of the Enlightenment (indeed he almost defined it with his imperative 'dare to know'), Kant was forced to accept that there are indeed limits to pure reason, things we cannot know. While human perspective may indeed be all, we are not gods who can create whatever we imagine. Nor is society — let alone art — open to being organised by scientists or mathematicians. It is, however, open to being changed in line with the exercise of practical reason and human judgement. Individuals may not know the Good in itself but they can certainly be better.

Reaction against the Enlightenment was always there within it. We can see it in the tortured imagination displayed in Piranesi's *Carceri d'Invenzione*, part of what Kenneth Clark called the Romantic rebellion against reason: explaining it as 'an expression of fear' of what happens when reason loses control

[37] Shook it so profoundly 'that Madame de Pompadour gave up rouge for a week', Clark (1973), p. 45.

or oversteps its boundaries.[38] The Romantics turned, in their various ways, from Wordsworth to Blake, away from human reason and towards nature, both actual nature (think of the poetry of John Clare) but also human nature: its passions, dreams, imaginings and fears. Reminding us that man is as fallible as he is perfectible. Thinkers such as Johann Gottfried Herder, developing the idea of the individual giving himself form—externalising himself through culture—argued that culture was *society's* self-expression: the collective consciousness of the people, the *Volk*, conceived of as a 'natural division of the human race, endowed with its own language; which it must preserve as its most distinctive and sacred possession'.[39] The *Kultur* of a people, a nation, was something in their blood. Other nations had their own *Kulturs* and between them struggle, *Kulturkampf,* was inevitable. We have moved from culture as 'sweetness and light' to culture as something to die for.

Culture and its Meanings

In the *Oxford English Dictionary* culture is defined in what I have grouped as five senses:

1. the cultivation of land, crops, plants, animals, or micro-organisms;
2. worship, cult;
3. cultivation of the mind, of the body (now rare), of a study or pursuit, hence;
4. refinement of mind, taste and manners, hence the arts;
5. the distinctive ideas, way of life of a particular society, people or nation; a way of life, e.g. youth or drug culture, corporate culture.

The first two senses we have seen in the discussion of culture's roots in Rome. The third and fourth arose in the German

[38] Clark (1973), p. 45.
[39] Watson (2010), p. 125.

intellectual tradition of the 18th century: placing a premium on self-development and the individual pursuit of cultivation. The fifth sense, popularised by Herder, came to express the idea that culture was something peculiar to certain social groups, societies or even nations as a whole.

My argument throughout is based on an understanding of culture in the third and fourth senses. Firstly, as a process of individual betterment and moral refinement through the making of judgements and discriminating between what one thinks one ought to like and what one ought not. This is not a simple matter of getting it *right*: the development relies on the *exercise* of the faculties of judgement, discernment and reason. This is the classical liberal understanding of individual freedom and growth found in writers such as Kant, Goethe and J.S. Mill.

Secondly, culture is equally a tradition whose rules operate at a social level and which we, as social beings, inherit. It is historical and something we are born into: the result of a long process of critical judgement. Culture in this sense also relies on freedom: degrees of both socio-political freedom (including an openness to building on and altering tradition; recognising it as the expression of conflicting judgements) and freedom from immediate necessity.

Understanding culture in this way — in the relationship between the individual and society — underpins my argument that culture relies on freedom and that it has a moral dimension: that is, what sort of person should one make oneself, what sort of society does one want to live in, how our reality and our ideals relate. It also means that the question of whether or not the value of the arts can be seen in objective or subjective terms necessarily remains an unresolved — and unresolvable — tension. We do speak of Beauty or Truth but as shorthand for our individual pursuit of them, on the one hand, and as what the cultural tradition esteems as beautiful and true, on the other, while being aware that the tradition may alter its judgement over time. Another expression of the same tension of course is that we as individuals are both body and mind: flesh and spirit. In the philosopher John Armstrong's words, we 'are physical creatures

with minds that aspire to abstract ideals: beauty, goodness and truth'.[40]

The reason for restating this is because the fifth — anthropological — sense of culture has become the dominant way in which it is understood today. It was through the 19th-century reaction against the Enlightenment — by which we are still determined — that the idea of culture as being something *in here* moved towards being something *out there*. 'Culture' became less a verb or a process and more a noun depicting the established and settled order of things.[41] Rather than having an active subjective sense, culture became an objective way of being: something to hear and obey, rather than study and pursue. Thus when we talk about German culture or English culture we talk as if about a 'thing': Germans imagined as having essentially Germanic traits because of their culture rather than viewing German-ness as an expression of historical and social development.

The *OED* also notes that this fifth sense of culture is a 'countable' use of the word (i.e. quantitative rather than qualitative) and, as such, has been used in the support of the 'rejection of normative or hierarchical conceptions of the development of society'. This is the root of today's understanding of *multiculturalism*: that is, that there are *cultures* rather than culture and that no one culture can be said to be better than another. At the same time the individual is increasingly seen as the product of — defined by — a particular culture: what is termed one's *cultural identity*. The effect of this understanding is to downplay the possibility or desirability of changing what one inherits. Why change it if no one culture is better than another? How *can* it be changed if it imprints itself on the individual from birth?

[40] Armstrong (2009), p. 59.
[41] See Williams (1983), p. 88: 'Culture as an independent noun, an abstract process or the product of such a process, is not important before lC18 and is not common before mC19.'

Despite this, high culture preserved its authority for a long time after its wellsprings of renewal had been choked off. Many who loved it wanted to bring the glories of elite culture to the masses—I am thinking of Raymond Williams' work in adult education as one example, the Workers' Educational Association for another—in the full belief that it was open to all. The identification, however, of culture with the culture of a nation or a social class prompted the question as to what made any of it better than anything else. And thereby opened a door to radicals, opposed to the *status quo*, to oppose *their* culture to the dominant model. In the progressive degeneration of left-wing thought post war, many took the opportunity simply to write off high culture in the name of so-called working-class culture: a phrase expressive of nothing more than how most people live. It was easy to oppose Western high culture in the name of the marginalised, colonised or oppressed; in the name of politics; or in the name of the Other of Western culture—the counter-culture. This was a continuation of *Kulturkampf* but fought inside nations not between them. Counter-cultural fighters all agreed on at least—and often only—one thing: 'bourgeois culture' was the enemy; everything else a potential ally.

Culture, Culture, Everywhere…

The word culture has now expanded its remit so far as to start to lose any clarity: it really often means no more than simply what is, whatever cultural identity you happen to possess. Commenting on this new use of the word, food critic and cultural commentator A.A. Gill writes:

> There is a civilised rule that states people who use the word 'culture' to mean health and safety have none of it, they're soullessly uncultured… They don't mean the books on your shelves, the poetry in your head. They don't mean the music in your fingers or the landscape, the bunting, the warp and weft on your mind's eye. They mean the mould in a petri dish. They

> think culture is an experiment, a series of statistics, social
> engineering—their culture can be nipped and tucked, edited
> and realigned.[42]

Culture is a thing, then, to be used to achieve certain social results: applied like a drug or a bandage or as a prophylactic against anti-social behaviour. Culture is also a thing we fight *against*: the culture of abuse, drink and drug culture, celebrity culture, macho culture, gun culture, consumer culture, and so on. In every case individuals are seen as having too much freedom: from cases of domestic violence to greedy bankers. In each of those examples of 'bad' culture, they are seen as the result of individuals not being able to—or not being trusted to—apply and enforce limits on their own behaviour. People are seen as addicts in need of help to change their culture: assistance the modern—increasingly therapeutic and paternalist—state is often only too willing to provide. Of course, sadly, there are few success stories since, if culture is just what you are—your tastes determined by your social class or your cultural identity fixed at birth—then it is no easy task to become someone different. All this goes to reinforce a culture of non-judgementalism, while culture becomes something we might need to be cured of, rather than something to be conserved and cared for. Or it becomes something that can cure *us*: an instrument to make us happier or healthier. Either way, we are placed in a relationship of dependence on culture.

Being Discriminating

There is never an easy, or perhaps any, return to the earlier senses of a word. It may be that the best we can do is be conscious of the changes and reflect on them. At least what I will attempt in this book is to explore the sense of culture as being expressive of human freedom and its relationship to and role in human history. I will try to maintain a sense of culture being as

[42] Gill, 'Table Talk', *Sunday Times*, 24 March 2013.

much a process as a state. Culture today has lost that historical perspective and is just for now, for today, but not tomorrow. As such, critiques of contemporary culture as mere kitsch or ephemeral entertainment have weight.

A particular and pressing concern is without that activity within us *for* culture, then others may attempt to *culture* us: to shape us, as they see fit. Stressing the active, subjective, pursuit of culture is equally to draw attention to the object of that pursuit, namely culture as denoting something that our 'best selves' *should* pursue. Culture exists in both a subjective and an objective sense: exists precisely in the relationship between the two. We find ourselves in this world (subject to it) and we, as actors (active subjects), cultivate the world and ourselves. In the same way, artists create and innovate within a cultural tradition. This relationship is what I mean by the pursuit of 'being cultured'. We create objects (pictures, books, buildings, institutions) that are designed to, or at least aspire to, outlast us. In this sense culture acts as a bridge between past and future — a bearer of meaning — situating us in a relationship with other generations and, by allowing the possibility of our action persisting beyond our lifespans, elevating our individual subjectivity into something greater, something transcendent. It is this truth and possibility that our notions of religion and the sacred reveal.

In these terms, the problem of culture today is primarily one of a shift and trend towards its objective interpretation (as in it is natural) and away from a subjective one (as being a product of nurture). This shift results in an emptying out of cultural meaning from both individuals and institutions since meaning only exists at the level of subjectivities. Instead we can only attempt to measure culture in quantitative terms: hours a day, visitor footfalls, diversity of audience, etc. For Terry Eagleton the crisis of culture is expressed in our being trapped between 'disablingly wide and discomfortingly rigid notions of culture... our most urgent need in the area is to move beyond both'.[43] He

[43] Eagleton (2000), p. 32.

sees that future in an 'enlightened political context'. Which rather puts the question to one side: making culture the hand-maiden of creative economics and politics. My argument instead is that culture should be the measure of man.

The ability to be cultured rests on an ability to discriminate. Between subject and object, between appearance and reality. Between what is beautiful and what ugly. What is true and what is false. Between, in the end, what is good and what is, if not evil, at least not good. To the extent we choose not to so discriminate, we fail to make or be meaningful.

Two

Down with Discrimination

> In matters of taste, more than anywhere else, all determination
> is negation; and tastes are perhaps first and foremost distastes,
> disgust provoked by horror or visceral intolerance ('sick-
> making') of the tastes of others. — Pierre Bourdieu, *Distinction.*

Thou Shalt not Discriminate

The speed with which non-discrimination policies have been
adopted throughout Western politics is breathtaking. The 1960s
saw the introduction of the Race Relations Act in the United
Kingdom and the Civil Rights Act in the United States. Since
then non-discrimination policy has extended to cover pay, age,
gender, sexuality, disability and religion: all of which are
wrapped up in the United Kingdom's Equality Act of 2010.
Campaigners continue to push to extend the reach of bans on
discrimination. Proposed legislation in Kalamazoo, Michigan,
would cover

> the actual or perceived race, color, sex, age, religion, national
> origin, height, weight, marital status, familial status, citizenship,
> physical or mental ability, gender identity, sexual orientation or
> genetic information of another person.

One of the high points for campaigners against discrimination
in recent years has been the legalisation of gay marriage:

culminating in the decision of the Supreme Court in 2013 that marriage is not based on the difference between a man and a woman but rests on the equality of both partners.[1] As American journalist Christopher Caldwell put it, gay marriage has gone 'from joke to dogma' in just a decade.[2] So mainstream has the prejudice in favour of non-discrimination become that it now extends into the private sphere: examples include the fines applied to a Christian couple in Cornwall in 2008 for refusing a gay couple a room; Derby Council's decision in 2011 to deny a black Christian couple the right to become foster carers because of their opposition to homosexuality; and Rotherham Council's removal of three Eastern European children from their white foster parents on the grounds that they were members of UKIP and, therefore, racist.[3] The state, public authorities and the law all now operate — not only to promote *ideals* of equality — but to enforce them in areas that were until very recently considered matters of individual conscience, and of which society need not approve but should at least tolerate. Demands for equality can increasingly partake of an empty, formal and dogmatic character.

When it comes to arts and culture, non-discrimination in the form of support for multiculturalism is also the order of the day. The Arts Council England, for example, has demanded that all regularly funded organisations implement a 'race equality or diversity action plan': an exercise in not much more than auditing the current racial mix in the organisation (ticking the ethnic boxes) and committing to change it.[4] The Arts Council itself 'as of 2008, demanded to know the sexuality of board members in

[1] I reprise here some material originally published as 'Oordeel zelf', *The Optimist*, September/October 2013, p. 21.

[2] Christopher Caldwell, 'Gay Rites', *Claremont Review of Books*, 4 April 2013.

[3] Tom Morgan & Alex West, 'UKIP foster couple: our agony', *The Sun*, 27 November 2012.

[4] 'Respond: a practical resource for developing a race equality action plan', Arts Council England, 2005.

applications for funding'.[5] For many organisations this can mean nothing more than hiring and firing on the basis of anything except merit. In this kind of top-down initiative by a public funder we have come a long way from Matthew Arnold's desire that the state should be driving us towards the very best of culture by making us more discriminating about what exists. Now public money goes to change existing cultural bodies until they fit a politically and socially correct image of how they should be; or should appear to be.

Official non-discrimination policy also has a very large indirect impact on culture in three important ways. Firstly, through a desire on the part of artists and critics to challenge and overturn perceived relations of inequality and cases of discrimination in the arts: both in the sense of undue preference and funding being given to high art forms like opera or ballet as opposed to, say, street dance, and in the sense of wanting to redress historic imbalances by giving artists with 'protected characteristics' such as race or disability equal billing with everyone else. This can result in at least an unconscious subjective bias towards minority culture if not open positive discrimination. Secondly, efforts to ensure audiences more accurately reflect the realities of contemporary society in terms of their balance of race, gender and sexual orientation. And thirdly, the use of the arts to actively change audience opinions and attitudes in a 'positive', non-discriminatory direction. The overall effect of these approaches to culture, I will argue, is to create a climate that has become very aware, hyper-aware in fact, of questions about the identity of artists and relatively less attuned to questions of artistic value and beauty. The embrace of non-discrimination in public has bled over into the private sphere and risks creating a situation where our demand to treat everything equally and fairly means that we become blind to beauty and actually indifferent, if not actively cynical, about a

5 Sidwell (2009), p. 24.

culture that can no longer tell the difference between what is good and what is not.

Before going on to examine these aspects of non-discrimination in culture we need to take a step back and consider the change in the way we think about discrimination in culture and examine its treatment by three influential cultural theorists: Susan Sontag, John Berger and Pierre Bourdieu. Between them they continue to dominate much contemporary thinking in this area. All three of them exemplify the desire to say black wherever tradition had said white.

Object to Subject

The widely understood sense of discrimination today is a prejudicial or distinguishing treatment of an individual based on his membership of a group or category. Opposition to discrimination in this sense extends to matters of taste: at least in the desire of much contemporary culture to challenge so-called conventional ideas of beauty. Just consider campaigns for fat and disabled ('body different') catwalk models to be as highly regarded (if not more so) than thin ones. Yet discrimination is not always a matter of bigotry and unthinking prejudice. Discrimination is both an action in the sense of seeing and noting and evaluating the differences between things. It is picking out what *matters* to us. It is also the faculty of being good at discriminating: some of us being more or less discriminate; exhibiting more or less discernment.

Good taste and discrimination, in the sense we are talking about, and increasingly so after the last war, has an association with stuffy elites trying to maintain their way of life—giving unfair preference to what they like—by refusing anything else entry and dismissing it as inferior. Thus any claim that classical music, for example, might be superior to pop will be met with the counter that a false objectivity is being claimed for what is in the end no more than the tastes of a privileged section of society. And that the tastes of that group for the great and the old is really just a way of being different from everyone else. There is, it follows, no *intrinsic* merit to a Chopin sonata: it is just *different*

from a Chaka Khan song. Now attacking stuffy elitism and cultural prejudice is a good thing, and there has been a long process of democratisation of culture from the 19th century onwards. We should all try and become better at making cultural judgements between what is good and what is bad: no matter the colour or sex of the artist or writer or singer. What is not such a good thing is the retreat from the idea that we can say nothing more about culture than how we, personally, *feel* about it. To do so is to remove any solid ground for disagreement about culture and, at the same time, any firm basis for agreement: if everyone has his own taste, then it amounts to no one having taste. It is also to say nothing much about the art itself: the object that we should be trying to understand and apprehend becomes a secondary concern to how I feel about it. It is to say, for example, that I just love such and such a picture or book or piece of music because it reminds me of when I split up with my boyfriend or bought my first house or stubbed my toe. The self-flattery involved in basing taste purely in one's subjective response to culture ultimately finds its expression in our indifference to — and silence about — the art itself.

Countering Culture

The idea that I might get to decide, for myself, without being dictated to by my elders and betters has a definite appeal and is in fact an important part of developing one's judgement. Freedom to decide for oneself what is beautiful and what is not and to justify one's choice is a legacy of the Enlightenment's break with the weight of what was often unthinking tradition. By the 1960s, however, the break with tradition often took the form of a default positive valuation of the 'anti-traditional', the 'counter-culture'. Young people asserted themselves negatively by rejecting the *mores* of their parents, asserting they weren't no squares. Their hostility was directed against so-called 'bourgeois freedom': rejected in the name of a new society, of communal living. Being a hippy was not about being an individual, or different, it was about being *together*. (And it was being together with a very small and highly educated entirely non-representative section of

society.) Despite the value given to experimentation and the fight for civil rights, we should also be aware of the degree of conformity to the new dogmas demanded by the 'theoreticians of sociability'[6] and the extent to which certain orthodoxies which sank into public consciousness at the time (opposition to 'hate speech', a cult of youth hostile to the past, above all an elevation of undistinguished equality, in which everyone was 'man', and a matching intolerance to the traditional values of the previous generation) have become so entrenched today that to question them can endanger one's career if not one's liberty.

So deeply held is the orthodoxy that the exercise of taste is a put-down, a disrespectful act, that whole theories, of which Bourdieu's is perhaps just the weightiest expression, have developed to naturalise taste: witness the long-running 'culture wars' between a rear-guard defence of Western high culture and the proponents of a radically 'other' and incommensurate popular culture. The key development is that taste is now treated as the expression of an aristocratic nostalgia that refuses to accept this modern world. It is not considered as an attempt to rid ourselves, as individuals, of the prejudices we inherit. In fact, and this is the real irony, it is seen *as* prejudice. Best not to choose than to risk perpetuating *their* tastes. Refusal to have an opinion itself becomes a site of radical resistance.

Do I Have to Choose?

Susan Sontag's essay, 'Against interpretation', published in 1964, is representative of a body of thought that dominated critical, or more accurately 'anti-critical' or 'beyond-critical', attitudes to culture in the 1960s. Sontag was an influential American filmmaker, writer and cultural theorist, maybe best known for her essay 'Notes on "Camp"', and very much the New York metropolitan intellectual in her rejection of anyone and anything apple pie: 'what I like about Manhattan is that it's full of foreigners. The America I live in is the America of the

6 Malcolm Bradbury, *The History Man.*

cities. The rest is just drive-through.' Her embrace of the Other, and her self-disgust, is clear in her view that 'the white race is the cancer of human history'.[7] In this early essay, she argued for a move away from interpretation — attempts by critics to explain the meaning of art — and towards feeling: 'pure, untranslatable, sensuous immediacy.'[8] Against content: for form. Against intellect: for sensibility. Against thought: for flesh. 'In place of a hermeneutics we need an erotics of art.' Interpretation itself she dismissed as 'largely reactionary... the philistine refusal to leave the work of art alone'.[9]

It was an influential work. Reprinted many times and in many languages, it is still a staple in the bookshops of modern art museums: lined up with other bestselling counter-cultural texts by Žižek, Badiou, Derrida, Bourdieu, Foucault, Barthes, Berger and so on. What is less well known and less commented on is Sontag's remarkable afterword to the collection of essays including 'Against interpretation'. Much later she admitted to her role as a naïve standard-bearer of what she called 'the age of nihilism'.[10] She wrote that the 'transgressions I was applauding' then 'reinforce[d] frivolous, merely consumerist transgressions. Thirty years later, the undermining of standards of seriousness is almost complete'. Sontag didn't have to make this confession and it is testament to her intellectual honesty that she did. Yet it is not a full apology. She still wanted to have her cake and eat it: still wanted to avoid making a judgement. She continued:

> The contemporary work I praised (and used as platform to re-launch my ideas about art-making and consciousness) didn't detract from the glories of what I admired far more. Enjoying the impertinent energy and wit of a species of performance called Happenings did not make me care less about Aristotle and Shakespeare. I was — I am — for a pluralistic, polymorphous

7 Quoted in Eric Homberger, 'Susan Sontag', *Guardian,* 29 December 2004.
8 Sontag, 'Against interpretation', in (1966), p. 9.
9 Sontag, 'Against interpretation', in (1966), pp. 7–8.
10 Sontag, 'Afterword. Thirty Years Later', in (1966), p. 311.

culture. No hierarchy, then? Certainly there's a hierarchy. If I
had to choose between the Doors and Dostoyevsky, then – of
course – I'd choose Dostoyevsky. But do I have to choose?[11]

Yes. She *had* chosen – 'what I admired far more' – and she
should have been willing to explain her choice and fight her
corner. One can like the Doors and Dostoyevsky equally – why
not? – but that is itself a choice. Not to choose is to show the
cowardice she accused the 'interpreters' of: those squares who
resisted feeling the 'cool' of her Happenings. Happenings
which, she admits, frequently took the form of cruel and violent
assaults on their audiences: 'designed to tease and abuse…
sprinkle water on the audience, or fling pennies or sneeze-
producing detergent powder at it.'[12] Sontag was complicit and
instrumental in attacking what she saw as the aloof and distant
elitism of traditional critics who tried to explain what high
culture was purely in terms of its *content,* rejecting this in favour
of the aggression of the work of art on the beholder: the use of
culture as an instrument and a weapon with which to assault
the 'normal'. She praises Artaud's Theatre of Cruelty and its
attempt to carry out 'a complete repudiation of the modern
Western theater, with its cult of masterpiece, its primary
emphasis on the written text (the word), its tame emotional
range'.[13] Her later admission that she had been undermining the
'standards of seriousness' on which culture relies is really an
admission that she hid the fact that she preferred Dostoyevsky
so as to fit in with the tastes of the moment. Her admission is of
a refusal to think for herself by saying that how she *felt* was
more important.

Sontag distinguished three cultural sensibilities:

[The] first sensibility, that of high culture, is basically moralistic.
The second sensibility, that of extreme states of feeling,

[11] Sontag, 'Afterword: Thirty Years Later', in (1966), p. 310.

[12] Sontag, 'Happenings: an art of radical juxtaposition', in (1966), p. 265.

[13] Sontag, 'Happenings: an art of radical juxtaposition', in (1966), p. 272.

represented in much contemporary 'avant-garde' art, gains power by a tension between moral and aesthetic passion. The third, Camp, is wholly aesthetic.[14]

This was a remarkably prescient take on the past, her present and our today. We now live the consequences of the victory of the aesthetics of Camp and a loss of a *moral* understanding of aesthetics: that is to say, there are some things you *should* like and some you should not, and the reason why is not *entirely* up to you but has something do with the work of art itself and with the tradition in which it was created.

Love Discriminates

The dangers of the growth of what Sontag called a Camp aesthetic, a playful sensibility, had been predicted ten years before by the English sociologist and founder of Birmingham University's Centre for Cultural Studies, Richard Hoggart. In his famous lament for working-class culture in the face of the dominance of the post-war culture industries, *The Uses of Literacy*, he observed that the individual who

> uses his freedom to choose so as to be unlike the majority… [is] likely to be called 'narrow-minded', 'bigoted', 'dogmatic', 'intolerant', 'a busy-body', 'undemocratic'. No one is so much disliked as he who persists in 'drawing comparisons'; he spoils the party-spirit.[15]

Hoggart was critical of a sensibility that licensed itself in terms of 'do what feels natural', 'if it feels right, then it's all right': the sort of sensibility that Sontag was to praise in the 1960s. He saw it, not as tolerance, but as a cowardly approximation to it. When someone says I like Dostoyevksy *and* The Doors what is really being made is a declaration about the kind of person 'I am not': I am not an old-fashioned elitist who *only* likes high literature. Oh

14 Sontag, 'Notes on "Camp"', in (1966), p. 287.
15 Hoggart (1957), p. 154.

no! *I* am an enlightened modern person because I *also* like whatever is not-high. On that basis I escape judgement because my tastes are plural and diffuse (if not irreconcilable): because I do not judge; judge me not. This inclusivity of judgement—the non-judgemental aesthetic—is, at heart, an expression of a fear of judging and being judged in turn. It is a retreat from possible judgement, which amounts to a fear of one's own freedom, a flight to security: to a place where you do not stand out or are likely to be noticed. It is a withdrawal from oneself.

As Hoggart put it:

> [T]he tolerance of those whose muscles are flabby and spirits unwilling is simply a 'don't-hit-me' masquerading as mature agreement. Genuine tolerance is a product of vigour, belief, a sense of the difficulty of truth, and a respect for others; the new tolerance is weak and unwilling, a fear and resentment of challenge.[16]

This 'new tolerance' means that inclusive judgement is simply the safe choice: it's a covering of bases in advance, we won't fall out because your tastes are so thoroughly catholic. Sadly, without mature conversation—agreement *and* disagreement—we don't really have anything to talk about; anything more that is than compiling compare-and-contrast lists of what we like: this and that and this too and oh a smattering of that as well. A masquerade, a mélange, a mixtape of adult relationships.

This truth is, as an aside, perfectly expressed by Nick Hornby's novel *High Fidelity*. Cool vinyl-store owner Rob Gordon's eventual 'commitment' to his girlfriend Laura is symbolised through his abandonment of musical snobbery in his gift to her of a thoroughly inclusive mixtape. What better expression of the fear of judgement than the mixtape of feelings and moments: that pious presentation of a vulnerable sensibility? Faint heart wins fair maid. And how different is the mixtape to the *Rime sparse* of Petrarch's celebration of his

unrequited love for a much earlier Laura. That Laura, Laura di Noves, denied Petrarch unto death, granting him instead the knowledge of 'how the world's delight is a brief dream'. And gave us, thereby, the immortal beauty of his poetry. Such is the power of love and what is, after all, more discriminatory than the choice of just one person from the whole world?

Sex and Power Everywhere

Art critic John Berger's *Ways of Seeing* was a radical perspective on Western fine art when it was published as a BBC series in 1972. Much like Sontag, he was reacting against what he saw as traditional aristocratic elitism in culture, personified for him by the towering figure of Kenneth Clark in the post-war British arts world. Not only is 'ways of seeing' a phrase used by Clark in his 1956 book *The Nude*, but Berger was directly responding to the hugely popular and influential BBC series *Civilisation* aired in 1969 which Clark had presented. Berger, by contrast, wanted to shift the emphasis away from paintings and sculpture themselves and on to how we see them or how we are free to see them differently since: 'The art of the past no longer exists as it once did. Its authority is lost.'[17]

Berger made just four arguments. The first, rehearsing that of German Marxist critic Walter Benjamin in his *The Work of Art in the Age of Mechanical Reproduction*, was essentially that the 'bogus religiosity' of the work of art had been destroyed because 'the painting now travels to the spectator rather than the spectator to the painting'.[18] It is active; we are passive. Secondly, that a painting of a nude is no more than a painting of a naked woman, or a picture of one, and there is no essential difference between a Botticelli Venus and a Playboy Bunny.[19] Third, he dismissed oil painting as merely the vaunting vanity

[17] Berger (1972), p. 26.
[18] Berger (1972), p. 13.
[19] Whereas for Clark the nude is always expressive of an ideal abstracted from reality.

of the wealthy bourgeoisie: just a way of owning something expensive, of showing off. Finally, that advertising and publicity, a world of images, now keep the masses in place: diverting them with consumption from the pressing business of revolution.

What were then marginal insights are now default prejudices: the idea that high culture is nothing more than the cynical mask for the brute power of money and class, and that we are all beholden to the power of the advertising image, is now nothing if not mainstream. British cultural critic John Holden's book *Culture and Class* of 2010 stands directly in this new tradition with its argument that 'status, education, wealth and culture march together, so one way of helping the disadvantaged is to increase their cultural capital'.[20] What such ideas often mean is helping people *see through* works of culture in order to discern the underlying relations of power: helping them *resist*, rather than revere or love. Thus wherever Berger looked he seemed to see the power of capital and of men and he saw sex. Beauty went unnoticed. As such *Ways of Seeing* would have been better called *Ways of Not Seeing*.

Determining Fractions

Berger believed that some people liked what they did, had certain tastes, simply because it reflected back to them their own power and freedom relative to everyone else. It was Pierre Bourdieu, the cultural anthropologist and sociologist, who gave the gloss of French philosophy and academic seriousness to very similar ideas. His book *Distinction: a social critique of the judgement of taste*, published in French in 1979, argues that discrimination — taste — is related to social position: in fact the exercise of taste is no more than an act of social positioning. By which he meant that to have taste is to put someone else down: I become a victim of your choice. Bourdieu aimed to reconcile and explain the question of structure and agency in society: to

[20] Holden (2010), p. 10.

what extent you are free; to what extent you are determined by existing conditions. He made extensive use of social science techniques of analysing large datasets (the book is thick with charts) to back up his assumption that the way we see things is because of our way of seeing ('it is the aesthetic point of view that creates the aesthetic object').[21] Thus 61.5 per cent of the professional classes like to lay out the silverware when entertaining along with the crystal (57.3 per cent) against only 27.8 and 29.3 per cent respectively for manual workers.[22] Presumably this preference for silver and crystal is nothing to do with their relative beauty compared to pewter and china mugs but entirely a way of marking out the difference between lawyers and navvies. The statistics show a difference and so the thesis, that there was a difference, is confirmed. Although not explained and, in the process, no account is taken of the question of *individual* judgement. After all, 39 per cent of professionals do not like to put out silver and then, of course, there is silver and there is silver.

Bourdieu's concept of 'habitus' is an attempt to explain how the taste and judgements of individuals relate to the objective social structures in which they find themselves and to which they are allegedly *habituated* by their parents and through education. In short what he called 'class fractions' (e.g. manual workers or teachers) inculcate certain aesthetic preferences to their children in order that they too can gain membership of the fraction. These preferences are internalised to such a degree that they appear to have universal validity: that is just the way things are, naturally. That is, people are unable to see beyond the prejudices instilled in them from birth. As Bourdieu concludes:

> [S]ocial subjects — including intellectuals, who are not those best placed to grasp that which defines the limits of their thought of

[21] Bourdieu (1984), p. 21.
[22] Bourdieu (1984), p. 196.

the social world, that is, the illusion of the absence of limits — are
perhaps never less likely to transcend 'the limits of their minds'
than in the representation they have and give of their position,
which defines those limits.[23]

Bourdieu's analysis discovers a shattered, fractional, aesthetic
reflecting a shattered divided society: it is the Humpty Dumpty
approach to cultural judgement. It might have superficial
appeal to class warriors but it amounts to a naturalisation of
social differences rather than any explanation with reference to
how society is organised. Thus he argues (prefiguring today's
celebrity chefs but with less of their disdain for working-class
diets) that those from the lower end of the social hierarchy will
choose 'heavy, fatty, fattening foods, which are also cheap' in
their dinner layouts, opting for 'plentiful and good' meals as
opposed to foods that are 'original and exotic'.[24] His position
amounts to a denial of free will since he is arguing that social
class determines likes and interests and that distinctions based
on social class get reinforced in daily life: 'the working-class
"aesthetic" is a dominated "aesthetic" which is constantly
obliged to define itself in terms of the dominant aesthetics.'[25]

Tastes, in this theory, are learned early on and are highly
resistant to change: they mark us like tattoos, and impair social
mobility. So it becomes a self-replicating system. But how did it
start and how might it change? Bourdieu offers no answer to
these questions but his analysis has been very influential in
posing the issue of culture in terms of the dominant limits
(despite the illusion of their absence) of class-bound taste: limits
which radicals should seek to break down and overcome in
order to bring about the *reality* of the absence of limits. This is
something we will return to in the next chapter but for now it is
worth bearing in mind that such a world would be one without
discrimination or taste: a bland and undistinguished world.

[23] Bourdieu (1984), p. 486.
[24] Bourdieu (1984), pp. 173, 72.
[25] Bourdieu (1984), p. 33.

Culture, Multi-culture and Identity:
flattering the self

We can look again at John Holden's book as an example of the contemporary influence of Bourdieu. Holden sees a way of overcoming the imagined limits of the dominant culture in challenging them with those of other cultures: 'the ability to understand and engage with the rich variety of cultures that everyone encounters is a precondition to being able to play a full part in contemporary life.' Culture can be used to 'break down class divisions and inequalities' but only if culture is unlimited: 'culture itself must be created by everyone and for everyone.'[26] We come now to another way in which individual discrimination and the existing cultural tradition is attacked: through casting doubt on the value of the work of 'dead white males'. A corresponding balance is found in the sympathetic elevation of the status of 'minority' arts and culture: calls that they be afforded equal recognition and affirmation *because* they are minority tastes. This feeling has led to decades of public funding of investment in diversity culture: the Arts Council England's 2003–2008 'decibel' programme 'to raise the profile of artists of African, Asian and Caribbean descent in England' being one of the more notorious recent examples. Matthew Arnold, once again, would recognise such a use of the state to promote and support culture. Though he might not understand why today's playgrounds and classrooms train children from nursery onwards in the etiquette of cultural diversity. And he would no doubt point out that the only reliable result of the promotion of culturally diverse artists will be the creation of an incentive to avoid mainstream culture. To their detriment and ours.

Sociologist Frank Furedi, in his book *On Tolerance*, argues that the dominant values of Western societies today no longer act in support of tolerance as classically understood in the trad-

[26] Holden (2010), p. 64.

ition reaching back through J.S. Mill to John Locke and beyond, but of what he terms a 'new intolerance'. While tolerance requires the existence in society of a cultural guarantee for discrimination and judgement, the new intolerance, on the other hand, rests on a 'powerful therapeutic etiquette of recognition and affirmation'.[27] This etiquette alone is a dangerous challenge to the discrimination necessary for culture and here Furedi echoes our earlier discussion of Hoggart. But the new intolerance comes with other values that also work to undermine culture. Furedi lists: 'risk aversion', 'the policing of uncertainty', scientific dogma or scientism, and the branding of 'offensive speech as traumatising'. The project of being cultured very much depends on a climate conducive to just the opposite values: a willingness to take the risk of not conforming to the status quo; always being sceptical of what are passed off as pious verities; a thirst to look beyond appearances, especially in the form of scientific 'facts'; and the courage, above all, to give and to receive criticism.

What though of the 'therapeutic etiquette of recognition and affirmation'? What does this mean and why is it so damaging to discrimination and judgement? The demand for recognition works primarily as a demand for recognition of an identity. The answer to the question 'what am I?' is often couched these days in terms of gender, sexuality and race. I am a male LGBT Latino, for example, and I demand that you recognise this fact (the implication is it has long been denied, unseen and ignored: or in fact, of any interest). And I demand that you do not, whatever you do, judge me. 'I am what I am', as Zaza the drag queen sings out at the end of Act I of the '80s Broadway musical *La Cage aux Folles*. *This* identity must be recognized — Zaza, not Albin — and it demands acceptance: a being said yes to; not, no. Affirmation, not rejection. The danger of denial, even of indifference, is that, so it is argued, the identity may remain

[27] Furedi (2011), p. 197.

suppressed, or ignored, and, therefore, self-confidence and self-esteem will not be allowed to develop.[28]

What has this to do with culture? After all, might it not be the case that, even if we accept the problems the politics of identity causes for tolerance and freedom in society, this does not necessarily mean it is a problem for culture? I think it is — on two levels. In general, because a society that restricts the freedom of its citizens in the name of equality of identity will feel threatened by those who do not conform to one of the identities on offer — actually a pretty limited range — and deemed worthy of social validation. Try demanding recognition and affirmation for the identity of a well-educated well-off white male. So the range of culture decreases. More courage than ever is required to rise out of whatever identity ghetto you might be born into. And it becomes particularly difficult — here is the real tragedy — for inner-city black youth to pass up hip hop for Haydn.

It is a problem for culture in particular because our tastes are seen as determined by our cultural identities. And, therefore, what we like becomes off limits to judgement. In a double sense. No one is entitled to criticise, or 'disrespect', your tastes because your tastes are working-class, cultural-minority or sexual-subculture tastes. And that is what you are. I must respect that. But equally, you must not let go of those tastes and start acquiring different ones — let alone 'higher' ones — since that would represent a betrayal of your identity. You are — as a Greek Cypriot — locked into liking Greek Cypriot art and culture. As the art historian Robert Hughes argued, such cultural segregation

> corresponds to one of the most corrosive currents in the American polity today — corrosive, I mean, to any idea of common civic ground — which is to treat the alleged cultural and educational needs of groups (women, blacks, Latinos, Chinese-Americans, gays, you name it) as though they overrode

[28] See Furedi (2011), p. 87.

the needs of any individual and were all, automatically, at odds with the allegedly monolithic desire of a ruling class, alternately fiendish and condescending, of white male heterosexual capitalists. More and more, it is assumed that one's cultural reach is fixed and determined forever by whatever slot one is raised in.[29]

Where the logic of Bordieu's argument has led us is clear: the way around the problem of the dominant aesthetic is simply to declare that the aesthetic of every fraction is as valid as that of every other. The existence of a dominant aesthetic in Britain, say, is challenged by the introduction of dominant aesthetics from other countries, races and even sexualities. The result is that nothing much is special anymore. Nothing sacred or elevated. Nothing off limits.

Down with the Ideal: up the real

The exercise of judgement and discrimination is part of a process of discovering and declaring what sort of person you want to be. It used to be the case that we tried to refine our taste so we could understand and enjoy complicated and difficult things (it is as true of the arts as of whisky) but, increasingly, attempting to strive towards any artistic ideal has been dismissed in favour of an obsessive concentration on the 'real' or 'lived experience'.[30] The '60s assaults, like Sontag's Happenings, aimed to *épater la bourgeoisie* in much the same way as the Decadent poets of the 19th century. The attack was pushed home, to take the British example, by what was called shock, or 'in-yer-face', theatre. Plays like Mark Ravenhill's *Shopping and F***ing*, Peter Handke's *Insulting the Audience*, or Sarah Kane's *Blasted* tore away at every convention and ideal. As theatre critic Alex Sierz puts it:

[29] Hughes (1993), p. 197.
[30] Used as an abstract noun, 'the real' has been found to appear 179 times more frequently in contemporary art gallery press releases than in standard English. See 'A user's guide to artspeak', *Guardian*, 27 January 2013.

Ideas were kidnapped and taken to the limit. If drama dealt with masculinity, it showed rape; if it got to grips with sex, it showed fellatio or anal intercourse; when nudity was involved, so was humiliation; if violence was wanted, torture was staged; when drugs were the issue, addiction was shown... Theatre broke all taboos, chipping away at the binary oppositions that structure our sense of reality.[31]

Theatre aimed to show the reality behind the façade: capitalism was mindless consumerism, love just sex, truths half-truths at best. Every ideal turned out, on inspection, to be tarnished. Reality was always more contradictory, ambiguous and messy than you thought. As, indeed, it often is, and certainly the '90s were bereft of that Cold War simplicity in which it was clear whose side you were on. What, however, our theatrical *enfants terribles* seemed not to have noticed was that the ideals and conventions—that they set upon so manfully—collapsed just so readily as they did because the mortar between their bricks had long been dry as dust. The much-remarked victory of the left in the 'culture wars' blinded them to the extent to which ideas like anti-racism, atheism and feminism had become the new orthodoxy: and that continued attacks on bourgeois values in the name of 'the real' had crossed a line from counter-cultural radicalism to nihilism. To put it another way, if *all* there is is the messy contingency of reality, then what does anything *mean*? Reality just *is*: we need ideals to help us structure, interpret and understand it. Nature needs art to comprehend it. Without it,

[m]ake-believe violence is a tool that all too easily becomes an indiscriminate weapon. It is a form of knowledge—of the body's vulnerability, of the aggression that lurks in the hearts of men—but it can also be a pernicious seduction, luring artists

[31] Sierz (2000), p. 30.

and audiences toward a nihilistic celebration of the destruction of meaning itself.[32]

In this sense, shock theatre acted as a 'weapon' against the exercise of discrimination. Shock, after all, precludes judgement—gives you no chance to think—and demands or enforces agreement. Yet, even though shock is no longer so shocking, the arts are still—from body piercing and tattooing to misery memoirs—set on pushing home to us how very-very real, earthy and material, reality actually is. In the process of drawing our attention to reality, it also demands that we look after a reality, damaged—so the argument goes—by our devotion to false gods and ideals like economic growth. Theatre, to continue the example, has become very much 'about' reality.

Get the Message

Recent plays in Britain, say Lucy Prebble's *Enron*, *Greenland* by Moira Buffini or Philip Ralph's *Deep Cut*, have all sought to expose and address social and political issues. They are plays 'about' things. Climate change, racism, bullying, corporate greed, the state of education. Often a season at the theatre can read more like an academic conference than entertainment. For example:

> [T]he Bush presents The Schools Season: *The Knowledge* by John Donnelly and *Little Platoons* by Steve Walters. The season will bring together an ensemble company of ten actors and a series of talks, debates and events which will examine education in Britain today.[33]

Very worthy—probably very dull—certainly preaching to the converted. By way of contrast, when Irish poet and playwright Brendan Behan was asked what *The Hostage* was 'about', he is

[32] Charles McNulty, 'Depictions of violence in theater: Revelation, not nihilism', *Los Angeles Times*, 15 February 2013.

[33] 'The Schools Season', http://www.bushtheatre.co.uk/schools/

said to have replied: 'Message? What the hell do you think I am, a bloody postman?'

This desire to be 'about' — and to 'do something' about it — is paralleled by what has happened to documentary film-making. A documentary is just not a documentary these days unless it has an associated online campaign (*An Inconvenient Truth, Gasland, Just Do It, The End of the Line, Erasing David*) for converts to sign up to and pledge not to eat fish anymore or fly less or whatever it is. The positive impact that comes as a result of the documentary has become more important than the documentary itself: certainly it has become a way of raising money from advocacy charities like Greenpeace in order to make the picture in the first place. As it happens, pedalling environmental orthodoxy is certainly not beneath Hollywood either: movies like *Wall-E, Rio* and *Avatar* spring immediately to mind.

As well as plays and films 'about' issues, the last decade brought us the phenomenon of verbatim theatre: for example, Erik Jensen and Jessica Blank's *Exonerated* (death row inmates), or David Hare's *The Permanent Way* (railway privatisation). Hare claims that the latter is so real, it 'does what journalism fails to do'. Another playwright, Robin Soans (*Talking to Terrorists, Arab-Israeli Cookbook*), thinks the 'normal channels of reportage, wherein we expect some degree of responsibility and truth, are no longer reliable'.[34] Since the media — the 'Murdoch' press — is seen as just spin, then verbatim theatre aims to tell the real truth: claiming to let people speak for themselves, in their own words. Theatre in this vision is more responsible and more true than the news. And, unsurprisingly, less entertaining. Verbatim theatre — in its unmediated word-for-word reliance on what actually happened — mirrors reality's lack of structure and, ironically, ends up telling us nothing.[35]

[34] Richard Norton-Taylor, 'Verbatim theatre lets the truth speak for itself', *Guardian*, 31 May 2011.

[35] Cf. Lasch (1979), p. 149: 'the slogan of relevance embodied an underlying antagonism to education itself — an inability to take an interest in anything beyond immediate experience.'

The proponents of verbatim theatre—in the absence of any authorial voice—explicitly argue its 'function is to keep society healthy'. It is a purgative or a therapy. It asks for empathy and identification with the voices—the verbatim stories—of victims: the bullied, or civilians in war zones. It explicitly does not ask for judgement. Verbatim aims to destroy the aesthetic difference between art and life and break the 'screen between performer and audience', so we are 'not abstractions to each other but living, breathing beings'.[36] Equally, its evidence-based reliance on facts demands acceptance and recognition of what just is, rather than any judgement such as that required by a story told through such old-fashioned narrative devices as a plot with a beginning, middle and end.

Where, in this new science—because it is more science than art—of the real, have the actors gone? What of the audience? What about any communication between playwright and audience? Is this even theatre anymore? It is certainly very different from the traditional view of theatre in which the playwright expresses his subjective judgement on the world and the audience on the night make that judgement objective: through their symbolic consumption of his work; through the active exercise of their imagination, discrimination and judgement. What the audience makes of the vision before them is, of course, up to them. The appeal is simply that they judge whether they think the play is good or bad: in the aesthetic, ethical and political senses. Sartre called watching and listening to theatre 'directed creations'. Fellow French thinker and writer, Gabriel Marcel, thought of theatre as an experience of 'communion'. David Mamet, too, says:

> The theatrical interchange, then, is a communion between the audience and God, moderated through a play or liturgy constructed by the dramatist... no one comes into the theatre with-

36 Jessica Blank and Erik Jensen, 'Verbatim theatre: the people's voice?', *Guardian*, 15 July 2010.

out a conscious or unconscious submission to the possibility of revelation.[37]

Today, under the influence of theorists like Sontag, Berger and Bordieu, the audience is more likely to be treated as objects: the most of which can be expected is that they do not judge. It might matter that they 'get the message', but it matters less if they judge the play to be good, bad or indifferent nor, in fact — so long as the message gets through — does anyone really care.

Discrimination Matters

Discrimination is more than judgement (whether negative or positive): it is its very possibility. To be able to discriminate between things they must be separate. The distinctness of objects is the ground on which we can distinguish them, though, of course, not all objects are *distinguished*. Without discrimination, of the world into objects, and in our appraisal of the world, there would be no mediation of existence and no grounds for reason. A discriminate world is lived in by the discriminating and it is a *reasonable* world in which we can tell where something begins and something else ends: where something *is*; and where something is *not*. Without discrimination we would be plunged into a Protean chaos where no sooner something is, then it was not: a world without boundaries; of fantastic and unlimited imagination, a world of unreason. A deconstructed world in which everything means everything else and nothing means anything at all. This is the danger attendant on what I see as the contemporary hostility to the exercise of discrimination: both to the idea that some works of art are more beautiful and more true than others; and, in particular, to the idea that some people might discriminate more finely, have better *taste*, than others. The quote from Bourdieu with which this chapter opens is, in the end, a recommendation that we do not 'negate' the tastes of others with our own. By reading taste

[37] Mamet (2010), pp. 47–9.

as simply determined by and expressive of power structures within society, he sees no way in which the idea of taste might correspond to the *tasteful*. All that matters is that my taste is *not* yours. His implied remedy to this situation is the one in fact adopted in many contemporary Western societies: that is, a bland indifference to the question of taste; a shallow form of tolerance that is not upset by your tastes—however peculiar—because these things really don't matter so much after all. I want to argue, on the contrary, that the exercise of taste, discrimination and good judgement matter very much. That the real danger we face today in culture is not the dominance of the tastes of the rich and the powerful, but rather the hold the idea of non-discrimination has on our contemporary cultural elites.

Multiculturalism and the culture of diversity, in their denial of boundaries and the right to discriminate, represent a culture that can no longer form part of a world we hold in common—precisely because they act to confirm us in our different identities. The absence of limits—ironically, and sadly—finds expression in our increasing separation: in our alienation from ourselves and from each other, in existential loneliness.

Three

Culture goes Total

> The issue is not between innocence and knowledge (or between the natural and the cultural) but between a total approach to art which attempts to relate it to every aspect of experience and the esoteric approach of a few specialised experts who are the clerks of the nostalgia of a ruling class in decline. — John Berger, *Ways of Seeing*.

> Who in the world today, especially in the world of culture, defends the bourgeoisie? — Daniel Bell, *The Cultural Contradictions of Capitalism*.

Neither the removal of limits, nor the exposure of the reality behind ideals, is necessarily liberating. The opening up of culture into multiculturalism can leave us locked into particular identities: left alone because there is no longer any society to be part of. The rejection of social restraint on personal behaviour has increasingly led to the development of an obsession with (and hatred of) the self in the form of narcissism.[1] The 'collapse of the Freudian superego, that part of the mind that seeks to maintain adult behaviour, social norms and standards' has left us with 'a widespread refusal to grow up: infantilism as an ideology'.[2] There seems to be little place anymore for that form of self-expression which is a matter of saying no to oneself.

[1] See Lasch (1979), p. 28, on what happens when the 'boundaries between the self and the rest of the world collapse'.

[2] Berman (2001), p. 71.

And an aesthetic approach that declares nothing off limits in making artistic judgement can find itself saying everything about every thing, but nothing much about any thing. When culture goes total, and everything and everyone is included, so too nothing and no one stands out: culture loses its distinction. The demand for everything to be judged as equally valid — what we could call an *imperative of relevance*[3] — means that cultural institutions which put the demands of access ahead of those of excellence, run the risk of ending up as nothing very special themselves: no longer willing to discriminate between in and out, the good, the bad, and the ugly.

Drawing the Line

Sir Alfred Munnings, President of the British Royal Academy of Arts from 1944–49, is remembered for his still very popular sporting paintings of horses and for a possibly slightly tipsy farewell speech in which he indicated that he would be willing to join Winston Churchill in kicking Picasso's 'something something' down the road. Although Munnings embraced Impressionism, he detested Modernism: 'What are pictures for? To fill a man's soul with admiration and sheer joy, not to bewilder and daze him.'[4]

Times change. Four appointments of Professors to the Royal Academy were made in 2011. Fiona Rae, one of the Damien Hirst brood of Young British Artists from the '90s — she works in abstract colour, a little Kandinsky, a dash of Dali, a little sci-fi landscape — was named Professor of Painting. Richard Wilson — the installation artist who shocked the Edinburgh of my youth with his 1987 piece *20:50* filling a room in the Royal Scottish Academy to waist height with 650 gallons of sump oil — became

[3] When relevance becomes an important criterion in culture, what is easiest to relate to is what is already known and familiar: culture becomes a hall of mirrors for the self.

[4] Quoted by Peter Chew, 'The Painter Who Hated Picasso', *Smithsonian* magazine, October 2006.

Professor of Sculpture. Humphrey Ocean—former bass player in the band Kilburn and the High Roads and a painter of quite flat, almost drab, portraits—is Professor of Perspective, a position once held by J.M.W. Turner. And Tracey Emin was announced as Eranda Professor of Drawing: to a certain amount of shock and controversy.

The issue here is not so much whether Emin is much good at drawing or not. One of her supporters in the RA indicated that he thought that, at the very least, she could certainly draw *as fast* as Picasso, Dali and Raphael.[5] Stephen Bayley, the British design critic, writing in the *Telegraph* in defence of Emin's appointment, dubbed her 'a graphiste of great style, if limited range' but went on to argue that the real point was that she understood how terribly, how 'superabundantly important', drawing is. So important, he urged the government to make it compulsory at school: we must *force* children to draw. Not so they will all go on to be artists, but because there

> is something about the act of drawing that bypasses mundane consciousness and reaches straight into the brain… People who draw have superior cognitive ability and enhanced hand-eye co-ordination. They also, although this, I concede, is subjective, tend to be civilised. I do not believe people who like drawing much enjoy looting.

And there we have it. Emin deserved her appointment, not because she was particularly good at drawing or was even acknowledged as an inspirational teacher of its techniques and skills, but simply because she was thought to be an effective, non-bourgeois, cool and edgy figurehead of drawing and, as such, will be a way of keeping the 'yoof' in line and keeping the RA hip by association. With her appointment, more social-engineering poster girl than professor, the august Royal Academy seemed to be declaring its relevance, rebranding a certain

5 See Nigel Horne, 'Shock of the news: Trace Emin becomes RA professor, *The Week,* 14 December 2011.

'toxic' fustiness, coming up to date, and getting down with the street: fitting in with an expectation in society that the arts are there, not for themselves, not to be admired in joy, but to make us better, and better behaved, citizens.[6] Which is very different from the idea that the individual might make himself more cultivated. And it implies that those art forms which 'cannot be simplified and made relevant... [need] to disappear or to be treated with disdain'.[7]

Of course tastes do change. On the face of it there is no reason to object to any of these appointments since arguably they are fairly representative of the state of the visual arts in Britain today. All the fuss made over Emin's appointment was maybe more to do with her: certainly the extent to which the other professors are all, in one way or another, non-traditional was largely overlooked. It appears that *les enfants terribles* have taken over the Academy, as well as the theatre, for the time being. All seem to share an ambition to unsettle or break traditional conceptions of colour or space or reality, to mix up high and low styles. Only Ocean, the oldest of the four, concentrates on trying to represent the human form in his work. And to my mind it is actually Wilson's appointment, rather than Emin's, that is emblematic of the change in the Royal Academy. His *Turning the Place Over*, a 2007 installation, was an eight-metre disc cut from Cross Keys House in Liverpool which revolved on a giant rotator: literally turning the building inside out. The Royal Academy, an institution set up to promote and maintain the highest levels of excellence in artistic standards, in these appointments at least, now seems to be going through something of a head-over-heels phase in abandoning those very standards—which apparently it now finds rather embarrassingly old-fashioned. One can hope those brave Academicians fighting a rear-guard action may yet win the day.

6 Stephen Bayley, 'Draw inspiration from Tracey Emin', *Telegraph*, 14 December 2011.
7 Furedi (2004), pp. 94–5.

One does not have to share the social or artistic prejudices of a Sir Alfred to be concerned about what may turn out to be rash experiments in the fashionable reform of institutions, nor to lament breaking with tradition for the sake of it. Just because we *can* do something is not always a good reason for doing it. Is it not the job of arts institutions such as the Royal Academy to set an example? Either it believes in artistic excellence and expertise — that some are better at drawing than others — or it does not. If it does not, and wants to thoroughly shatter what remains of such bourgeois misconceptions, why not turn the dial up to 11, and really stab home the point by appointing as professors people who don't even pretend to be artists? Or, maybe better yet, why not grow old and irrelevant — if that's the way things are going — with some grace, and hold the line on its founding principles? It is the job of old institutions to resist the new as a test of its worth. In a way their very point is not to be fashionable. Let new institutions bring themselves into being as they see fit: to be judged by their own standards.

Cultural Free Fall

The authority of many arts institutions found itself increasingly shaky post-war: they struggled to operate to standards, rules and aims established by an elite increasingly seen as out of touch and very much on the defensive. There was a widespread feeling in society that there would be no return to the old ways of a top-down society; immediately symbolised by the rejection of Churchill in the elections, British withdrawal from India, the foundation of the welfare state and the NHS, and the creation of the Arts Council of Great Britain in 1946 with John Maynard Keynes in the chair. Even a conservative like T.S. Eliot now wrote, in *Notes Towards the Definition of Culture*, of culture being 'simply as that which makes life worth living', as 'the *whole way of life* of a people', so inclusively drawn as to embrace

> Derby Day, Henley Regatta, Cowes, the twelfth of August, a cup final, the dog races, the pin table, the dart board, Wensleydale cheese, boiled cabbage cut into sections, beetroot

in vinegar, nineteenth-century Gothic churches and the music of
Elgar.[8]

While still trying to hold onto distinctions between high and
low culture, Elliot felt he had to take account of popular culture
and bent over backwards to produce something for everyone: to
such a degree that his list features sport eight times, and food
three, while architecture and music appear only once each in
this baker's dozen.

When the authority of tradition itself became open to doubt,
it became very difficult for many to assert what once would
have been intuitive and beyond question: that, for example,
Michelangelo was better than Mondrian; that Beethoven beat
big-band swing. There was no longer a consensus of taste, a
shared theory of value, and in its absence came increasing
uncertainty as to why some things were in and others out.[9] That
this was art; *that* was not. When such attempts at judgement
were made — and this is even truer today — they were met with
accusations of social elitism: you are excluding this because it is
working-class culture, not because it is not art. And, over time, it
appeared that the only way that institutions could survive was
by trying to bend before the storm and give way to the new,
however shocking. The pressure was on to keep up to date,
never to appear outmoded or behind the times. Hence the
development of the imperative of relevance as a pragmatic
response to a loss of faith in their ideals: causing institutions to
start to define themselves — not in their own terms — but in rela-
tion to something else, that is, in relation to something they are
not.

Eliot's famous attempt to define a culture that everyone — at
least everyone in Britain — could relate to was an attempt to hold
the barbarians of the future — in their 'mechanised caravans' — at

8 Eliot (1948), pp. 27ff.
9 An example is the 'U', 'non-U', debate launched by Nancy Mitford in the
 1950s which expressed the death of the ideal that one should emulate the
 manners of one's betters.

bay. While he did try to find a basis for hierarchy and grada-
tions in society, they were not of more or less culture, but of
more or less consciousness of and specialisation in a *shared*
culture. This is not a theory that can really hold water. It is a bit
of a stretch to talk of degrees of consciousness or particular
specialisations when it comes to Eliot's 'boiled cabbage cut into
sections'. Eliot knew the ship was holed below the water line
and that he was just bailing for time:

> I see no reason why the decay of culture should not proceed
> much further, and why we may not even anticipate a period, of
> some duration, of which it is possible to say that it will have *no*
> culture.[10]

We may not have '*no* culture' today but arguably we have the
opposite, and that amounts to the same thing: we have a culture
that will not say 'no'; will not, or cannot, hold the line. We have
a *total culture*: a culture that exists without limits, and can, in
that sense, equally well be thought of as being no-where, or not
there. Quicksilver leaping from a smashed thermometer. With
the further erosion and withdrawal, if not breakdown, of dis-
crimination, of judgement and good taste, with the rejection of
elitist standards and institutions as unacceptably exclusive and
the resultant turn to diversity and multiculturalism, to the
plurality of *cultures*, it appears that culture today is both every-
where and nowhere. It's the classical music in the lift, advert, or
box set: the unheard background hum to our lives. Culture
comes in weekly listings, culture supplements deliver the fix to
our arts addiction.

Culture struggles to be noticed, to stay relevant and novel
(something traditionally associated with the more ephemeral
realm of entertainment): to get rated, pull the crowd, break the
box-office. Total culture is ubiquitous, determinedly inclusive,
open to all: yet flat and hollowed out, superficial, and lacking in
depth. There is something for everyone: every art form has its

[10] Eliot (1948), p. 19.

festival now and so too do most towns and cities. Culture is more and more abstract, more and more about expression: more artist; and less art. It is the showmanship of a Damian Hirst or Joseph Bueys. The 'Superflat' low-packaged-as-high-packaged-as-low 'art' of Takashi Murakami. That is not to say there is nothing left of beauty, but what beauty there is too often remains without remark or distinction: a shy flower on the wall. When we abandon particularity in the form of individual discrimination—let alone the shared culture of a nation—far from reaching the universal, we inevitably move into a world of totality. The universal is embodied in reality. The total, on the other hand, represents an attempt to make reality play the role of an ersatz universal. An attempt to plug—or deny the existence of—the hole left by the collapse of the universal. A world lacking limits. A world without borders. A world that, saying yes with all the passion of Nietzsche or Molly Bloom, fails to realise that 'yes', when there is no 'no', means little more than 'whatever'.

And, above all, a world without beauty—'the real' unmade—without the form and order that art imposes on the raw stuff of matter. In this sense the imposition of limits is part of culture. And the refusal to set limits is characteristic of what I am calling total culture. The idea that the limited is good and beautiful is at least as old as Pythagoras but certainly finds expression in Plato. The *Republic* warns against the dangers of democracy taken to an absurd extreme, with its 'equality of a peculiar kind for equals and unequals alike'.[11] When equality becomes an organising principle of society—as Athenian election by lot allowed the unskilled and skilled equally to hold the same office—then what is different is treated as if it were, in effect, the same. In philosophical terms, the one is treated as equal to the many. The individual living in this democracy is, Plato says, the slave of his desires, living only for each passing pleasure. That is to say, he does not control himself nor place any limit on himself. Instead

11 Plato (1941), p. 277.

he confuses anarchy with freedom and will brook no restraint: 'citizens become so sensitive that they resent the slightest application of control as intolerable tyranny.'[12] Although Plato might not have put it quite like this, these citizens are not autonomous because they do not impose laws on themselves. This leads to a breakdown in society in the absence of any authority and the picture Plato paints is one we may recognise today:

> Citizens, resident aliens, and strangers from abroad are all on an equal footing... the schoolmaster timidly flatters his pupils, and the pupils make light of their masters... the young copy their elders, argue with them, and will not do as they are told; while the old, anxious not to be thought disagreeable tyrants, imitate the young and condescend to enter into their jokes and amusements.[13]

Eliot again was quick to see what was at stake here. Culture as he knew it — gentle, organic, European — was caught between the frying pan of an exclusive particular nationalism, intolerant of cultures other than its own (his example is Nazi Germany) and the fire of a 'uniform world culture' as envisioned by the universal ideals of a communist world state.[14] He worried that culture would become a mere handmaiden of politics, that a total 'culture' would be imposed to the dictates of political planners and cultural commissars, in a way that Britain had never attempted even in the Raj.[15] At the same time he felt — like Matthew Arnold — that only the State could organise the education required to preserve a culture 'in not very good health'. As regards the

[12]　Plato (1941), p. 283.

[13]　Plato (1941), p. 282.

[14]　Eliot (1948), pp. 118–9.

[15]　Eliot (1948), p. 90. On this it is worth noting that the Empire made no effort to enforce English on India, and its take up was not evidence of 'cultural imperialism', but of the enthusiasm of local elites. I am grateful to David Graddol for this and for pointing me in the direction of S. Chaudhary, *Foreigners and Foreign Languages in India,* and J. Brutt-Griffler, *World English: a study of its development.*

intervention of the State, or of some quasi-official body sub-
ventioned by the State, in assistance of the arts and sciences, we
can see only too well the need, under present conditions, for
such support.[16]

Present conditions have stayed present since — as is so often the
way with temporary measures — and, sadly, less and less heed is
now given to Eliot's warning against allowing 'increasing
centralisation of control and politicisation of the arts and
sciences' or to the need to separate 'the central source of funds
from control over their use'.[17] Even Eliot, despite his prescience,
would have been shocked at the speed at which his barbarians
of the future have driven their mechanised caravans through
the very idea of any limits and boundaries to culture: their
blitzkrieg launched not in the name of nationalist particularism,
nor universalist uniformity, but under the banners of an
inclusive and totalising *absence* of borders.

Categorical Breakdown

The imperative of relevance expresses the fact that cultural
institutions and high culture itself can no longer justify them-
selves in their own terms but are forced to explain themselves in
relation to something else, something which, of course, they are
not. One way of doing this, for example, is to argue that the
value of the Western high tradition is only contingent on the
existence of — and through comparison with — other traditions.
More concretely, it can be seen in the case of street dance and
ballet: very few people are prepared to assert that any great leap
is required to move from one to the other. Dance is viewed as
simply being constituted of various forms of dance existing on a

16 Eliot (1948), p. 94.
17 Eliot (1948), p. 94. The UK government website states that there is 'no
 question of any political involvement in arts funding decisions'. In the
 next sentence it says the Arts Council England 'accounts for and explains
 their decisions to government through the Department for Culture,
 Media and Sport'.

continuum rather than on any hierarchy of value: ballet and barn dance, modern contemporary and Morris dance, tango and tap. The end result of this refusal to evaluate — to make a case for why one form might be better than another — tends to provoke indifference. If they are all just as good... then why care about any one of them really?

Examples of this tendency to break down what were once distinctive and exclusive cultural categories are everywhere. I will look at the case of pop art but it is worth a quick survey of some of the more obvious examples. The ubiquitous term 'the creative industries', which apparently contributes so much value to the economy, on examination is found to be a veritable witch's cauldron. As defined by the UK's Department of Culture, Media and Sport (itself a monstrous hybrid), the creative industries include advertising, architecture, art and antiques markets, crafts, design, designer fashion, film and video, interactive leisure software, music, performing arts, publishing, software and computer services, television and radio.[18] Not only are the boundaries of what is considered to be 'creative' drawn so broadly as to include activities that stretch the meaning of the word to breaking point, but they also include 'the *subsidised cultural sector*, which *consumes* a subsidy' and the '*profit-making*, creative components of the British economy'.[19] That is to say, opera *and* musicals, documentaries *and* game show formats like *Who Wants To Be A Millionaire?*, art house films *and* computer games. This conflation of two very different things does nothing to help us make judgements about cultural art forms and, importantly, it also introduced the possibility (and now the reality of UK government policy) that everything included under the heading of creative industries would end up being assessed in terms of the only thing they do have in common:

[18] See 'Mapping the creative industries: a toolkit', British Council, pp. 16-7, http://www.britishcouncil.org/mapping_the_creative_industries_a_toolkit_2-2.pdf

[19] Heartfield, 'A business solution for creativity, not a creativity solution for business', in Mirza (2006), p. 78.

namely, how much economic value they contribute to UK plc. It is worth noting that the contemporary obsession with the question what are the arts good for cannot be understood in isolation from the breakdown and elision of what was special and different about one cultural activity and another: in this case that of the creative industries and the arts.

In addition, the same elision of categories can be seen between culture and sport: as in the government department which unites them but also in the ongoing effort of arts communities to try and demonstrate that the arts have as great a popular appeal as football. Not only is that a dangerous funding game to play (what if everyone *did* prefer football?), it is not clear what if any conclusions should be drawn from such comparisons, nor why. Football and fiction really are apples and pears. Broadening out culture to include ball games is driven by the same imperative which allows of no substantial difference between 'high' and 'low' culture.

Classical music is reaching out to include far more than just music. The European Union funded New Music: New Audiences website says that it is rarely the case that audiences still have to *suffer* music—and just music—for hours with contemporary concerts

> often involving other art forms such as lighting design, dance, theatre, video—or, as the Swedish Gageego ensemble did recently, having a graffiti artist decorate the whole concert hall while the music plays.[20]

Anything to distract you from having to listen to the music.

Comic books ('graphic novels') are lumped in with fiction and even welcomed by the Man Booker Prize chairman.[21] Academic conferences treat Bob Dylan lyrics as poetry, and

[20] 'There was a time when nothing happened at a classical concert...', http://www.newaud.eu/working-communities/mixing-art-forms

[21] Sameer Rahim, 'Drawing a line: Man Booker judge welcomes graphic novels', *Telegraph*, 22 November 2012.

even science and art are increasingly to be found together: as in the argument that 'contemporary science and art have found gaps in each other that require filling'.[22] Artist Marc Quinn has managed the production, for example, of a portrait of genetic scientist Sir John Sulston — *Genomic Portrait* (2001) — in which the collaboration saw Sulston spread bacteria carrying his DNA on agar jelly to form a portrait and Quinn picked out a frame for it.[23] The finished work is a yellow rectangle of jelly in a silver frame that reflects the face of whoever looks into it.

While such fusing of categories can no doubt appear exciting, creative, even radical, they raise questions such as on what basis should we assess the portrait of Sulston? Is it a self-portrait or a portrait of him by Quinn? Is it science or art? What is science? What is art? If the purpose of such cross-category work is to raise precisely those tricky and oh-so subversive questions, then we must judge it a success, although we might wonder just how many more times we need such questions to be raised. If the purpose was to create something beautiful and true in the portrait tradition, then I am not sure it is so easy to justify its hanging in the National Portrait Gallery (NPG). Maybe the real point is less that works such as *Genomic Portrait* are really expected to be taken seriously, but that their value lies in demonstrating how modern and relevant, unstuffy and cool, an institution like the NPG really is. That, after all, was the stated purpose of the Wellcome Trust's thinking in bringing science and art together:

> [T]he true power of science and art as a union is not what science can learn from art in terms of practical breakthroughs,

22 Ken Arnold, 'Science and art: symbiosis or just good friends', *Wellcome News* Science and Art supplement, 2002.

23 Stuart Jeffries, 'When two tribes meet: collaborations between artists and scientists', *Observer*, 21 August 2011.

but what it can gain from art in terms of building a more engaged relationship with the public.[24]

This is, then, a more or less cynical and instrumental use of the arts to soften the 'hard' image of science. And the display of 'sciart' in the NPG is a more or less cynical use of not-art—science—to justify the inclusion of actual art. Look, don't judge us because we have a world famous collection of portraits by great artists: we are so much more than that, look science, sexy science; in fact, don't judge us at all. Both science and the arts attempt to borrow from each other's assumed credibility and legitimacy—to the long-term advantage of neither party.

This is a form of all-are-equal elitism that constitutes itself on the basis of its anti-elitism: expressing, at heart, a feeling of embarrassment—if not hostility—when it comes to ballet, classical music, fine art, opera, and high culture in general. This narcissistic self-defensiveness was perfectly summed up in Saatchi and Saatchi's branding of the Victoria and Albert Museum in the 1980s as 'an ace caff with quite a nice museum attached'. With the collapse of categories, the creation of hybrid forms, and the rejection of judgement, it can be difficult to see what room there is, if any, for the use of reason or for criticism when it comes to the world of total culture.

Art goes Pop

Pop art is in some ways the clearest expression of categorical breakdown. Its elevation of the everyday into the status of art (whether Duchamp's *Fountain* or Warhol's *Brillo Box* sculptures) is precisely about breaking down the self-definitional limits of traditional art: turning it into something mass-produced and repeatable. A recent exhibition of his work at London's Barbican was described by one reviewer as reminding us of how Duchamp himself

[24] Ken Arnold, 'Science and art: symbiosis or just good friends', *Wellcome News* Science and Art supplement, 2002.

didn't get rid of the word 'art' but he made sure that it would never be used in an uncomplicated way again. Meanings would become slippery, values subverted, spectatorship undermined.[25]

Pop art dresses itself up as popular and anti-elitist: easy to get, not difficult, funny, ironic, non-serious. The Tate Modern's major retrospective in 2013 of the work of American pop artist, Roy Lichtenstein, was praised, for example, for showing us how his use of comic book pictures brought a *reality* into fine art that had been, apparently, missing previously.[26] There is certainly an irony there given that Lichtenstein himself said he used Ben-Day dots because his work was 'supposed to look like a fake'.[27] Pop art was certainly not about being measured according to the specialised expertise of the few. In the words of its clown prince, Andy Warhol: 'Art is what you can get away with.' Or, as Daniel Bell put it, pop represented a new 'hedonism' as 'traditional morality was replaced by psychology, guilt by anxiety'. Pop as the 'iconography of the everyday' contained 'no tension' but only parody.[28] He saw pop art, and comparable developments in music, as trends which

> pose a new kind of threat to the traditional (and formal) conceptions of genre. If John Dewey could say that 'art is experience,' what these practitioners are saying is that all experience is art. In effect, they deny specialization by insisting on the fusion of all arts into one. Theirs is an erasure of all boundaries between the arts, and between art and experience.[29]

[25] Peter Aspden, 'The revolution continues', *Financial Times*, 8 February 2012.

[26] BBC *Culture Show*, 15 February 2013.

[27] Quoted by Sarah Churchwell, 'Roy Lichtenstein: from heresy to visionary', *Guardian*, 23 February 2013. He used a colour range 'perfect for the idea, which has always been about vulgarisation'.

[28] Bell (1996), p. 72.

[29] Bell (1996), p. 96.

No More Borders

Today that erasure even applies to the boundaries between countries. The Tate Modern announced in late 2012 a pro- gramme to 'break' what it thinks of as British insularity when it comes to contemporary art. The Tate's director, Sir Nicholas Serota, hasn't the money to follow the lead of the Louvre's expansion to Abu Dhabi or to emulate the Guggenheim's global empire (New York, Venice, Bilbao and Abu Dhabi again). But if he can't take the inside out, he can try and take the outside in: claiming 'areas outside Europe and North America cannot be regarded as the periphery'.[30] Serota rejects 'a focus on national histories', preferring 'an international history of art'. In particu- lar, he is targeting contemporary art from South Africa, Nigeria and the Sudan, although the Tate has made a virtue since 2002 of buying whatever is *not* European or North American. Rosie Millard, former BBC Arts Correspondent, welcomes this: 'it is a relief to break free from a continuous Picasso-Pollock-Paolozzi timeline'; arguing the Tate should not fear accusations of a 'modern form of colonialism', since nowhere is as 'international, multicultural, and relatively accessible' as London. Millard wants everything for everyone, which means

> not stamping our feet when foreign institutions want to buy works we consider hold 'national status'. Art these days is not national, but global.[31]

Which is also an argument for nothing being seen in context and for the relevance of everyone and everything to everyone else given the apparent irrelevance of tradition. And for the acquisi- tion, presumably, in 2011, of Lebanese artist Saloua Raouda Choucair's *Infinite Sculpture*: 'twelve rectangular stone blocks piled on top of one another in a tall column nearly two and a

30 Quoted by Charlotte Higgins, 'Tate opens the door to Africa', *Guardian*, 1
 November 2012.
31 Rosie Millard, 'Before Ai WeiWei, who knew China had contemporary
 artists?', *The Times*, 2 November 2012.

half metres high.'[32] Though arguably, with this acquisition, the
Tate is following in its own tradition of buying piles of bricks
established in 1972 with the purchase of Carl Andre's *Equivalent
VIII* but, it is interesting to note, without any of the attendant
criticism and national outcry as to the wisdom of spending
money on piles of bricks and blocks that the Tate faced in the
'70s.

The Tate itself is merely following in the footsteps of
London's Institute for Contemporary Arts (ICA) which featured
Chinese artists heavily in the late '90s under the direction of
Philip Dodd, a man who revelled in the collapse of dis-
crimination:

> A lot more than the Berlin Wall has collapsed since 1989. The
> landscape that you and I were brought up with, where there
> was subsidized art here, and commercial art there, where art
> was one place and rock and roll was another place, and film
> was something else, has collapsed. We live after an earthquake,
> which was the collapse of these categories. They collapsed
> because finally they bore next to no relation to the life that most
> of us live.[33]

Dodd, despite being one of the architects of Cool Britannia, was
described by no less than a Labour culture minister, Kim
Howells, as a 'sneering guardian of the emperor's new clothes'.

Total Culture: flat and central

Without discrimination, we are all in culture and yet none of us
is *cultured*. Today's 'total culture' is the product of neither the
people nor an elite: it exists in the space abandoned by them; a
vacuum created by their withdrawal. Within total culture, as
individuals, but not as members of society, we find ourselves
alone, yet *en masse*. A massed loneliness in which we lack the
basic normative vocabulary to even tell each other what we

[32] *Tate Report 10–11*, http://www.tate.org.uk/download/file/fid/11449
[33] Millard (2002), p. 100

think about culture, maybe even lacking the ability to *think* culturally. The citadels of culture have been dug up, their foundations torn down, leaving the individual without bearings in a field of culture stretching to an infinite horizon.

Increasingly culture, as it happens, does take place in fields. What better way to express the lack of boundaries than by taking everything outside? The Latitude Festival is one (very pricey, very middle-class) example: the line-up for 2013 featured popular music (Bloc Party, Foals, Kraftwerk), comedy (Marcus Brigstocke's Policy Unit, Dylan Moran), theatre and dance (National Theatre Wales and Sadler's Wells), film (Sheffield Doc Fest), art (cartoonist David Shrigley, the National Gallery's 'Titian Experience'), poetry (Carol Ann Duffy, Liz Lochhead) and even claimed to represent literature (in the form of Germaine Greer and Jeremy Dyson). This is culture as circus sideshow: with no barriers to entry and, as a result, no real depth to it.[34]

The inclusion of high art forms into the counter-cultural experience usually associated with this kind of festival is instrumental in intent. Theatre and ballet aim to look good by association with the young and trendy. In the relative absence of the ability to confidently express any sense of the intrinsic worth of a Titian then there is a perceived value in taking it to new audiences. There is nothing wrong with new audiences for art of course — the more the merrier — but there is something wrong with finding no other way to value art but in the counting of heads. After all, the audience at Latitude is not a *particular* audience — not a pop audience, neither a theatre audience nor a ballet audience — but, if anything, a dilettante, channel-hopping, and, in the end, indifferent, not very choosy, audience. There is a price to pay equally in the admission that drama, ballet and

[34] Cf. Scruton (2000), p. 118: 'The youth culture prides itself on its inclusiveness. That is to say, it removes all barriers to membership — all obstacles in the form of learning, expertise, allusion, doctrine or moral discipline.'

fine art need to leave stage or museum to pursue those audiences wherever they may be: it is to undermine any sense of high culture as something sacred to which we might devote ourselves. That we should aim to culture ourselves. That, in other words, the V&A would still be an ace museum even if it didn't have a nice caff attached.

The other price to pay for this hybridisation of art forms and fusion of incommensurate spheres like culture and sport is the —lacking any internal standards—increasing reliance on external forms of validation: both the size and diversity of audiences; but also the positive impact culture is claimed to make *on* those audiences. New sets of standards are emerging around total culture which value, for example, hybridity as such, non-exclusivity, the participatory, the quirky, ironic, emotional, fun and camp. Such non-standards, as we will see in the example of the Olympics 2012 Opening Ceremony, can still be very demanding.

The Spectacular State

'Culture is everything and it runs from razzmatazz like this evening down to a lonely anguished poem.' So said Danny Boyle, picking up the award for theatre event of the year for directing the Olympics 2012 Opening Ceremony. Boyle has become a cultural hero in Britain since the games: he is credited with having given Britain a 'smiley face', for letting us express our feeling that 'we don't want anyone to be left out', for allowing us to 'smile at people in the street'.[35] For one *Guardian* writer, the magic Boyle conjured was so powerful as to challenge even his loathing for

[35] India Knight, 'Britain has found a smiley face—don't let it slip away', *Sunday Times*, 2 September 2012.

this rain-soaked dime of a country—its meanness, racism, its imperial shame, its Eton mess of a government and its mediocre royals who hold part of the nation in thrall.[36]

He was reduced to tears by Boyle's vision of a 'Britain with a prouder history (public health services, killer music, birthplace of the industrial revolution etc.) and a more hopeful future'.[37] In the summer of 2012 Britain seemed in a state of total unity brought about by the fusion-magic of culture and sport.

Yet cultural events *en masse* like the opening and closing ceremonies of the 2012 Olympics exist within a cultural force-field that rejects any attempt at evaluation of what really operates as at best feel-good entertainment, nostalgia-therapy for an imagined, and rewritten, past. This was culture as state spectacular—neither bread nor circuses—but a ceremony of memory (a memorial), in which we must all take part or risk breaking the spell. Boyle's opening ceremony, *Isles of Wonder*, was—for those who choose to see through the fireworks and feats of engineering—a straightforwardly revisionist account of British history: in which ordinary British workers, immigrants and nurses live together in a multi-ethnic, green and pleasant Neverland. A world that doesn't exist, where every child is poorly, every nurse compassionate. A world beset by fears, where adults would snatch away our youth, bankers deny us mortgages and pensions—our very futures—but where Nanny State, the NHS and the BBC, always come to the rescue. A Britain so diverse as to be unrecognisable, so inclusive as to fail to stand for anything. A very particular, and very political, take on modern Britain.

Many people loved it. Or said they did. After all, it was carefully calculated so that most people would love it. But when one Conservative MP, Adrian Burley, tweeted that the whole

36 Stuart Jeffries, 'Has London 2012 got us all blubbing? I second that emotion', *Guardian*, 3 August 2012.
37 Stuart Jeffries, 'Has London 2012 got us all blubbing? I second that emotion', *Guardian*, 3 August 2012.

thing was 'leftie multicultural crap' he was to find out that if you didn't love it, you had better keep quiet. Despite (or because of?) the fact he was pretty much the only voice critical of the ceremony, he was branded as 'incompatible with modern Britain' by Labour MP Tristram Hunt—himself an historian—and even attacked by the *Independent* for the 'ill-advised move of publishing his thoughts'.[38] There appears to be no room within total culture for even such limited dissent from the new standards. The ceremony, while self-consciously placing itself in a dissenting tradition, failed to notice how entirely mainstream and conformist defending 'our' NHS and having a pop at evil bankers now is. And the lone voices of real dissent were denounced as intolerant and intolerable.

The logic of non-exclusivity and non-discrimination that underpins total culture naturally tends to a lowest common denominator approach and art which we can all, on some level, agree with. Sir Simon Rattle, the London Symphony Orchestra, *and* Mr Bean. At the same time these new standards, much as they deny they are standards, can be every bit as intolerant of anyone who questions them as old-fashioned elitists could. Maybe more so since they derive value from their ability to perfectly represent a modern multicultural and diverse society: anyone who challenges them represents, therefore, some form of challenge to society and to the state. The total culture anti-elite elite is actually ever so exclusive in its apparent inclusivity, its clubby subjectivity.

Why is it that total culture feels so insecure in its non-discriminatory, diverse and anti-elitist aesthetic that it cannot afford to ignore or engage with any criticism but feels the need to silence it? Is it really the case that individuals are a threat to the social fabric, and, if so, might society's cloth already be worn pretty thin? Might it be the case that the supposed unity of the public (as in the slogan of the 99 per cent) is more imagined

[38] See Brendan O'Neill, 'Celebrate or be for ever cast out!', *spiked*, 30 July 2012.

than real? That when the individual is held up as destructive of society all that is evidenced thereby is the absence of any strong social bonds and society's fear of judgement? Its fear of freedom?

At the end of *The Work of Art in the Age of Mechanical Reproduction*, Walter Benjamin noted the 'introduction of aesthetics into political life' by Fascism and how 'Communism responds by politicizing art'.[39] While Benjamin approved of the latter, he serves as a salutary reminder of the need to maintain the autonomy of the cultural sphere against those that would manipulate it for their own ends. Of the need to maintain, like the painter he deplores, 'a natural distance from reality' rather than penetrating too deeply into its web: like the cameraman he applauds.[40] And how, when it comes to culture, we must uphold the freedom of the individual to sing his own tune rather than being forced to sing along. To put it another way, culture justified in terms of public interest will always be culture open to censorship made in the name of — as it always has been — the public interest.

Being Indifferent

One of the effects of the existential confusion as to the value or meaning of the arts has been a growth in indifference to the arts. This indifference is the flipside of there being no limits: given those in the arts can do whatever they like, it is really a case of what does it matter, there is no outrage any more, no more shock value. One of the terrible ironies of the imperative of relevance has been to render art *irrelevant* to the lives of more and more people.

To quote Hoggart again, we have suffered

> a loss of sense of order, of value, and of limits. If that is good
> which is the latest in the endless line and which meets the

39 Benjamin (1968), pp. 234–5.
40 Benjamin (1968), p. 227.

wishes of the greatest number, then quantity becomes quality and we arrive at a world of monstrous and swirling undifferentiation. This kind of undifferentiation can lead, as Matthew Arnold pointed out a century ago, to 'indifferentism', to an endless flux of the undistinguished and the valueless, to a world in which every kind of activity is finally made meaningless by being reduced to a counting of heads.[41]

There can be no iconoclasm in such a world: all is shattered and nothing is left to break, just the wreckage to put on display as in the *Combines* of Robert Rauschenberg. Dissent actually requires a broadly, but not totally, shared tradition or social norms in order to be possible and have force. To the extent that is not the case, that we lack broad agreement on what is good, we become conformist at least by default.

Those that argue for particularist interpretations of culture *and* those arguing for a universalist approach both miss the point that culture should exist in the relationship between the two: precisely what is missing today. Those arguing for the specificity of culture (e.g. multiculturalism) simply push us further away from each other. Those arguing for a return to some imagined golden age of the universal at best remove themselves from the debate: often avoiding the need to argue for discrimination through simply asserting their superior taste, and at worst, further eliding boundaries in the name of a supposedly universal culture. What we have instead is a total culture that has little place in it for the freedom to discriminate and which finds itself necessarily administered by committee given the absence of anyone willing to stand up and judge.

When no one draws the line, everyone is included and nothing is off limits. Not only are there no limits to what counts as being art but so is there a logic which says that everyone can love art: even that everyone can be an artist. When art indiscriminately 'relates to every aspect of experience', everything

[41] Hoggart (1957), p. 171.

becomes reflected in art, and everything *is* art. Including, notoriously, Tracey Emin's *My Bed*: neither made, nor judged. Art is less and less something that might offer itself to the individual as a bridge between past, present and future — might hold out the promise of transcending experience — and becomes something which values itself in terms of a public who are said to need access to culture so it might do them some good: rather than any sense that culture can only be of any possible benefit to those who make their own way to it.

Imagine All the People

The arts, the expression of our culture, are as deep a need in us as food, shelter, sex and security. We must have them. We must use them to express our human nature and our social existence. They are the way in which we communicate beyond the grunt and the whack. — Liz Forgan, former chair of the Arts Council England, farewell address, 15 January 2013.

I hope some day you'll join us/And the world will live as one. — John Lennon, *Imagine*.

For a mass society is nothing more than that kind of organised living which automatically establishes itself among human beings who are still related to one another but have lost the world once common to all of them. — Hannah Arendt, *Between Past and Future.*

As boundaries between art forms erode, individual discrimination becomes more difficult to exercise. Hybrids of classical music and rap, for example, as featured in the 2013 (Urban) Proms season, defy criticism in terms of either musical form.[1] Maybe a new critical tradition appropriate to the fusion will evolve, but since the mix has been driven by non-artistic concerns it seems unlikely. The point of the fusion is simply to

[1] 'BBC Proms mix urban and classical music for the first time', *BBC News,* 10 August 2013: 'The Urban Proms are the latest evidence of the annual festival's attempts to connect with younger audiences, already seen in the successful Doctor Who Proms, which attracts families and sci-fi fans of all ages.'

equate rap and classical and the only appropriate response is a polite clap. Strong value judgements are discouraged by a society that bases itself—insofar as that is possible—on pluralism, on being contemporary and on diversity. Discouraged too by a cultural elite that—lacking confidence in its own judgement—appeals to the court of public opinion.

The result is that the question of audiences (wondering what do *they* think) becomes ever more pressing. Audiences—their size, colour, age and sex—have become one of the major administrative preoccupations in the arts as seen in any number of drives to widen access and increase participation. Such initiatives can appear radical, fresh and exciting: after all, if more people—from all walks of life—enjoy great art as great art, then we should celebrate that fact. The attendant danger, however, is that the drive to inclusion becomes about inclusion *per se* —and about social mobility targets—rather than about the inclusion of people who ask to be included on the basis that they love the arts. When that happens, then the question of excellence starts to take a backseat to that of access and—by far the greater danger—the question of excellence begins to be answered precisely in terms of access. That is, art is praised when it is inclusive and contemporary, and condemned to the extent it can be branded exclusive and irrelevant. Or to use slightly different terms: the good becomes identified with what is fashionable and easy, while anything difficult and traditional is seen as bad.

The current strategy of the Arts Council England, 'achieving great art for everyone', rests on just this tension between great and everyone—between excellence and access—which might be unremarkable if we were more confident about what we judge to be excellent but, in today's conditions, runs the risk of plumping for the everyone rather than the great. Certainly the supporting documentation takes that line: the Arts Council England says it will 'work to get great art to everyone by championing, developing and investing in artistic experiences that enrich people's lives'; it will 'embed the arts in public life'; and 'commission projects or programmes to address particular

challenges'.[2] Very like former New Labour culture minister Ben Bradshaw, who celebrated the last decade as 'ending at long last the stale and outdated debate between access on the one hand and excellence on the other'.[3] In the next chapter we will look at the instrumental use of culture to achieve certain outcomes – to *do* things to the public – but first we need to look at just who this public is or, at any rate, is imagined to be.

Is There Anybody Out There?

In the UK there is a charity called The Audience Agency, which resulted from a merger of All About Audiences and Audiences London in 2012, with the purpose of providing England-wide audience-development services to the culture industry: helping 'museums, arts, heritage, libraries and other cultural organisations understand and grow audiences'.[4] With £3.5 million provided by the Arts Council England Audience Focus fund it is constructing 'a single framework for collecting, understanding and using audience information across the arts sector in England'. That is, a database of box-office and customer-survey data which will be mapped, segmented, profiled, sliced, diced and benchmarked. The Audience Agency offers a range of online resources which include: 'Monitoring Audience Diversity', 'Developing the Cultural Diversity of Your Audiences', 'Developing Relationships with Deaf and Disabled Audiences', and 'Not For The Likes Of You'.[5] One 'success story' claimed by the 'Not For The Likes of You' project will explain its focus. When Simon Rattle left the City of Birmingham Symphony Orchestra in 1998, a quick rebranding threw out 'anything stuffy, snobby and dull' and replaced it with 'informal, chatty, and unashamedly enthusiastic and emotional'. The 'audience

2 Arts Council England, *Achieving Great Art for Everyone: a strategic framework for the arts*, p. 23.

3 Arts Council England and others (2010), p. 14.

4 http://www.theaudienceagency.org/aboutus/whatwedo

5 http://www.theaudienceagency.org/resources/

experience' was transformed in a 'non-traditional' direction with 'children conducting the orchestra, lighting effects, magicians, players dressed up as wizards etc.' and the orchestra playing 'all sorts of music, from Stravinsky's ballet *The Rite of Spring* to the theme music from *Babe*'.[6]

In a similar vein the Culture Programme of the European Union supports the 'New Music: New Audiences' project of which the London Sinfonietta and Contemporary Orchestra are members. It is dedicated to finding new contemporary-music audiences: in 'old industrial buildings, in the streets, in department stores and other places that are not reminiscent of another time'.[7] Apart from the fact that 'old industrial buildings' might well be 'reminiscent of another time', this hostility to the idea audiences might want to sit and listen quietly in somewhere as forbidding and old as a concert hall is very much the zeitgeist. As is the idea that new audiences do not want to listen to 'old' music.

The Barbican in London—even under the direction of John Tusa, someone certainly not afraid of artistic elitism—shifted after 1995 towards programming that was 'more contemporary, more adventurous, more risk-taking and more international'.[8] The aim was to attract

> new and quite different audiences—note the plural. Instead of a broadly classical, conservative audience of a fairly homogeneous kind, the Barbican now acquired a spectrum of different audiences: one audience for baroque music; one for high classical performances; a distinct one for multimedia theatre;

[6] Morton Smyth, 'Not for the Likes of You', Phase Two Final Report, Document B, http://www.theaudienceagency.org/media/ PDFResources/ResourcesSection/14_-_Not_For_The_Likes_Of_You_ Sucess_Stories.pdf

[7] 'Ditching the concert hall', http://www.newaud.eu/working-communities/ditching-the-concert-hall

[8] Tusa (2007), p. 83.

and so on. These audiences are identifiable, and tend to be younger; they are extrovert, curious and, undoubtedly, fun.[9]

Tusa goes on to note how this approach also produced a more 'diverse' audience and how an 'essentially artistic, values-led decision' can achieve a desired social outcome. That is to say, move away from conservative repertoire and you will get a more diverse audience. If that is the desired social outcome, then you might please your funders and some politicians. The question remains why break with the Barbican's tradition in the first place? Tusa does not advance arguments to say *why* Steve Reich and Karlheinz Stockhausen are better than Beethoven or Mahler, but one gets the sense in reading him that it is really to do with the fact that they were seen as contemporary and fashionably cutting-edge.[10] Which is another way of saying that their value is seen to consist in their *not* being traditional or conservative.

Certainly, since Tusa's departure in 2007, the Barbican has continued a policy of cheerleading for how fun, easy, non-threatening and accessible culture is, but it is now even more explicit about trying to 'achieve wider societal aims and con-tribute to personal development and wellbeing' as well as taking upon itself to meet the 'needs of young people and their contemporary cultural landscape'. These initiatives, we are told, are necessary because we live in a 'fast changing world' of total culture in which 'boundaries between art forms are blurring'.[11] Two questions arise. The first is just how does the pursuit of artistic excellence dovetail with 'desired social outcomes' or, indeed, who is it that desires these outcomes? Is it the Barbican? The players? The audience? If all of these are in agreement, then surely we are living in a society much more deeply conservative

9 Tusa (2007), p. 84.
10 Tusa (2007), p. 84.
11 Sean Gregory, 'Music education must keep on moving', *Guardian*, 10 April 2013.

and homogeneous than that which John Tusa set out to challenge the tastes of in the first place.

The second question is just what is the value of the inclusion of young people *as* young people and especially those of them who have never been exposed to classical music or opera? It seems counterintuitive. Would a high culture institution like the Barbican not find it easier to recruit new audiences from those who already have some liking for high culture? If, however, the problem is that young people today don't know anything about Beethoven *at all* (which seems increasingly to be the case) then it would follow that what they need most of all is a solid ground-ing in the *classical* tradition and not exposure to Steve Reich, and certainly not to a 'nite' with Da Bratz. That much they are doing already. If the world really is changing as rapidly as we are told it is, then surely *contemporary* programming can be nothing more than chasing after here-today gone-tomorrow trends? In such a fast-moving world, in which everything seems to be fusing into everything else, there must be a strong argument for a conservative approach to programming, since at least we can be sure that Beethoven and Mahler have passed the test of time. Arendt, aware of the crisis of culture and education in the 20th century, made the point that

> the function of the school is to teach children what the world is like and not to instruct them in the art of living. Since the world is old, always older than they themselves, learning inevitably turns toward the past, no matter how much living will spend itself in the present.[12]

Something the Barbican might consider if they are concerned about the 'needs of young people'. There is, of course, always a balance to be taken by an institution when it comes to the ques-tion of pleasing audiences. It would be self-indulgent and self-defeating if an orchestra were to play only what audiences, and young people, do not want to hear. The 'Not For The Likes Of

[12] Arendt (1968), p. 192.

You' initiative, however, is an example of a trend that goes much further than toning down excesses of elitism and complexity. What it achieves — consciously or not — is to alienate existing, 'traditional', audiences who, while they no doubt love both classical music *and* children, see good reason for keeping the two apart on the night. Its success is measured — and this is where The Audience Agency segmented customer database comes into its own — to the extent that the 'crowd is younger and more culturally diverse' and less 'white, middle-class, middle-aged'.[13]

The question of the *quality* of the audience is a much more important consideration than its age, let alone the thoroughly disgraceful idea that a symphony orchestra should be involved in racial profiling of its audience. It should be the job of an orchestra to create an audience for *classical music*: a particular *sort* of audience. Not a certain *sort of person* in a sociological or class sense, but the right sort of audience: one composed of individuals who want to hear the very best of classical music. The danger of chasing an audience is that it flatters it (as young, as diverse) in ways that have nothing to do with the music. When young people discover classical music has nothing to say to youth *per se*, nor to diversity, they may well become cynical. Even switch off. The hostility to discrimination on the part of arts programmers and the waning of the authority of the classical tradition invites attempts to finesse the problem by finding value in the very presence of new audiences. The problem of course is that the audiences are not there because they are discriminating about the value of classical music: logically they do not even have to like it. They are there as a stage-army: their value resting in the extent to which they are non-traditional and diverse. In other words, the audience becomes a way of quantifying the value of culture.

[13] 'Not for the Likes of You — document B. Success Stories', http://www.takingpartinthearts.com/content.php?content=942

Mirror, Mirror on the Wall

This objectification of the audience—almost into a 'thing'—can take the form of treating it as a sounding board (or echo chamber) for artists themselves. The Audience Agency's CEO, Anne Torreggiani, for example, says 'engagement is no longer heresy'. Instead 'artists, curators and producers are increasingly inspired by audience encounter'.[14] Of course this can amount to simple pandering to popular taste rather than making an attempt to educate or develop refinement and discrimination. Inspiration from 'audience encounter' tends to lead to artists reflecting audiences back at themselves: not artists giving *their* vision to an audience for *them* to judge. So engagement with urban youth leads to the insight that they like dub-step and then to the inclusion of dub-step in concerts in order to attract more urban youth and achieve those desired social outcomes. One outcome that is guaranteed—if not desired—is that this insulting assumption of what urban youth is like, or could like, leads to essentialising its musical taste: deriving the individual from the group.

The advantage for arts programmers is that they do not have to go out on a limb and *argue* for what they consider to be good to create an audience. Much easier to flatter one. In this sense arts programmers are simply doing what politicians have been doing for years: relying on focus groups, polls and consultations to set policy—rather than on principle. TV news programmes are equally desperate to solicit the public's views: making it easy to phone, email, tweet or text them in, it's the 'news that matters to you'. Everyone celebrates the ordinary and demotic: from bankers not wearing ties, to politicians in rolled-up sleeves drinking pints. In a way the public acts as something that by its very existence gives value to whomsoever touches the hem of its cloak. Politicians fall over themselves to show how in touch

[14] Anne Torreggiani, 'The Audience Agency: open for business', 25 July 2012, http://www.museumsassociation.org/comment/25072012-audience-agency-open-for-business

they are. Here is Margaret Hodge in 2008, UK culture minister at the time, speaking at an IPPR (New Labour's favourite think tank) event:

> The audience for many of our greatest cultural events — I'm thinking in particular of the Proms — is still a long way from demonstrating that people from different backgrounds feel at ease in being part of this.[15]

Coronation Street was a better example of what she wanted to see: bland enough for all; challenging to none. Sometimes all this is explained as nothing more than dumbing down, but there is more to it than that. In wanting the Proms to become more inclusive, Hodge was attacking Western high culture in the name of other cultures, 'different' cultures. Using the public as a battering ram to break down a tradition she associates with British exclusivity, if not racist nationalism. In the words of academic James Heartfield:

> Once elitism was concerned to protect its monopoly over the best society had to offer. Today's elites by contrast have prostrated themselves before the judgement of the wider public — except that this public exists largely in the imagination of the elite itself.[16]

In the absence of faith in culture in itself, the overriding concern has been that audiences must at least accurately reflect the actual makeup of the country in terms of numbers of women, ethnic minorities, age ranges and so on. Again the audience is seen in quantitative and not in qualitative terms.

Hand in hand with constructing a mirror of how society should look today goes the project of shattering the image of how it looked yesterday. Former Mayor of London, Ken Livingstone, for example, called in 2000 for the statues of what

[15] Quoted in Angus Kennedy, 'A Hodge-podge approach to high culture', *spiked*, 6 March 2008.

[16] Heartfield (2006), pp. 215–16.

he called the 'unknown generals'[17] in Trafalgar Square to be pulled down and replaced with something 'identifiable to the generality of the population'.[18] Outbursts of iconoclastic vandalism do have historical precedent but they normally command wider grassroots support and idealism—such as the Reformation vandalism of the Dom in Utrecht in the 16th century, or that of Puritans in Ely Cathedral's Lady Chapel in the 17th, or the toppling of statues of Stalin after 1989—than even Red Ken could claim to enjoy. There is a certain level of intolerant self-regard and narcissism involved in the confidence of the arts establishment—their consultants, audience-development executives and marketing creatives—that *their* vision of a multi-cultural, postmodern, diverse society is one shared by everyone of sound mind. It can amount to an objectification of a certain taste—which should really have to argue its corner—in the name of a people who are always spoken *for* rather than giving voice. It prompts the question as to whether today's cultural leaders are really so brittle and defensive about their view of how society should be that only a perfect reflection of it back to them will reassure them. They should take note, perhaps, of the fate imagined in Borges' parable *On Exactitude in Science*:

> …In that Empire, the Art of Cartography attained such Perfection that the map of a single Province occupied the entirety of a City, and the map of the Empire, the entirety of a Province. In time, those Unconscionable Maps no longer satisfied, and the Cartographers Guilds struck a Map of the Empire whose size was that of the Empire, and which coincided point for point with it. The following Generations, who were not so fond of the Study of Cartography as their Forebears had been, saw that that vast Map was Useless, and not without some Pitilessness was it, that they delivered it up to the Inclemencies of Sun and Winters.

17 General Sir Charles James Napier and Major-General Sir Henry Havelock.
18 Paul Kelso, 'Mayor attacks generals in battle of Trafalgar Square', *Guardian*, 20 October 2000.

In the Deserts of the West, still today, there are Tattered Ruins of that Map, inhabited by Animals and Beggars; in all the Land there is no other Relic of the Disciplines of Geography.[19]

Australians in Opera

The logic of audience development is towards creating an audience that acts as a perfect reflection of an idea of how society should be. The argument says until the audience is a statistically accurate representation of the actual make-up of society, or even better, as it *should* be, then it represents an inequality and perpetuates an injustice. One only needs to push it just a little way towards the absurdity, as the next example will show, of 'total representation'.

Lydon Terracini, Artistic Director of Opera Australia, wrote an essay in *Policy* magazine in 2012 that is worth examining in a little detail as it is an exemplary statement of the concerns of many high arts institutions. He starts by emphasising the pace and imperative of change and how behind the times opera is:

> [V]ery little in opera has changed since the nineteenth century... the lack of change in the fundamental structure of opera companies... a very different time... sense of patrician entitlement... simply not acceptable in a democratic society... any arts organisation receiving public funds is obliged to justify that funding by including all members of society.[20]

Terracini, so incensed by the niche nature of opera audiences, claims a democratic mandate to carry out a revolution on behalf of those he imagines it excludes: 'faces on our streets', faces

19 Borges (1998) 'On Exactitude in Science' in *Collected Fictions,* trans. Hurley, A., London: Penguin, p. 324. NB interestingly also cf. 'We actually made a map of the country, on the scale of a mile to the mile... [but] the farmers objected... So now we use the country itself, as its own map, and I assure you it does nearly as well', Carroll, L. (1893) *Sylvie and Bruno Concluded,* London: Macmillan, p. 169.
20 Lyndon Terracini, 'Re-imagining opera in Australia', *Policy,* Vol. 28, No. 1, Autumn 2012, p. 13.

more 'representative of contemporary Australia'. He *feels* that things have changed — that opera is out of time — and therefore, *he* can re-imagine opera.

He concedes that excellence is Opera Australia's priority *but*

> our art will also have integrity. Just because a painting or a performance is popular does not mean it is inferior; in fact, the greatest works of art are enormously popular. We will present the most interesting repertoire *but* we also want as many people from the widest demographic to be part of this extraordinary experience… the faces of new and contemporary Australians, the faces of Aboriginal Australians, as well as our long-term traditional supporters. At Opera Australia we are committed to ensuring that great art embraces the faces that represent Australia in the twenty-first century.[21]

So committed is Terracini to becoming 'audience-driven' that he can even countenance opera as mash-up, wondering why 'the club' will not countenance touching 'a note of Mozart or Verdi', and goes on to wonder where he can find '20/20 versions of opera performances to run in tandem with our test match opera'.[22]

The logic of Terracini's argument about the greatest art being popular does not extend to considering what to do with great art which is not 'enormously popular' — nor popular art which is not great. More than an appeal to popularity is required. Rossini was the most popular composer of his day: not necessarily the best. Terracini, rather than looking to merge opera into 'the mainstream popular culture of our time', should concentrate on putting on the best opera he can.

Rather than judging the book of opera by the colour of the faces in the stalls, Terracini should be happy if an *opera audience*

[21] Lyndon Terracini, 'Re-imagining opera in Australia', *Policy*, Vol. 28, No. 1, Autumn 2012, p. 48, my emphasis.

[22] Lyndon Terracini, 'Re-imagining opera in Australia', *Policy*, Vol. 28, No. 1, Autumn 2012, p. 48.

appreciates his efforts. Just what business is it, after all, of opera to concern itself with ethnicity, let alone to make such racially-charged judgements as 'the ethnicity of our vibrant communities must be included'?[23] Are all 'ethnic' communities 'vibrant'? Equally so? Or are there degrees of vibrancy? Does the quality of opera relate to the vibrancy of the audience? In whole, or in part?

Not every initiative to take opera to the public is part of this logic: there is something to commend in live streaming from the Royal Opera House or 'Live from the Met'. Nor is there good reason to object to opera being performed in pubs or metro trains. You don't *have* to have the associated grandeur of the great opera houses although, we should remember, it is a good way of reminding us that we are in the presence of something out of the ordinary. The problem is when directors like Jonathan Miller *reject* the existing audience of opera and the 'gigantic, gilded theatres' in the name of a faux populism and sham anti-elitism.[24] To think in this way is necessarily to start to sacrifice excellence for increased participation. A genuinely new development in opera might well *start* in pubs but would set its sights on getting *into* the Royal Opera House, not leaving it.

My point is not that opera must never change. It may well need to be re-imagined for the 21st century. The point is just that, if it is to be re-imagined, it must be as *opera*: within the tradition and framework of that art form. There is nothing democratic at all in the argument that changes in things external to the arts — politics, fashion, society, demography — *must* dictate matching changes in the arts. There is nothing democratic about the *production* of an opera, nor the workings of a symphony orchestra: yet they are inherently democratic forms since they demand individual judgement on the part of both director and

[23] Lyndon Terracini, 'Re-imagining opera in Australia', *Policy*, Vol. 28, No. 1, Autumn 2012, p. 47.

[24] See Angus Kennedy, 'Jonathan Miller's Pub-lic opera', *Independent*, 11 October 2010.

the audience. Thus a democratic process of change involves exposing *artistic* decisions to intense scrutiny and criticism. Better to have opera fade into quiet irrelevance than have it hollowed out in the name of relevance. Better still to win an audience to great opera.

The Public Gets What the Public Gets

Nick Serota of the Tate Modern believes that new galleries all over the UK—and there have been many built in the last ten years—are 'exciting spaces offering a social and cultural mix that engages young people in the culture of their time'.[25] The recourse to bland and bureaucratic circumlocution is usually a sign that something much more straightforward is not being said. In this case there is no mention of how *good* the art in these new galleries is: just how up to date it is. Housing great art to its best advantage is not always what these galleries do, even when they try. The case of The Public—the Arts Council England's notorious £50 million and then some white elephant in West Bromwich—does not need rehearsing, except to note the delicious irony that its gallery of the 'arts of the future' was not state of the art enough to stay open for more than two days due to technical difficulties.[26] But it is its mission statement that disturbs even more than the waste of money:

> [M]aking the arts more accessible to a community which traditionally has low participation in the creative industries. We are a place where people who don't normally feel comfortable in arts venues can enjoy themselves, feel welcomed and are confident to experience new things.[27]

This betrays a vision of culture as something you need special assistance and a leg-up to reach. Such is the loss of faith in culture itself. And such is the loss of faith in its ability to attract

[25] Nicholas Serota, 'A blitzkrieg on the arts', *Guardian*, 4 October 2010.
[26] Sidwell (2009), p. 8.
[27] http://www.thepublic.com/public

visitors from West Bromwich and Sandwell all the way, say, to Birmingham's Museum and Art Gallery, let alone to the National in London. Instead the public were to be given The Public. Along with a programme of stand-up, hip hop, burlesque, community knitting and tea dances. Local culture for local people.

The only example I can think of that expresses more contempt for the capacities of individuals to get culture is the remarkable piece of advice given by John Holden—even though he is talking about primary school children—who argues they should

> be taken to a theatre not only to see a play or to work with actors; the first step is to show them where the toilets are, how the lighting works, where the Director's office is, and let them own the building.[28]

So much for the sense of wonder and mystery we should dearly hope children experience on their first trip to the theatre.

No one in Sandwell demanded The Public. It was not the result of a hard fight for recognition of their exclusion from high culture. Nor the outcome of demonstrators chanting 'we want value for money', 'we want a social return on our investment', 'when do we want it?', 'now!' And its arrival was met with indifference and subsequent cynicism. Initiatives such as these are managerial, bureaucratic, and come from the top down onto those least able to resist them. But neither, as it happens, is London immune to the trend towards public art. Right in front of the National Gallery in Trafalgar Square, for those imagined to lack the cultural confidence to brave its forbidding threshold, is the Fourth Plinth project.

Again it was Ken Livingstone who came up with the idea of a rotating series of art works to fill the empty plinth originally intended for a statue of William IV. The sculpture *Alison Lapper Pregnant* was displayed there in 2005. Sculptor Marc Quinn

28 Holden (2004), p. 11.

designed it expressly as a means to an end, to counter what he saw as a great injustice: 'the under-representation of disabled people in art... Alison's statue could represent a new model of female heroism.' An ironic counterpoint no doubt to the old model of male heroism that is Nelson's Column. Lapper herself called it a 'modern tribute to femininity, disability and mother-hood'. While Bob Niven, chief executive of the Disability Rights Commission, hoped the statue would raise public debate on disability, only Robin Simon, editor of the *British Art Journal*, had the courage to make an *aesthetic* judgement: 'I think it is horrible.'[29]

Alison Lapper Pregnant brooded on her plinth for two years. Jump forward to the spring of 2013 and the plinth was occupied by Scandinavian art-combo Elmgreen & Dragset's *Powerless Structures Fig. 101*. Art critic Alastair Sooke felt its 'camp insouciance' was a 'scrotum-shrivelling riposte to the concept of machismo, a satire on Britain's standing in the pecking order of the world': good precisely because it is so easy to 'get'.[30] Just when people were beginning to think that Britain's standing in the world was getting off lightly too! Apparently *Powerless Structures Fig. 101* 'questions the tradition for war monuments to celebrate either victory or defeat'. One wonders what other options are open to war monuments, but maybe that is precisely the question that the radical pair pose. In their own words, they would rather celebrate 'the everyday battles of growing up'.[31] All of these views tell us nothing about the art itself but every-thing about its 'message'.

Public art is imagined to have almost magical powers. Its appearance can bind communities together, make people happy and raise their awareness of things they could not see on their own. How far away the museums, theatres, concert halls and

[29]　'Square's naked sculpture revealed', *BBC News*, 19 September 2005.
[30]　Alastair Sooke, 'What does Elmgreen and Dragset's Fourth Plinth sculpture say about us?', *Telegraph*, 23 February 2012.
[31]　'Elmgreen and Dragset', http://www.london.gov.uk/priorities/arts-culture/fourth-plinth/commissions/elmgreen-and-dragset

statues of the Victorians appear now: a time when the public actually commissioned sculpture themselves and paid for them with collections and subscriptions.[32] Instead the idea that society is changing so quickly forces art to evolve and turn itself inside out. Today public art has nothing to do with the public, certainly not in any active sense: it is imposed almost by whim by bureaucrats and arts mandarins. Nor does it have anything much to do with art given that, as we have seen, aesthetic criteria play second fiddle at best. Today public art is done *in the name* of the public and *to* the public. What this is really about is bad faith, or lack of faith, on the part of a cultural elite that will not, or cannot, play the role of a cultural elite. So consumed with self-hatred — look how white, middle-class and old we are — that it says instead: let the young, the hip, and the Other decide. 19th-century Victorians could certainly be top-down and elitist but there was still faith in the capacity of the arts to be appreciated by all and in their intrinsic value.

The other thing about public art is that it does not stay with us. It too changes and moves on. The Fourth Plinth now has a giant blue cockerel on it: I'm not sure for how long except that it will not be long enough to grow to love it, were that possible. This is not conceptual art. It is just not *art*. No artist has created anything of beauty for us, something to last or endure. The Arts Council England spent £5.4 million on public art during the Cultural Olympiad. It has left no trace of itself behind. As David Lee, editor of *Jackdaw* magazine, put it:

> Not a single painting, print, sculpture or ceramic in any gallery. Not a mural or stained glass window in any civic building. No worthy public sculpture. Not even a sprawling installation or soporific video destined for a gallery warehouse.[33]

[32] Appleton, 'Who owns public art?', in Mirza (2006), p. 62.
[33] David Lee, 'We blew £5.4m on Olympic art and got nothing of merit', *The Times*, 25 July 2013.

'Public art' then—stripped bare of its pretensions—seems to be neither public nor art: it could perhaps be seen as marketing; maybe as propaganda.

Apparartchiks

Where once the elites of modernism sneered at popular culture (Stravinsky, Woolf, Mann, Beckett, Adorno), today's post-post-modern anti-elite elites operate without the distinctions that make terms such as high and low culture meaningful. Instead we only have total culture to be weighed and measured by 'stated preference techniques' or 'contingent valuations': more sack of potatoes than field of gold.

In 2010 the Department for Culture, Media & Sport published the results of a three-year study it had commissioned into the question—central to its very existence one might have thought—what is the value of engagement in culture and sport? It attempted to quantify 'short-term individual value—the improvement in subjective well-being generated by engagement in culture and sport'.[34] It used data from surveys of how people assessed their own subjective wellbeing (SWB) after attending concerts, the cinema or doing sport. That is, how do you feel today about how you felt then. Despite the limitations in aesthetic terms of relying on a ranking from one to 10, the resulting assessment was that SWB could usefully 'inform policy making in a number of ways'. Maybe that was always the desired result, since the same report states that in

> the absence of government intervention, the market may fail to efficiently provide engagement opportunities. The evidence generated by this report allows the value of engagement to be

[34] CASE programme, 'Understanding the value of engagement in culture and sport', July 2010, p. 5.

better represented in economic appraisals of policy options, balancing the costs of intervening with the benefits.[35]

The value of engagement was assumed from the start: the exercise just a search for numbers in support of the conclusion.

Approaches like these can equally justify the funding of bad art as it can good art. It is strictly a matter of indifference to the bureaucrat. Bad art that makes the public feel good becomes worth funding and there is a clear danger that what is most likely to make people feel good is something 'relevant' (what they already know), and something 'accessible'. Anything supposedly irrelevant and difficult is going to be harder to get funding for. The result is that people will be denied such challenges.

Employing the public as a stage-army to justify arts funding benefits neither the people nor culture. Both become subordinate to the funding imperative and excellence is inevitably trumped by access. Sometimes cultural bureaucrats — the 'appparartchiks' we could call them, or the 'nomenkultura' — are even prepared to be explicit about the need for this trade-off. In their pamphlet *Arts Funding, Austerity and the Big Society: remaking the case for the arts,* John Knell and Mathew Taylor, chief executive of the RSA, argue that there are good grounds for funding, in their example, a people's orchestra because of the 'possibly important positive impacts on the self-confidence and cohesion of the communities involved' *regardless* if the performance was not 'excellent when judged in any traditional peer artistic review sense'.[36] My concern here is not so much the validity or otherwise of the instrumental argument, but rather the abandonment of the intrinsic argument: what Knell and Taylor call the 'traditional peer artistic review sense'. They accuse the arts of hiding behind intrinsic justifications like

[35] CASE programme, 'Understanding the value of engagement in culture and sport', July 2010, p. 6.

[36] Knell & Taylor (2011), p. 14.

beauty—a 'difficult to measure and highly subjective' term—
when in reality it is *they* that are demanding

> greater emphasis on access, reach, and tangible economic and
> social outcomes as the most important criteria that should drive
> public funding of the arts.[37]

So concerned are they to make sure that the 'art' in *Achieving
Great Art for Everyone* does not 'trump the "everyone" in the
allocation of funding resources',[38] that the only form of intrinsic
value for art they can imagine is itself determined by the public,
that is through:

> Contingent Value (CV) and Willingness to Pay (WTP) estimates,
> which ask the public what they would be prepared to pay, faced
> with a choice of spending the money on something else.[39]

Which is a way of asking what is the value of beauty when
compared to football or health or education or community
cohesion. An invidious question only made possible because
Knell and Taylor firmly believe that art is not there 'for itself'
but must pass a 'social productivity test'. Here we see the final
irony: the public (the social) is not yet even formed but must be
first produced under the expert guidance and assistance of the
RSA.[40]

Art cannot create society—a common world we share—but
rather it is the other way round: having a world in common
may afford us the freedom to seek out beauty. When adults feel
part of something, then they do not need to act up as youthful
iconoclasts: rather they feel it is their duty to equip their
children with their knowledge; that is, a knowledge of the past.

[37] Knell & Taylor (2011), p. 16.
[38] Knell & Taylor (2011), p. 25.
[39] Knell & Taylor (2011), p. 19.
[40] There is something of a parallel in the German *Gebrauchsmusik* ('utility
 music') of the Weimar period: popular on both left and right for its
 perceived value in terms of uniting the people.

An approach that values access above all else offers no more lasting significance than a group hug.

Access All Areas

Our cultural knowledge of the past—the canon, the Western tradition—is often criticised for being elitist, irrelevant to the modern world, or inappropriate when judged in the light of contemporary mores. Without the authority of that tradition to set a standard and a bar of achievement, then it can appear that anyone can do it. Contemporary examples abound: *Maestro*, *The Choir*, *Popstar to Operastar*; the explosion in creative-writing courses, the 'everyone is an artist' mantra. These are partly the result of the loss of faith in the intrinsic value of culture itself: a gap filled by the idea that taking part and having fun is really what it is all about—that there is a particular therapeutic value in including people who have traditionally been 'excluded' from or were not interested in the high arts. By this logic participation and having a 'go' can be seen as more important than either talent or skills such as reading music or composition. The absence of meaningful barriers to entry is quickly interpreted as meaning that nothing should be a barrier to *me*: finding expression in a powerful—although unearned—sense of entitlement. In the 'narcissistic entitlement'—the 'grandiose illusions, inner emptiness'—displayed in every *X Factor* or *American Idol* audition.[41]

In fact, very real barriers to access exist in becoming an opera singer, say, or truly understanding Wagner's *Ring* cycle. Both require years of training and study. These barriers are neither social nor arbitrary, but based in the actual complexity of the work and the effort required to grasp it. The effect, in the end, of privileging of access over excellence is to break down what should be the relationship between audiences and art. The individual subject should try to apprehend culture through the exercise of his reason and discrimination: the process demand-

[41]　Lasch (1979), p. 221.

ing (and maintaining) a certain distance from *this* work of art, from other works of art (to let it be a *particular* judgement), and from other individuals (otherwise it is not your *own* judgement). To the extent that subjects do not discriminate in this way, they risk a blurring of their own boundaries. Individuality is suppressed ('maybe best I don't say that classical is better than rap just now') and one starts to stand out less, to recede into the background of the public as a whole. Put more literally, the subject starts to merge into the world of objects: subjectivity ebbing away through the loss of the ability to discriminate. Which is to be talked about as thing—in the abstract and not as a 'you'. And 'you', *qua* object, ends up being used: as a means and not an end in yourself. Art starts to be something justified in terms of what it might do to you. Which, of course, justifies exposing more of you to it.

Culture Dependent

The contemporary obsession with audiences for culture shows just how much interest and focus there is on the public. The Department for Culture, Media and Sport churns out reports like *Taking Part 2011/12 Adult and Child Report* while the Art Council England produces *Arts audiences: insight*. Audiences are very much under the microscope. When what matters to the public is foregrounded then, logically and naturally, the individual tends to become lost in the big picture.

To take the example of the Arts Council England—where we started this chapter—its own history traces the institutionalisation of a shift in attitudes towards and within the authority of high culture after the war. It used to report to the Treasury, not to an Arts Minister, let alone to a Minister for Culture, Media and Sport. The most profound of these shifts has been a betrayal of the ideal that people might be able to 'get' art for what has become the rallying cry and self-justification of the arts establishment: that it is the job of the arts to grip the masses.

When the Arts Council's strategy is great art for *everyone*, when we are told that culture and art is produced by *everyone*, we need to ask, what about the individual? When we are so

concerned about reaching out to new audiences do we lose sight
of the individuals that make up those audiences? Let alone what
they might be looking *at*? We also need to interrogate the under-
lying assumption that *everything* is possible: that anyone can
make anything and that it will be meaningful. Such an assump-
tion is not far off the sort of myth-making fantasy that under-
pins totalitarianism: after all, if anything is possible, then
nothing is necessary. Including you.

The idea of active participation in the arts — once you scratch
the surface — turns out, more often than not, to be a demand that
individuals open themselves up to 'new', 'challenging', per-
spectives and see things differently: that is to say, the demand
for *active* participation is at heart a demand that you put your-
self (the old 'wrong' you) *passively* in the way of forces that will
shape you. Drawing stops you looting. Active, then, in the sense
that stones rolled and ground by the incoming tide might be
said to be active. Active in the erosion of our humanity. Not
active in the sense of critical involvement.

What is missing is any real conversation about what *matters*.
Traditionally this happened through certain individuals —
curators, directors, art historians — discriminating to create
collections of work — objects — which were open to you, the sub-
ject, to explore and find out about. In an ongoing discussion
between public and experts. The trend today rather is for the
objects to be brought to bear on you. To the extent there is a
reluctance to discriminate there is a corresponding openness
and receptivity to being told that you *need* the arts: that you are
lacking something that only the arts can supply. This is a logical
point: to the degree that you do not choose the world it will be
chosen for you. Maybe not through the conscious design of
others — this is not a conspiracy — but certainly by default.
People start to be imagined as needy rather than as individuals
who act on the world. They start to be imagined as lacking. And
culture becomes imagined as the solution to that lack. As an
instrument that can civilise us beyond the 'grunt and the
whack'.

Culture as Weapon

A great work of art is never simply (or even mainly) a vehicle of ideas or of moral sentiments. It is, first of all, an object modifying our consciousness and sensibility, changing the composition, however slightly, of the humus that nourishes all specific ideas and sentiments. —Susan Sontag, 'One culture and the new sensibility', in *Against Interpretation and Other Essays*.

Without them [the arts], we are less. Less human. Less empathic. Less inspired. Less inventive. Less resourceful. Less fulfilled. Less creative. Less visionary. Less future-proof. Less socially aware. Less globally aware. Less economically viable. Without them we are less of a society. —Anita Holford, freelance writer and comms practitioner, Writing Services, quoted as part of the *Guardian's* Case for Culture —100 Voices campaign.

A source of ideas and inspiration, the arts play a vital role in society. They can drive regeneration, they can be crucial in helping with education and even fighting crime. —Nick Clegg, deputy prime minister, February 2010.

Culture should be something you choose rather than something chosen for you. Of course, I might select a piece of art or music or a book for you because I think you will enjoy it: because I think it will be good for you. That relationship though is one of friendship, love, or education, rather than state-directed paternalism and, crucially, it relies on my belief that the work will be good for you because *it* is good. If the only definition of the good in culture was whatever social or political impact it might have on you, then we would have no way of accounting

for intrinsic worth and beauty: such concerns would become secondary to the question of impact. Utilitarian questions such as will art make you happier, healthier or richer are of quite a different order than the question as to whether or not it is good. Not objectively good but, to qualify, good in the sense of being the sort of thing you *should* like or, in Kant's use of the word, something your reason should have an *interest* in: as opposed to something that you *need* in the sense of wanting it or desiring it. When we focus instead on instrumental value, we sacrifice the work of art to the desired outcome: we *use* it in the attempt to achieve that end and, in that respect, the only judgement we can make about the art is how impactful it is, how very useful it is.

Since any impact culture might have on any one particular person is of course largely subjective (who is to say that anyone else will necessarily react in quite the same way?) it follows that the only way for the utilitarian to judge the value of a work of art is in terms of its impact on a *mass* of people: the more it impacts equating to how useful it is and, therefore, how valuable. The end result of this approach, as we shall see, is that we become indifferent to two things: to the work of art in itself; and to you, the individual spectator. Of course it can be objected that it is the job of art to make people think and that only excellent art is able to achieve this. There is, of course, nothing necessarily wrong with artists trying to make people think about something (whether or not such intentions ever succeed in a straightforward way is another question), but art that is only *about* a contemporary issue always runs a very large risk of becoming yesterday's art rather than something that continues to make us think — let alone love — through the centuries. Art certainly is — logically — less an end in itself to the degree that it is about something else: more concerned with getting the message across, closer to propaganda than art. A great danger with artistic instrumentalism is that if we get into the game of valuing art in terms of its impact on the greatest number of people, then the easiest way to achieve this is of course for art to push messages that most people already agree with: or to only allow them to see certain things. Artists who challenge the *status quo*

will find it harder to win grants for their work. When intrinsic arguments for the value of culture have less force, then it is harder to resist the temptation to take the instrumental shilling.

It has always been the case that people in power have tried to use art to achieve various ends: whether they be religious, economic, social or political. And critics have always attacked artists who challenged tradition and convention. Artists and cultural organisations have not always, however, acceded to such pressure quite as readily as they do today in the US, UK and much of Europe. They have certainly not often been at the cutting edge of arguments that the arts have the power to remould and reshape not only individuals but even society as a whole.

Art Works

Here, for example, is a representative statement of the instrumentalist credo by the UK's Society of Chief Librarians:

> [A]rts and culture can help to change the narrative of an area for the better, raising aspirations and a belief in what is possible, whilst also offering tangible opportunities to boost economic growth—through tourism, the creative industries or improving skills and educational attainment.[1]

Broadcaster Melvin Bragg has gone so far as to argue the arts in the UK have 'replaced our reliance on heavy industry'.[2] In the US, Rocco Landesman, chairman of the US National Endowment for the Arts, coined the slogan 'Art Works' to showcase the role of culture in lifting the economy out of recession: arguing artists living downtown can

> renew the economics… someone who works in the arts is every bit as gainfully employed as someone who works in an auto

1 'Libraries are part of the solution', *SCL Blog*, 11 March 2013.
2 Anita Singh, 'Melvin Bragg: why the arts have replaced heavy industry', *Telegraph*, 18 January 2011.

plant or a steel mill… We are going to make the point till people are tired of hearing it.[3]

While, in the UK, London's mayor, Boris Johnson, is equally business-like:

> Arts and culture are not a luxury, they are part of this city's DNA, its USP. It is why people want to live and work here, and seven out of 10 tourists say it is a reason for their visit.[4]

The arts, we are told, are no luxury but an economic necessity: hard at work attracting tourists.

The arts do not only have economic 'value add'. The Arts Council England and the Royal Society of Arts credit art with power over the weather: they jointly supported a 'global hub for artists whose work centres on environmental and ecological themes'. Announcing its launch at the Venice Biennale in 2007, Matthew Taylor of the RSA excused what even he termed such 'crude propagandism' in the name of saving the world: 'how will we think of those who argued that artistic purism trumped the need for action?' One of the artists he credits with 'a unique role to play in raising awareness' is Jeremy Deller, the British conceptual artist.[5] Deller was actually chosen to represent Britain at the Biennale in 2013: his modestly named exhibition, *English Magic*, designed to raise awareness about such rarely discussed subjects as consumerism, the royal family and the fact that Roman Abramovich is rich and owns a big yacht. Whatever the subject, Deller's stated aim was to provoke people and 'annoy everyone'.[6] It appears that artists who choose to produce

[3] Robin Pogrebin, 'New Endowment Chairman sees arts as economic engine', *The New York Times*, 7 August 2009.

[4] Ben Bailey, 'Boris Johnson calls for voluntary museum charges as he joins Kevin Spacey for arts boost', *London Evening Standard*, 21 September 2009.

[5] Matthew Taylor, 'Art can make a green impact', *Guardian Art & Design Blog*, 21 May 2007.

[6] Ralph Rugoff, 'Jeremy Deller: a kind of magic', *Art Quarterly*, Summer 2013, pp. 38–43.

propaganda in support of causes dear to the heart of Britain's cultural elite can be confident of receiving funding and the Brand Britain imprimatur: any aesthetic value in their work taking a distant second to its potential impact on how people think.

Museums are expected to do their bit too and many, for example the National Museums Liverpool and the Happy Museum Project (sic), work towards social justice and wellbeing by using their 'assets of collections, buildings, knowledge and networks to help create a fairer society, in which people live better lives'.[7] This approach is echoed in the 2013 publication by the Museums Association *Museums Change Lives* which demands that museums engage with contemporary issues, enhance wellbeing and contribute to communities and the environment.[8] Actor and theatre director Kevin Spacey also sees culture as no luxury: putting forward a defence of the arts in 2009 as 'a necessity in our lives'. Theatre, he claimed, 'teaches young people to communicate, to resolve conflicts, to collaborate and to explore emotions'.[9] Since Aristotle there have been those that believed theatre can act as a form of therapy, a purgative for the soul, though he limited its effects to ridding the Athenian citizen body of unruly passions. Spacey loads theatre with a much heavier, and worthier, burden but the question of what, if anything, it might be worth *beyond* teaching conflict resolution is left hanging.

Across politics, the media and the arts establishment there is a remarkably large degree of consensus that the arts need to be put to use. In the last twenty to thirty years there has been an incredibly rapid change in attitude towards the arts — so rapid it should prompt a question as to why this might be — to the extent that they are now afforded powers of regeneration,

[7] Maurice Davies, 'Social justice vs wellbeing', *Museums Association blog*, 26 February 2013.

[8] Museums Association, *Museums Change Lives* (2013) p. 5.

[9] Kevin Spacey, 'I won't apologise for defending the arts', *The Times*, 9 May 2009.

restoration and renovation that are almost magical in their extent. The range and impact of culture as a weapon is now extensive: from the economic regeneration of nations and of cities to the creation of cohesive and inclusive communities, increases in health, wellbeing and happiness, and the all-round creation of a better future through the education of the next generation. The best introduction to how deeply it is felt that the arts can achieve all this, however, is to examine the reaction when anyone suggests cutting public funding of the arts: taking away what we are told we so desperately need.

The Culture Deficit

The RSA report already referred to lists the sort of things we are now imagined to lack:

> A growing body of research suggests that the arts can be a valuable engine of civic renewal, in nurturing social capital and trust by strengthening friendships, helping communities to understand and celebrate their heritage, and in providing a safe way to discuss and solve difficult social problems.[10]

All these things — that were traditionally imagined as coming from *inside*, from the autonomous action, say, of virtuous citizens or proud communities — are now treated as things to be instrumented through the medium of the arts. The arts are to be put to work.

When civic society is argued to be something that can be renewed through the arts then the flipside to that argument is of course that turning off the culture 'engine' leads to civic corrosion and disintegration. If people are imagined to be reliant on culture then cuts in public funding can be seen as damaging to them. One striking example of this was the series of attacks launched by the great and the good of the British arts establishment on culture secretary Maria Miller in the run-up to planned budget cuts at the end of 2012. On a high from his success with

[10] Knell & Taylor (2011), p. 29.

the Olympics, Danny Boyle demanded that Miller dance to the
tune of British theatre directors rather than set the pace herself:

> Not one of those [artistic directors, including Nicholas Hytner of
> the National] has been even approached by this woman. That is
> outrageous. This is the cultural life of our country. She is the
> minister of fucking culture. I mean, come on.

Boyle went on to argue (with a remarkably candid level of dis-
taste for those staples of working-class life: pubs and football)
that local authorities must maintain regional theatre grants
because they provide something

> in our cities and towns that isn't Wetherspoons and Walkabout
> pubs and Mario Balotelli and John Terry... You can grow and
> build good communities through the investment in the arts.[11]

Lee Hall, of *Billy Elliot* fame, jumped on the moral bandwagon,
dubbing proposals to cut all of Newcastle's £1.6 million culture
budget a 'nuclear blast' as well as 'culturally, socially and,
crucially, economically illiterate'.[12] Nearby Gateshead, of course,
has had 20 years of arts-led regeneration (the *Angel of the North*,
the Baltic contemporary art gallery, and the Sage 'home for
music and musical discovery') without any discernible uptick in
the local economy, but nonetheless the prejudice that arts
investment is a panacea for local economies runs deep. Over the
years, as faith in the argument that the arts are good in them-
selves has waned, so the arts establishment has come to rely
more and more on instrumental arguments to make their case.
The review commissioned by the Labour government in 2007
from Sir Brian McMaster, former director of the Edinburgh
International Festival, actually represented something of a
reaction against this trend towards meeting 'simplistic targets',
in its commitment to the 'profound value of art and culture' and

[11] Charlotte Higgins, 'Danny Boyle accuses culture minister Maria Miller of
 "outrageous" snub', *Guardian*, 15 November 2012.
[12] Charlotte Higgins, 'Lee Hall attacks Newcastle council's decision to cut
 entire culture budget', *Guardian*, 23 November 2012.

its call for 'objective judgements about excellence'. While many welcomed the language of artistic excellence in the report, fewer commented on the fact that it was largely undercut by its demand that artists and funders 'must have diversity at the core of their work'.[13] Is such work excellent *because* it is diverse? Or is something else required as well? If so, then what? Even less remarked upon was McMaster's definition of cultural excellence as being 'when an experience affects and changes an individual'.[14] That is to say, a thoroughly relativist account of what constitutes excellence in the arts. Given this, it is maybe no surprise that, when push comes to shove and cuts in budgets are being threatened, instrumental arguments are normally the first line of defence with intrinsic arguments coming a distant second. If excellence and access appear to clash then access wins out. At least heads — as compared to life-changing experiences — can be counted.

Many artists today, and certainly arts mandarins, passionately believe they have a better knowledge of how to allocate local-authority budgets than elected councillors and demand the arts take precedence over direct investment in industry, say, or hospitals or social work. Those who point out — Will Gompertz of the BBC for one — that much public funding benefits only a tiny minority of eight per cent who go to 'ballet, opera and classical concerts' risk getting into a numbers game as others fight back with Arts Council England figures that claim that an astonishing 76 per cent go to an 'arts event' once a year: even though 'arts event' here is a broad church including going to see a film or a rock concert. In the same article, *The Times* columnist Libby Purves claimed that we all know the arts 'matter'. Why do they matter? Because they are so very profitable. She cites figures that

[13] McMaster (2008), pp. 5–6.
[14] McMaster (2008), p. 9.

[even] apart from the 14 million London theatre tickets sold
every year—more than Premier League football tickets—and
leaving aside the international prestige of Broadway experts
and big-hitters nurtured under subsidy, the positive economic
impact of theatre alone is around £2.6 billion a year.[15]

This £2.6 billion figure—give or take a bit—has been around for
a while. It was quoted in the Cultural 'You can bank on culture'
Capital Manifesto and found first in a report commissioned by
the Arts Council England in 2004.[16] That report stated that £1.5
billion of this contribution was generated in London and that
the figure *did* include the disproportionate contribution of West
End musicals. According to the BBC, 64 per cent of tourists take
in musicals like *Billy Elliot*, *Chicago*, *Sweeney Todd* or *The
Bodyguard*. 25 per cent go to the theatre. Three per cent the ballet
and only one per cent the opera.[17] Leaving aside the question of
the actual artistic value of *Chicago*, an obvious issue arises when
budget cuts are to be made. On what possible basis do opera
and ballet deserve any public funding when times are hard?
There might seem to be a much easier argument to be made for
bigger, showier and more populist musicals. Even for staging
musicals in Chinese to help grow the share of the emerging
market in globe-trotting tourism. It might be objected that
musicals need less support than opera and ballet because the
former are profitable *without* subsidy and that those latter
deserve public support because they are higher forms of art. I
entirely agree, but this is precisely the problem: where *is* the
argument that is prepared to stand for funding culture simply
because it is good? That we need to spend on culture precisely
as a *luxury* and not as an economic or therapeutic necessity? It is

[15] Libby Purves, 'A £20,000 snip... a company closes down', *The Times*, 3
 December 2012.
[16] Arts Council England, 'Economic impact study of UK theatre', 5 May
 2004.
[17] BBC News, 'UK theatre helped boost economy by £2.8 billion', 24
 September 2010.

in the absence of any such confidence in culture in itself that it is touted as able to achieve almost anything imaginable: described in every which way except in its own terms of beauty and of truth.

Creative Cities

The European Capital of Culture programme, as an example, has taken an openly instrumentalist approach to culture since 1985 when Greek film actress and then Culture Minister Melina Mercouri and her French counterpart, Jack Lang, suggested it. Any retrospective cynicism about Greek arguments to access European funding to one side, the stated purpose of the initiative is twofold: on the one hand to celebrate the 'richness and diversity of European cultures' and 'foster a feeling of European citizenship'; on the other, to 'regenerate cities' and 'raise their international profile, boost tourism and enhance their image in the eyes of their own inhabitants'.[18] There is therefore a material dimension to the initiative (regeneration, tourism) and a therapeutic-political dimension (to look good is to feel good; citizenship and togetherness). When the initiative started the cities chosen were cities obviously associated with high culture: Athens, Florence, Amsterdam, Berlin and Paris. The choice of Glasgow in 1990 was the point at which the selection criteria started to shift from what a city *was* in terms of culture to what it could *become*: a future mainly imagined in terms of increased development investment and a boost to tourism. There was opposition at the time to the choice of Glasgow headed by the Workers' City group—including Scottish novelist James Kelman—who saw the move as cynical and the renaming of part of the city centre as the 'Merchant City' as transparently meeting the interests of big business rather than ordinary Glaswegians. Similar cynicism about the creation of middle-class artistic 'ghettoes' can be seen, to take a

[18] 'A long-term trip through Europe', http://ec.europa.eu/culture/our-programmes-and-actions/capitals/ european-capitals-of-culture_en.htm

US example, in Detroit, where even cultural booster Richard Florida admits that

> a political divide has opened up between the largely young, white, educated 'new' Detroit and the mostly African-American, undereducated and unemployed longstanding citizens.[19]

Cynics, or realists, might observe similar patterns in London's Hoxton or Deptford, even in Bilbao, and in the relentless spread of cultural or creative 'quarters' across modern cities. Creative quarters may be everywhere but, sadly, Montmartre they are not: as a visit to the Wood Green Cultural Quarter in north London will reveal.

A European City of Culture is now selected not for what culture it *has*, but for how much it promises to achieve in terms of highlighting 'the richness of cultural diversity in Europe' and bringing 'the common aspects of European culture to the fore'. One of the ways in which the stress on diversity and commonality (an interesting, and almost paradoxical, pairing, not least in the fact that culture is *uncommon*…) is realised is through the now formally acknowledged policy of choosing not one but at least two cities a year. If the point is about using culture as a transformative force for the better, it almost makes sense to choose the most decayed, depressed and derelict cities going: if you start with little, then it is much easier to show that culture makes a difference.

Marseilles (twinned with Košice in Slovakia) is European Capital of Culture 2013. It is using the fact to rebrand itself

> from a poor, rough, crime-ridden and corrupt crossroads whose economy declined with the end of colonialism to an attractive tourist destination of sun, sea, seafood and culture.[20]

[19] Richard Florida, 'Detroit shows way to beat inner city blues', *Financial Times*, 9 April 2013.

[20] Steve Erlanger, 'Known for crime and poverty, but working on its image', *The New York Times*, 4 February 2013.

$135 million is being spent on what one of the organisers calls a 'cultural earthquake' of new buildings—including the obligatory new museum housed in a giant concrete box—and a celebration of multiculturalism. Between them the two cities are said to represent a fusion of West and East—rich and poor—and, as such, embody the dream of every social-mobility, 'united in diversity', Eurocrat.

The European programme now has a national spin-off in terms of the UK City of Culture initiative launched in 2009 by then Labour culture secretary Andy Burnham. In 2013 the city of Derry (rebranded Derry-Londonderry) was the inaugural UK City of Culture: chosen ahead of Birmingham, Norwich and Sheffield. Derry, in Northern Ireland—sadly best known for the Bloody Sunday shootings—has three museums: the Tower Museum where you can see an Armada shipwreck and learn about Derry's history, the Workhouse museum, and the Foyle Valley Railway. Cultural figures of note include the poet Seamus Heaney, Nadine Coyle from Girls Aloud, and Feargal Sharkey of The Undertones. Derry owns only 29 pictures but, thanks to the City of Culture programme, it now has a gallery space—The Void—and an equally imaginatively named temporary-venue space—The Venue—with £5 million pounds worth of temporary seating. It might appear that Derry-Londonderry is getting a cultural shot in the arm rather than a well-deserved recognition of its cultural weight. In fact, the sense in which culture is being *applied* to its citizens—Catholic and Protestant, Republican and Nationalist—to shape them and mould them is made clear by chief executive and apparartchik of Culture Company 2013, Shona MCarthy, who said: 'We're not programming for one community, then the other. This year is about lifting us out of parochial politics. That's what the arts can do.'[21] She was echoed by another Undertone, John O'Neill: 'This year should make us more confident and help with openness'. The overall sentiment being that the programme will act as post-

conflict therapy and boost self-belief. In particular, McCarthy is not troubled by the lack of pictures to look at: 'our focus is [on] the active participation of our citizens to express their own creativity, rather than the passive consumption of art.'[22]

How a programme of Brian Friel plays, collections of family photographs and music lessons for three- to eight-year-olds will raise confidence could be debated. Can an exhibition of photography like *Me, Myself, I* at The Void work regeneration magic? The exhibition aimed

> to examine self-identity of older LGBT people through the medium of photography. As we grow older, the subject of self-image is one that we all must address and it can be particularly complex for older LGBT people.[23]

There is no doubt that the emphasis on self-image is to the point in a city known for bitter political division. The hybrid new brand name for the city pointedly refers to it and ignores it at the same time, reflecting perhaps a certain level of indifference, if not contempt, on the part of the organisers for the reality of that conflict and the 'parochial politics' of its citizens.

Cohesive Communities

'A city without shared public goods is one where a sense of communal attachment will be weak. Civic culture needs culture.' The Times leader, 4 December 2012.

The idea that the arts can have such positive effects on communities and the fabric of society is something of a new one. Why did the beauty of the Renaissance not keep the French and Spanish invaders at bay or at least transform them into cultural tourists? In fact, if the Medici had spent rather less money on the arts and rather more on building up an effective

22　Martin Bailey, 'Derry-Londonderry: plenty of history but not much art', *The Art Newspaper*, December 2012.

23　'Me, Myself, I', http://www.cityofculture2013.com/event/me-myself-i/

citizen militia (as Machiavelli advised them) might history have been different? Certainly, in the UK, defence spending already makes a massive contribution to the economy, and maybe getting young people into the army would be a very straight-forward way of meeting Kevin Spacey's goal of teaching young people how to 'resolve conflicts, to collaborate and to explore emotions'? As well as teaching them discipline, life skills and the value of things that go beyond the crudely material. Such as patriotism and comradeship.

Certainly joining the armed forces was once a way off the dole queues of yesterday's cities and towns. Today one can sign up instead to the forces of culture and, in Peterborough, even join the ranks of Citizen Power: 'a partnership between a pioneering, active think-tank (RSA), an ambitious local author-ity (Peterborough City Council) and an influential national arts body (Arts Council England).'[24] Similarly to the cities of culture, it is the most depressed communities in the UK that have been targeted first for renewal through culture. One particular focus has been the seaside of South East England, and I decided to trace a loop of nearly 150 miles from Margate in Kent to Chichester in West Sussex to see for myself the investment – the so-called 'string of pearls' development – that has been made in culture and what is being done in its name.

Margate

'The brilliant thing about Turner Contemporary is that it has given people hope that things are going to change here and also put Margate back on the map.' Tracey Emin, local artist.

The Turner Contemporary is a 'dynamic visual arts organ-isation that believes in making art open, relevant and fulfilling for all'.[25] It opened in 2011 at a cost of £17.5 million. Whether or not it has had any success to date in achieving regeneration in

[24] 'Citizen Power', http://www.thersa.org/action-research-centre/public-services-arts-social-change/citizen-power

[25] http://www.turnercontemporary.org/about

Margate: well, maybe it is still too early to tell. At the time of writing, however, even the Non-Stop Pound Shop had just closed its doors, moved out, and stopped.[26] Peter Bazalgette, now chair of Arts Council England, though, sees the Turner as a 'beautiful… far-sighted' building and cheers its 'sparkling exhibitions' as well as claiming that the benefits of increased 'leisure, tourism, job creation, education, regeneration… more than add up'.[27] Whether or not the 19 jobs he says the Turner has created plus the joy of some temporary contemporary art exhibitions offsets the loss of 2,400 jobs at nearby Pfizer, or those that will be lost when Dungeness nuclear power station is decommissioned, depends, I imagine, on how much fish and chips day-tripping Londoners can eat.

There is a deep cynicism expressed in Bazalgette's wish that Margate Council emulate and rival Westminster City Council, home of the Barbican and the London Symphony Orchestra. Cynical too, given the reality of Margate today, was the decision to display Rosa Barba's multi-platform film installation *Subconscious Society* which

> depicts a 'society' trapped inside a deteriorating interior where the characters explore what happens when objects lose their functions and meanings, whilst being hidden from the crumbling, abandoned world outside: rusting boats, collapsing piers and rollercoasters, and deserted buildings rising from the sea.

Barba says of herself:

> In my work I don't observe reality; I am reinterpreting it in a certain direction by making very personal decisions. I don't pose critical questions; I am trying to invent a utopia by showing political and social mechanisms set against technical

[26] Georgia Graham, 'Queen of Shops "all pomp and flop"', *The Sunday Times*, 3 March 2013.

[27] Peter Bazalgette, 'We can avoid an Age of Foolishness in the arts', *The Times*, 8 March 2013.

mechanisms which are themselves fragile. The paradox which results from such a tension is used to posit a utopian solution to the problem, a kind of magic which stops time and offers a slowed-down view of otherwise hidden aspects of reality. It offers an alternative reading of the past and also the future.[28]

There is no permanent collection at the Turner: outreach is the name of the game reflected in the fact that the education room is a beautiful space—flooded with light from the sea—while the gallery spaces are bereft (maybe it is a blessing) of any natural light. £17.5 million is a considerable investment when it gambles on the ability of a temporary 'kind of magic' to turn Margate around. Building a gallery in Margate to honour J.M.W. Turner more directly through showing some of his works against the sea and sun that inspired them would at least make sense in artistic terms, although—if we are honest—it is not what Margate needs right now.

Margate's latest great white hope is a plan by Wayne Hemmingway (*Red or Dead* fashion designer) to develop a £10 million heritage park on the old Dreamland theme-park site to 'celebrate British seaside amusement park heritage'. Its 'evocative content' will include

old neon signs collected from around the UK... placed in the hands of artists to create installations... Anyone fancy taking tea in a Waltzer or enjoying a Coke float in a rescued dodgem car?[29]

Margate's future exists in the dreams of culture wizards like Hemmingway who believe they can make anything up. And do. And get away it.

28 'Rosa Barba: Subject to Constant Change', http://www.turner contemporary.org/exhibitions/rosa-barba
29 'Dreamland Margate', http://www.hemingwaydesign.co.uk/projects/ design/dreamland-margate

Folkestone

Round the coast, Peter Bettley of The Creative Foundation, which administers the Folkstone Triennal contemporary arts festival, says: 'The Triennial is about establishing Folkestone as a centre of contemporary art, assisting in its transformation.'[30] Creative Foundation invites artists

> to use the town as their 'canvas', utilising public spaces to create striking new pieces that reflect issues affecting both the town and the wider world.[31]

What Folkestone's elderly population make of the Tracey Emin, Mark Wallinger and Richard Wentworth artworks dotted around their town is anyone's guess. Emin's work consists of *Baby Things* — a bronze glove on a railing, an abandoned shoe — which exude

> an aura of the forlorn and dejected, they are poignant reminders of Folkestone's high teenage pregnancy rate, which is similar to that of Margate, Emin's home town.[32]

Bexhill On Sea

According to its website, the 'De La Warr Pavilion is a Grade I listed Modernist icon and an international centre for contemporary arts on the seafront'. In 2013, alongside its regular programme of cinema (*Quadrophenia, Mary Poppins*), theatre (*The Gruffalo's Child*), comedy (Julian Clary, Paul Merton's Impro Chums) and music (The Summer Sing, RAFA Wings Appeal Concert), the DLWP hosted an exhibition by Mark Leckey, a Turner-prize winning artist. His *The Universal Addressability of Dumb Things* provides another statement of the contemporary belief in the magic powers of art. It presents a kind of 'techno-

[30] Oliver Bennett, 'Galleries and festivals are reinvigorating our coastline but do they bring lasting renewal?', *Independent*, 1 July 2011.

[31] http://www.folkestonetriennial.org.uk/about/

[32] Quoted in Deyan Sudjic, 'Back to the future', *Observer*, 24 April 2005.

animism' in which 'images are endowed with divine powers, and even rocks and trees have names'. Leckey claims:

> [T]he status of objects is changing, and we are once again in thrall to an enchanted world full of transformations and corres-pondences, a wonderful instability between things animate and inanimate, animal and human, mental and material.[33]

For me, the value of culture is how it expresses our freedom: being 'in thrall' is nothing to celebrate but something to escape. Maybe the last word should go to George Bernard Shaw. When he heard the Pavilion had opened in 1934 he telegrammed:

> Delighted to hear that Bexhill has emerged from barbarism at last, but I shall not give it a clean bill of civilisation until all my plays are performed there once a year at least.

Eastbourne

In Eastbourne there is another contemporary art museum: the Towner Art Gallery, originally established by philanthropic bequest in 1923. It has a permanent collection: built in the main on the work of the popular Sussex watercolourist and print-maker Eric Ravilious; though it now includes Tacita Dean, Julian Opie and Grayson Perry. It also has an 'Outreach and participation' programme with straightforwardly instrumental aims:

> Towner works intensively with small groups of young people and adults to tackle problems at an individual level, problems which may have contributed towards offending, health inequal-ity or substance misuse.[34]

This is directly comparable to the use of Beethoven's Ninth in *A Clockwork Orange*. Another project, 'Generate', allows 14–19

[33] 'The Universal Addressability of Dumb Things', http://www.dlwp.com/event/mark-leckey

[34] 'Outreach & participation', http://www.townereastbourne.org.uk/community/participation/

year-olds access to iPads and Photoshop to create street art and graffiti: providing a 'welcoming space for you to create, play, eat, drink and relax'.[35] The Towner at least seems unclear whether it is a museum of art, medical clinic, remedial unit or nursery.

Chichester

Finally to Pallant House Gallery in Chichester, a lovely Queen-Anne townhouse marred by a contemporary extension, but holding a good collection of British 20th-century work. The bequest, made in 1977 by Dean of Chichester Cathedral Walter Hussey, includes pieces by Roger Fry, David Bomberg, Ben Nicholson, Graham Sutherland, Henry Moore and Frank Auerbach. Once again, however, it is the community programme that grates. Pallant House runs *Outside In,* set up

> to provide opportunities for artists with a desire to create who see themselves as facing a barrier to the art world for reasons including health, disability or social circumstance. The goal of the project is to create a fairer art world which rejects traditional values and institutional judgements about whose work can and should be displayed.[36]

In other words, Pallant House runs a programme dedicated to undercutting its own raison d'etre. It is tempting to take them at their word and offer a loan of some of *my* art in exchange for a Nicholson or Walter Sickert or two to hang in my hall.

Arts-led Regeneration

Despite all the hype that surrounded Richard Florida's 2002 book *The Rise of the Creative Class* and its claim that parachuting culture into deprived post-industrial areas could turn them

[35] 'Generate', http://www.townereastbourne.org.uk/community/participation/generate/

[36] 'Outside In', http://pallant.org.uk/learning-community/learn/learn/projects-partnerships/outside-in

around, there is simply no hard evidence of what experiments like these will lead to. Reports by the Turner Contemporary itself or the now defunct government Sea Change regeneration programme claim success, maybe unsurprisingly, with the latter claiming evidence of some 700 jobs created after an investment of around £100 million.[37] I don't know if seven jobs for every million pounds of investment represents a particularly good return, but neither would I want to discount the value of the physical assets that have been created: even if they are mainly steel and glass boxes.

Given this level of investment there must be *some* effect on the local economies although the jury is very much out on what the long-term benefit may turn out to be, given the deep-seated nature of structural decline in these seaside resorts. There is a question too — once the building and restoration work has dried up — if the resultant creative and cultural quarters will remain isolated — creative ghettoes — from the towns in which they are embedded. In Margate, for example, as in Folkestone, efforts seem to be concentrated on the old town and seafront and have little impact elsewhere.

Whatever figures I might come up with to indicate scepticism about arts-led regeneration — Margate still has an unemployment rate of 20 per cent, one of the highest numbers of people dependent on benefits in the country and, at the time of writing, one could buy a nine-bedroom Edwardian detached house for £284,950 — is irrelevant in a way.[38] Professor Loretta Lees of the Department of Geography, King's College, London, fears the arts-led regeneration model 'favours the middle-to-high income demographic at the expense of others' and argues:

[37] Steve Rose, 'The rise of the seaside gallery', *Guardian*, 14 March 2012.
[38] It is interesting to note that Lambeth council in London is considering moving homeless families to Margate to take advantage of the cheaper housing on offer, treating it as a sink: Nick Hodgson, 'Lambeth council plans to move homeless families to Margate', *London Evening Standard*, 4 April 2013.

> The 'evidence' on arts-led regeneration is very poor in relation
> to socially-excluded communities and evaluations have been
> weak… A real problem is that there are few, if any, in-depth
> studies. Nonetheless, it is still the way that Government
> thinks.[39]

In fact she suspects that the effect in Glasgow and Liverpool of
their time as Cities of Culture may have been the creation of
pockets of art-led gentrification and the 'displacement of low-
income groups'. Even if well-heeled Londoners did get drawn
by the Turner Contemporary to relocate to Margate that might
not be an economic benefit to those who live there at all.

But, as I say, the figures are irrelevant given the dynamic of
the whole discussion is towards treating the people of Margate
as a mass to be experimented on by art. They have things
decided for them, on their behalf, and the best they can hope for
is to become parasitic on a day-tripping London crowd of arty
types. So much for civic pride and community cohesion. No-
strings-attached philanthropy would surely be preferable. And
what will happen when someone points out more direct and
profitable ways of creating jobs and helping the local economy?
Margate, for example, would be immediately improved (and
made more beautiful) by demolishing the eyesore flats of
Arlington House that loom over the seafront, by new housing
and by welcoming Tesco's building a supermarket and employ-
ing people, rather than trying to block it. Such arguments of
course might leave the arts stranded as investment flows else-
where. After all, similar claims were made for the transforma-
tive power of green technology as are still made about art but, in
the wake of the ongoing recession, enthusiasm has dampened.
Do the arts risk getting washed up too?

[39] Quoted in Oliver Bennett, 'Galleries and festivals are reinvigorating our
 coastline but do they bring lasting renewal?', *Independent*, 1 July 2011.

Prescribed Reading

'Our historic environment is not only an extraordinary economic asset — it is the source of so much well being.' Baroness Kay Andrews, chair, English Heritage, December 2009.

Culture can regenerate failing cities, bind communities together and keep you out of jail. As the UK government says:

> Innovative, challenging and exciting arts and culture improve people's lives, benefit our economy and attract tourists from around the world. Arts and culture strengthen communities, bringing people together and removing social barriers. Involving young people in the arts increases their academic performance, encourages creativity, and supports talent early on.[40]

It should be no surprise that it is also a magic potion for health. The Reading Agency charity has developed a 'Books on Prescription' scheme — endorsed by the Department of Health — based on work done in Cardiff by clinical psychologist Neil Frude.[41] He admits some self-help titles are better than others — 'some of them are atrocious and some of them are absolute gold' — but is confident nonetheless that his 'evidence-base' supports what has become a 'quality assured national reading list' as to what 'patients' should read, and what they should not. Now the agency wants to extend reading prescriptions beyond cases of depression, anxiety, stress or phobia, even chronic pain, to the rather generally stated category of 'children and young people'. Meanwhile, the Reading Agency runs the Reading Groups For Everyone initiative pushing 'Mood Boosting Books'. The list includes *Notes from a Small Island* by Bill Bryson, *Cider*

[40] Gov.uk, 'Policy: Supporting vibrant and sustainable arts and culture', https://www.gov.uk/government/policies/supporting-vibrant-and-sustainable-arts-and-culture

[41] Find the full list here: http://readinggroups.org/news/general/boost-your-mood-with-our-mood-boosting-books.html

with Rosie by Laurie Lee and Nancy Mitford's *The Pursuit of Love*.

It may be no surprise that the Society of Chief Librarians—representing many libraries faced with budget cuts—has opportunistically embraced these schemes, promising that libraries are not a problem—a drain on the public purse—but part of the solution as they will now offer, not just books, but four 'services': health, reading, information and digital.[42] The first of these, the 'Universal Health Offer',

> builds upon the generic library assets which include a network of local hubs offering non-clinical community space, public health information and promotion, signposting and referrals and creative and social reading activities.

Now libraries will be sold as clinical space to local health trusts, in order to 'deliver wider aspects of the health and wellbeing agenda' while

> staff are being supported to refer and signpost and a grant from adult and community learning is supporting libraries, museums and archives to develop and deliver local history/reminiscence and family history workshops to and with local communities.[43]

All this work is part of the Arts Council England's 'Single Cultural Conversation' framework for joint working between it and the Local Government Association. The degree of contemporary politicisation of the arts has now far eclipsed anything achieved under Stalinism, which lacked any idea that libraries might ever have to 'articulate their role in supporting the new

[42] Mark Brown, 'GPs to prescribe self-help books for mental health problems', *Guardian*, 31 January 2013.
[43] 'Libraries are part of the solution', *SCL Blog*, 11 March 2013, http://www.goscl.com/libraries-are-part-of-the-solution/

public health responsibilities of local authorities as part of the commissioning landscape'.[44]

Libraries are now often WiFi enabled, certainly have computer Internet access for job-clubbers looking for work, and some even allow lone businessmen to hold meetings and trade day-to-day. Some are 'start2' centres. Or to use its full title: 'start2: Change Your Life With Art' as brought to you by 'Start', the award-winning NHS service 'that uses art and horticulture to help people rebuild their mental wellbeing after a period of ill health'. It promises

> new ways to approach wellbeing, through learning to harness your natural creativity... Experience for yourself the many ways that art can enhance your life. Expert advice will guide you all the way.[45]

The eagerness of librarians to make instrumental arguments for funding is one thing. Their willingness to act as pseudo-therapists—trained to point patients in the direction of boost-your-mood literature available on prescription—is another. What if the book doesn't deliver the required boost? Is it no good? Conversely, might it be that the very wonder of a public library as somewhere you are free to make your own mind up about what to read is the real tonic? Certainly, when I was a teenager, and before it became a community information service, the Edinburgh Central Library seemed to be a magical gift: its very existence proof that society cared about letting me choose what to read. Whatever that might be.

How long before we are told that it is simply unacceptable, that it is an abuse, when parents do not do enough to encourage their children, to *make* their children, read? What moral entre-

[44] 'The single cultural conversation—making a difference locally', http://blog.cloa.org.uk/2013/03/13/the-single-cultural-conversation-making-a-difference-locally/

[45] See the start2 website at http://www.start2.co.uk for more information and a chance to self-assess with their Wellbeing Thermometer or 'Mix yourself a Recipe for a Good Mood in our Animation Generator'.

preneur, what state official, will then decide for them what they should read? In fact, there already is no shortage of lists of what your children should be reading at any stage in their lives. Can you afford to ignore World Book Day? Have you read *The Novel Cure: an A to Z of literary remedies*? In all this, just where is the argument for libraries *per se*? If budget cuts go further and deeper, if political enthusiasm for the arts as political instrument wanes, then might it become obvious that libraries can be closed, the approved books moved to hospitals, and the middle-man cut out?

A common defence of the instrumental use of the arts is that if it works for some people — makes some happier or healthier — then it is just elitist to object: no more than an attempt to reserve the arts for some higher purpose. Why not, so the argument goes, subordinate the arts to the noble end of making people better? The problem here is that the arts rely on the freedom of the individual and not on the effect they may — or may not — have. If the value of art is seen in a happiness or wellbeing outcome, then what about a book which makes one unhappy, angry or sad? Should it go on the reserve shelves? Is there a case for less Wagner and more 'happy' music? What about people who refuse arts therapy? Do they need to be taught the error of their ways?

Cultural Re-education

Whatever doubts there may be about the effectiveness of culture in making a new Britain, there should be no doubt that education can shape the minds of a generation. For better or worse. It can foster in our children the ability to judge and discriminate. Or destroy it. It can introduce them to the canon of the best that has been thought and said — the wonders of great books — or it can replace books with 'readers', mistake literacy for literature, and turn the arts into just another career choice.

Education has become a key battleground for those committed to the instrumental use of the arts. Tracey Emin, for example, backed a Tate Modern campaign in 2013 to derail Conservative education secretary Michael Gove's plans to

remove art from the core subjects of the new English bacca-laureate (Ebacc). She threatened that, without a creative outlet, inner-city children would explode into violence: 'if anyone thought the riots in 2011 were bad, take the arts out of the curriculum and it will be worse than it was before.'[46] This is to turn the arts into a political pacifier: a dummy in the mouths of babes. Nor did Sir Nick Serota mount any intrinsic defence of arts education. There was no call for life-drawing or learning to read music: he simply demanded the Ebacc include art so as to allow self-expression and keep our 'cultural skills' sharp enough to stop the UK losing its 'leading edge in creativity'.[47] Arts education, not for its own sake, but for political, thera-peutic and economic ends.

There is nothing wrong with teaching children how to play a musical instrument. There is everything wrong with justifying it solely, or even primarily, in terms of the

> benefits of musical learning in improving motor skills, thought processes, personal choices, in liberating creativity and encouraging co-operative working.[48]

All of these benefits might accrue. Equally they might accrue more easily playing tennis. There is even more danger in the fashionable degradation of the acquisition of knowledge as mere rote learning: downplaying the 'passing of grades or the improvement of technique' for the soft skills of 'personal development and wellbeing'.[49] Such well-intentioned ideas will leave young people mediocre musicians. Is it not still the job of

[46] Nick Clark, 'Tracey Emin warns of "rioting in the streets" over marginalisation of art in education', *Independent*, 21 January 2013.

[47] Mark Brown, 'Generation of children could lose vital cultural skills, says Nicholas Serota', *Guardian*, 27 September 2012.

[48] Nicholas Kenyon, 'Grace notes', *Times Literary Supplement*, 12 October 2012.

[49] Sean Gregory, 'Music education must keep on moving', *Guardian*, 10 April 2013.

educators to challenge and push their charges as well as their duty to pass on the hard-won knowledge of the past?

It is genuinely remarkable the English arts establishment looked Gove's Ebacc gift horse in the mouth: he was offering a *relaxation* of the level of political control of arts education by the state. The arts should be associated with freedom in the minds of children: one chooses the arts; they are not to be forced upon one like double maths. T.S. Eliot—author of the lines 'on Margate sands, I can connect nothing with nothing'—was alive to this danger nearly seventy years ago. He condemned the use of education as 'an instrument for the realisation of social ideals'

> which can only be fully realised when the institution of the family is no longer respected, and when parental control and responsibility passes to the State... [education] will take upon itself the reformation and direction of culture, instead of keeping to its place as one of the activities through which a culture realises itself.[50]

Modern advocates of compulsory culture should take heed of the danger that tailoring education towards the subjective well-being of young people may lead to moves to reform the culture we have to suit them better.

Culture Force

The instrumental approach, in conclusion, to the value of culture treats a piece of art or a theatre performance as good insofar as it has a given effect, outcome or impact on its audience. The work of art is seen as an object of use. It is the active force; we are the object of that force. Considerable faith over the last 20 years has been vested in the power of culture. Culture is believed, passionately believed, to have a use value.

Artists have long been divided over the question of the utility of art. The cultural Marxist tradition (Benjamin, Gramsci,

[50] Eliot (1948), pp. 99–107.

Adorno, Eagleton) attacked elite culture as an instrument of social control, claiming a conspiracy:

> the concoctions of the culture industry are neither guides for a blissful life, nor a new art of moral responsibility, but rather exhortations to toe the line, behind which stand the most powerful interests.[51]

Is it possible that today's cultural elites so firmly believe in this that they are willing to make use of culture as an instrument of social control *themselves*? Do they share Adorno's view of culture as an opiate preying on the 'ego-weakness to which the powerless members of contemporary society, with its concentration of power, are condemned'?[52] Are the arts just being used to make today's elites appear non-toxic, relevant and legitimate? Are they bearing down on us: standardised and standardising, rewarding conformity? Is there even a danger that when the value of the arts is linked to public utility, then some art will be identified as *not* useful? If art can lead to regeneration, is it not logical that it might also cause degeneration? After all, if we accept that culture can have such profound and wide-ranging impacts for the good, is it not conceivable that some works of art might have comparable *negative* effects?

The linking of culture to the idea of regeneration is driven by a widespread feeling that the world is changing and that we need to keep up or risk being left behind. To regenerate, after all, is to make new again. To make the traditional contemporary. Such is the fashion for the new that one is reminded of the words of Italian futurist Filippo Tommaso Marinetti: 'To admire an old picture is to pour our sentiment into a funeral urn.'[53] Leaving for one moment the question of the necessity of tradition to create the very possibility of originality, Marinetti precisely missed the point: culture is something we produce in

[51] Adorno, 'Culture industry reconsidered' in (1991), p. 105.
[52] Adorno, 'Culture industry reconsidered' in (1991), p. 105.
[53] 'The foundation and manifesto of futurism' in Chipp (1968), p. 287.

order that it may become old and serve as a testament to our continued and continuing existence. Great works of art may reflect the cohesion of our common world but it is a mistake to imagine it works the other way round: that culture can create cohesion where there is none. It appears that rather than existing in a living tradition, we live today with at best the *memory* of culture. We have a feeling that it is something special and precious but — try as we might — we cannot put our finger on it: a figure in a dream who would speak truth to us but we are deaf and it dumb. Memory is, of course, notoriously open to selectivity, exaggeration and subordination to the exigencies and expediency of the present: culture as memory is all easily turned into an instrument of policy by those who would speak on its behalf.

The only way to resist the weaponisation of culture we have been describing is through asking oneself searching questions: *should* I like this or that; or *should* I not? There is a moral question involved when we evaluate art, and art can only aspire to immortality if we judge it should. Such judgements require freedom to have validity: they need a clash of critical perspectives, they have to be *your* decision. Culture seen under the aegis of necessity will prove short lived at best. If times are hard, then it would be more honest to say that we will produce and fund beauty when we can afford to: and aspire to it when we cannot. Rather than *doing* anything much, the arts are for *you* to contemplate in those moments of freedom of spirit when you don't *do* anything much either. Not so much a moment when you forget yourself but a moment when you find yourself in a tradition: and see yourself in the relationship between — as the hinge and possibility of — past and future.

Interlude: traditional, modern, contemporary

When the past no longer illuminates the future, the spirit walks in darkness. — Alexis de Tocqueville, *Democracy in America.*

The line of demarcation between prehistoric and historical times is crossed when people cease to live only in the present, and become consciously interested both in their past and in their future. History begins with the handing down of tradition; and tradition means the carrying of the habits and lessons of the past into the future. Records of the past begin to be kept for the benefit of future generations. — E.H. Carr, *What is History.*

This grave dissociation of past and present is the generic fact of our time and the cause of the suspicion, more or less vague, which gives rise to the confusion characteristic of our present-day existence. We feel that we actual men have suddenly been left alone on the earth; that the dead did not die in appearance only but effectively; that they can no longer help us. Any remains of the traditional spirit have evaporated. Models, norms, standards are no use to us. We have to solve our problems without any active collaboration of the past, in full actuality, be they problems of art, science, or politics. The European stands alone, without any living ghosts by his side, like Peter Schlehmil he has lost his shadow. This is what always happens when midday comes. — José Ortega y Gasset, *The Dehumanization of Art.*

Culture, in the high culture—classical—sense we have been discussing, relies on tradition rather than memory: both in order to act as a repository of meaning and experience for us; and as something to be created within, and against. In this way culture is always historical insofar as it exists in a tradition that is long-lasting. Without a tradition classical music would not be *classical* but would be folk music. Epic poetry would be just campfire song. Tradition takes the ephemeral and local up into its system, hierarchy and rules and—contrary to much contemporary prejudice—in so doing allows for works of art to become unique, individual and different. It does this precisely by differentiating between them, by judging them: saying *these* are good enough to last, they have stood the test of time; but *these* are not. Without such a tradition—or canonical test—art remains outside of time, untimely. Homeric bards may never sing the same song twice—not exactly—but it is in a way always the same song because we have no way of judging it, studying it, conserving it. Lacking the authority of a tradition, culture works more in the fashion of ritual, magic or myth.

Culture started there: it has its root in *cult*. Benjamin is right to say the 'earliest art works originated in the service of a ritual—first the magical, then the religious kind'.[1] Culture was something that underpinned us: a sacred foundation from which we derived our values. By the end of the Renaissance beauty took on a more human and increasingly secular form and a revolution in thinking occurred in which we started to have the confidence to see beauty as something that might lie in front of us—in a future we might create—rather than behind us in the past. Man became aware of—took a perspective on—his history-making potential and himself. The modern world was born as we became conscious both of what was unique about now and what we had the capacity to make different tomorrow. Kenneth Clark provides an example of this turning point in his identification of the first painting to attempt to portray the ancient world

[1] Benjamin (1999), p. 217.

as ancient, rather than peopled with 'fifteenth-century dandies': Mantegna's *Triumph of Caesar* circa 1480, which he called the 'first piece of romantic archaeology'.[2] Since then we have increasingly, and consciously, worked to create and conserve a cultural tradition. *Modernism* — in philosophy, architecture, fine art, literature and music — although it reacted against that tradition, did so from within that same tradition. Modernism is a double-edged sword. It can be taken as expressive of what Schiller termed 'the disenchantment of the world' or Hegel called 'the unhappy consciousness': as man steps forward to take control of what is now his world he realises he has left God behind and does not know which way to turn, resulting in existential panic.[3] Or, modernity's self-awareness and its consciousness of the unbridgeable gap between real and ideal can be taken as the opportunity for and possibility of self-creation. And, of course, both sides of a sword are always sides of the same sword: aspects of the same process. Thus, to name only a few, Kierkegaard, Frank Lloyd Wright, Matisse, Woolf and Stravinsky worked in obedience to Ezra Pound's injunction 'to make it new': it did entail making a break with the past (as we must always); but it did not mean 'destroy the old'.

Modernism, however, is always open to the temptation to deny or simplify the creative tension between individual and society, real and ideal, past and future and to suppress the former in the interests of the latter. In the artistic sense, given the weight of tradition behind one, there is always a danger of taking the easy route of being a big fish in a small pond. Standing out from other artists by simply denying that they have any validity or relevance anymore: attacking tradition as such. This chapter traces that reaction though the examples of Futurism and Nazism and examines whether or not their attack on the past in the name of the future — their desire to cast off all inherited limits and judgements, even history itself — has had

[2] Clark (1969), p. 123.
[3] See Josipovici (2010), pp. 12 13.

the effect of leaving us almost after tradition: not at the end of history; but out of history. That is to ask whether or not the contemporary—as in contemporary art—still holds with this idea of the modern—as in modernism and the avant-garde—as representing a break with tradition or whether it, in fact, represents the end of tradition.

Past Imperfect: future perfect

Italian Futurist Marinetti declared war to be the revolutionary path to a utopian future:

> We will glorify war—the only true hygiene of the world—militarism, patriotism, the destructive gesture of anarchists, the beautiful Ideas which kill, and the scorn of woman.[4]

His *Manifesto* of 1909 is explicit about the value of tradition for culture:

> In truth, this daily frequenting of museums, libraries, and academies (those graveyards of vain efforts, those Mount Calvaries of crucified dreams, those registers of broken-down springs!...) is to the artist as the too-prolonged government of parents for intelligent young people, inebriated with their talent and ambitious will.
>
> For the dying, invalids, and prisoners, let it pass. Perhaps the admirable past acts as a salve on their wounds, as they are forever debarred from the future... But we will have none of it, we the young, the strong, the living futurists!...
>
> Therefore welcome the kindly incendiarists with the carbon fingers!... Here they are!... Here!... Away and set fire to the bookshelves!... Turn the canals and flood the vaults of museums!... Oh! Let the glorious old pictures float adrift! Seize pickax and hammer! Sap the foundations of the venerable towns![5]

[4] 'The foundation and manifesto of Futurism' in Chipp (1968), p. 286.
[5] 'The foundation and manifesto of Futurism' in Chipp (1968), p. 288.

Four years later painter and composer Luigi Russolo published another key manifesto of the Futurist movement. His *L'arte dei Rumori*, or *The Art of Noise*, announced that traditional music — with its melody and harmony, its 'restrictive circle of pure sounds' — was completely passé: high time it was swept away. It was to be replaced with 'noise music' or sounds classified into six families including: roars, whistles, whispers, shrill sounds, percussive noises, and shouts and screams.[6] Noise-music was to be produced by machines called 'intonarumori': to delight us with the sounds of 'trolleys, autos and other vehicles, and loud crowds'; because we are 'fed up' with the likes of Beethoven and Wagner.[7] This boredom onto death demanding a caco-phonic drowning out of traditional music found an echo in 1922 in Arseny Avraamov's *Symphony for Factory Whistles* in which 'artillery, machine guns, bus and car horns, shunting engines, and the foghorns of the Caspian fleet' played the *Internationale* and *La Marseillaise*.[8]

Russolo also demonstrates a hostility to the linear develop-ment of the classical tradition that became a theme for the rest of that century and the beginning of this. In the *Art of Noise* he says his

> new orchestra will produce the most complex and newest sonic emotions, not through a *succession* of imitative noises repro-ducing life, but rather through a fantastic *association* of these varied sounds.

My emphasis. Tradition here is once again seen as somehow 'limited', and limiting, and to be replaced by 'infinite variety'.[9]

The Spanish philosopher José Ortega y Gasset saw more clearly than some between the wars what this hostility to the past really entailed. He observed that hostility to past art is not

6 Russolo (1967), p. 14.
7 Russolo (1967), p. 6.
8 Ross (2007), p. 240.
9 Russolo (1967), p. 11.

really about hostility to the past *per se*, but to the period from the Renaissance, through the Enlightenment and the 19ᵗʰ century in particular:

> [T]he new sensibility exhibits a somewhat suspicious enthusiasm for art that is most remote in time and space, for prehistoric or savage primitivism… what attracts the modern artist in those primordial works is not so much their artistic quality as their candor; that is, *the absence of tradition*.[10]

My emphasis. For Ortega y Gasset the modern artist was 'brazenly set on deforming reality, shattering its human aspect, dehumanizing it'.[11] Art was reduced to play, essentially ironic, mocking and a thing of no great consequence. No doubt he had Duchamp's *Fountain* firmly in mind, but also the extremes of Fauvism, the Cubists, Dada and surrealism. Whatever we think of the art in question, I think his principal argument holds water. Namely, that artistic modernism gradually came to symbolise or express a great self-hatred, a self-disgust, of the West for itself:

> Hatred of art is unlikely to develop as an isolated phenomenon; it goes hand in hand with hatred of science, hatred of State, hatred, in sum, of civilisation as a whole. Is it conceivable that modern Western man bears a rankling grudge against his historical essence?[12]

Just think of Francis Bacon's self-portraiture or *Study after Velázquez's Portrait of Pope Innocent X*. Ortega y Gasset saw Europe entering an age of youthfulness — with a fascination for sports, athleticism and a cult of the body — and interpreted modernist art in terms of its mission to 'instill youthfulness into an ancient world'.[13] That youthfulness was already finding

[10] Ortega y Gasset (1968), p. 45.
[11] Ortega y Gasset (1968), p. 21.
[12] Ortega y Gasset (1968), p. 45.
[13] Ortega y Gasset (1968), p. 50.

expression in the heroic realism of Stalin's Soviet Union and Hitler's Germany.

The Nazis were of course implacable foes of what they saw as the degeneracy of Modernism[14] and, on the face of it, espoused a form of frozen lifeless Classicism. The tragic irony is that the violence of their assault on those who sought to 'make it new' — whether through the Bauhaus or in the Bavarian Soviet Republic — developed beyond the avant-garde into an attack on tradition and history.[15] The Nazis reacted against culture in its Enlightenment and universalist sense — of being about freedom — and embraced instead *Kultur*. Wagner was good, not because he was Good; but because he was German. Taste became about the eternals of race and blood. Bach was good; the Jew Mendelssohn bad, as was Schoenberg, the founder of 'music-bolshevism'. The paintings of Dürer were thought to 'represent a mythic ideal of nationalism', while 'the German songs of Schubert were deemed to support the ideal of the Volk'. In short, the Nazis used 'the core values of Western civilisation... as a weapon against themselves'.[16] Hitler prefigured contemporary instrumentalism in the arts: bending and twisting them to support his vision of the future and marshalling them — in words that would get applause at a National Union of Teachers conference today — to ensure 'the general sense of self-confidence was increased, as well as the capacities of individuals'.[17]

The experience of Nazism, however, served to discredit vast swathes of classical music post-war: music historian Alex Ross has noted Thomas Mann's 'contention that during Hitler's reign

[14] Cf. the infamous exhibition of *Entartete Kunst* ('Degenerate Art') in Munich 1937, and see Spalding (2003), pp. 17–18.

[15] So, Goebbels to Richard Strauss: 'The art of tomorrow is different from the art of yesterday! You, Herr Strauss, are yesterday!' Quoted in Ross (2007), p. 357.

[16] Yvonne Sherratt, 'Heroes and villains', *Times Literary Supplement*, 4 January 2013.

[17] Quoted in Dennis (2012), p. 461.

as dictator of Germany great art was allied with great evil'. After 1945,

> classical music acquired a sinister aura in popular culture. Hollywood, which had once made musicians the fragile heroes of prestige pictures, began to give them sadistic mien. By the 1970s the juxtaposition of 'great music' and barbarism had become a cinematic cliché: in *A Clockwork Orange*, a young thug fantasizes ultraviolently to the strains of Beethoven's Ninth, and in *Apocalypse Now* American soldiers assault a Vietnamese village with the aid of Wagner's 'Ride of the Valkyries.' Now, when any self-respecting Hollywood archcriminal sets out to enslave mankind, he listens to a little classical music to get in the mood.[18]

The other side of the coin was that whatever the Nazis had hated must be good by default. The US Army—as part of its de-Nazification programme—funded a music school at Darmstadt where Pierre Boulez and Karlheinz Stockhausen trained a generation in a style of musical serialism designed to be so formal that it could never be used for any political purpose: taking art for art's sake to a dead end. In fine art the equivalent was the work of American abstract expressionists: enthusiastically promoted by the CIA as propaganda or what today is called cultural diplomacy. As art critic Julian Spalding puts it, from

> the 1940s access to the high road of modern art was strictly restricted to splashy abstracts expressing a grimly isolationist view of human nature—just the artistic dish Hitler so despised.[19]

The position of literary critic George Steiner also shows the tendency to problematise culture after 1945, note his use of scare quotes:

18 Ross (2007), pp. 334–5.
19 Spalding (2003), p. 19.

> The deployment of ultimate sadism and obscurantism from within the very heartland of Western philosophical-humanist ideals and practices, the symbolic contiguities between Goethe's garden and Buchenwald, raise questions of uttermost complexity and consequence. Any notion of "culture" persists in their shadow.[20]

Taking the reaction against *Kultur* so far as to implicate Goethe is, in a sense, to accede to Nazi efforts to rewrite him as a 'Nordic genius' and prophet of war. It has been of no benefit to culture that anything the Nazis disliked became automatically good. Camus saw this clearly, arguing the Nazi state was based 'on the concept that everything was meaningless' and expressive of only despair, passion and action rather than faith, reason or any standard of values. 'Deprived of the morality of Goethe, Germany chose, and submitted to, the ethics of the gang.'[21]

Despite the fact that Nazism owed 'nothing to any part of the Western tradition, be it German or not, Catholic or Protestant, Christian...',[22] British literary critic, John Carey, can still write that the

> superiority of 'high' art, the eternal glory of Greek sculpture and architecture, the transcendent value of the old masters and of classical music, the supremacy of Shakespeare, Goethe and other authors acknowledged by intellectuals as great, the divine spark that animates all production of genius and distinguishes them from the low amusements of the mass — these were among Hitler's most dearly held beliefs.[23]

After the Nazis, in other words, high culture was, at best, 'high'. And with this the idea of discriminating within a tradition was

[20] George Steiner, 'How private a Nazi', *Times Literary Supplement*, 22 February 2013.

[21] Camus (1953), p. 148.

[22] Hannah Arendt, 'Approaches to the German Problem', *Partisan Review*, vol. XII no. 3, Fall 1945, p. 96.

[23] Carey (1992), p. 208.

shattered. The possibility of judgement was destroyed: decried as elitist if not racist. With the disintegration of the Western tradition, the fundamental condition of both artist and audience is a deep and essential loneliness. Where once tradition had acted as a guide — a mediator, an interpreter, Virgil to our Dante — now one stands alone before the world, bereft of signposts, whirling before an infinity of directions.

In the Continuous Present

In the contemporary imagination the past, and certainly the Western tradition, is increasingly viewed as a place where we can easily find negative lessons — in the 'bad old days' — but is considered much less as a useful resource. Rather than seeing the past as a repository of positive moral experience and insight — as a giant on whose shoulders we could stand — it can appear that the only moral it offers, at least the only one we can be really sure about, is the profoundly negative one of the Holocaust. We look at history and say never again. Less dramatically the Western tradition is seen as elitist, snobbish, exclusive: the dead white men's club. As a result, on the one hand, we feel the past as another country, as more remote than ever before, stretching away from us into pre-history, but on the other, the past is inescapably and always present: insofar as it is treated as a moral touchstone of immediate relevance to today. We have to keep referencing it to tell us that we are OK. If the past works to show us what is bad, then it needs to represent an eternal bad — Evil — otherwise it runs the risk of telling us nothing about the very different conditions we find ourselves in today. The tendency then is for history to be made Absolute: frozen and eternal.

The recent spate of fashionable apologies for the past is a revealing example of this trend. Tony Blair apologised in 2007 for the slave trade, saying it was imperative to 'remember what happened in the past, to condemn it and say why it was entirely unacceptable'. Australian prime minister Kevin Rudd apologised in 2008 to all Aborigines. The US Senate apologised for the 'inhumanity of slavery' in 2009 and, in 2010, David Cameron

made atonement for Bloody Sunday. In such ritual acts, the past is simultaneously condemned and put off limits: 'we did not do this and we would not have done, we do not carry the burden of the past', a sort of 'not-in-my-name' attitude; but, with the same gesture, its ongoing presence is asserted, as in 'we are not to be compared with them'. It is an unhealthy relationship in that the gain of cheaply validating the present through a negative counterposition to history comes at the expense of our being located in any historical narrative that could help give meaning to today. That is, we choose to disavow the cultural and moral inheritance that could help us make sense of today and tomorrow. The impact on high culture is the impossibility of being original to the extent that tradition, on which it is reliant, is rejected. Growing up is struggle enough with parents, but without them?

Cultural expressions of this sense of the present moment as being out of touch with the past naturally tend to emphasise and stress the speed and pace of change: to foreground the transient and ephemeral, or to meditate on death and decay. Warhol's famous for 15 minutes, Gunther von Hagens' *Body Worlds* or Wim Delvoye's *Cloaca Professional*: an art-machine which turns food to shit.[24] Literature too has an uneasy relationship to tradition in a post-canonical world: writers easily find themselves at the end of a post-modern cul-de-sac. They can trace how 'everything's cracking up'[25] — the disintegration of subjectivity and the inner self — or they can demonstrate the end of literature: plucking words from a hat like Tristan Tzara, using cut-up techniques like William Burroughs or David Bowie. Contemporary theatre finds Aristotle's notion that plays should have a beginning, middle and end an intolerable straitjacket and not a *sine qua non*. In many art forms there is a preference for

[24] A machine of 'the real' in other words since what is more real than shit? For more examples, see the entertaining Dudley Edwards (2012), pp. 159–63.

[25] Lessing (1962), p. 25.

exposing the creative process instead of trying to operate within the constraints of traditional forms.[26] Just as you can do a magic trick for children any number of times, but you can only tell them once how it is done, so inside-out architecture like the Pompidou Centre gets an initial round of applause but after that it fades away into cynicism. This is not to imply that these artists should just get a grip and turn traditional. Looking back kills what we love. It is, however, to demand an honest admission that we need an alternative.

The effect in cultural terms of the imperative of relevance is comparable to what Richard Hoggart in the 1950s called 'progressivism': what happens when one succumbs to the temptation to live in 'a constant present'. The result is that

> time has been lost: yet time dominates, because the present is for ever changing, but changing meaninglessly, like the clicking-over of lantern-slides with no informing pattern.[27]

Without a workable idea of a living tradition,

> the past becomes laughable and odd. To be 'old-fashioned' is to be condemned... the wagon, loaded with its barbarians in wonderland... moves irresistibly forward: not forward to any-where, but simply forward for forwardness's sake. Somewhere out in front are the scientists ('it's new — it's scientific') handling the controls.[28]

Hoggart, of course, was writing about the impact of advertising and consumerism on working-class ways of life post-war, but the impact on self-discipline and individual judgement is comparable to that caused by the erosion of the tradition of high culture. Culture has become something un-rooted, not long-

[26] Classical concerts and opera have begun to suffer now from inter-ruptions and delays while the performers are asked to explain what they are doing.

[27] Hoggart (1957), p. 168.

[28] Hoggart (1957), pp. 169–70.

lasting, but of and for now, for the present, short-lived and transient, mortal: cut off from the nourishment of the past.

The Past: passed its sell-by date

The London contemporary art fair, Frieze, has only been running since 2003, a mere ten years, but has already acquired a leading reputation in the global art market—covering some 175 art galleries and over 1,000 artists—and it has recently, in 2012, expanded again to include Frieze New York and, interestingly, Frieze Masters. Because Frieze only sells contemporary art made after 2000, Frieze Masters has been established to sell everything else: from the ice-age to 1999. In other words the art market is now divided into two camps: the Contemporary in the van and the Pre-Contemporary or Masters bringing up the rear. Or what we could call the art of Today and that of Yester-day. Dealers in the work of Yesterday need to be at Frieze to get something of the Frieze 'effect', hoping that the high prices commanded by contemporary art might rub off on them by association. One dealer in megalithic axeheads said it was an opportunity to find new audiences, another that if they could not persuade contemporary art collectors to buy Yesterday's art then there would be no tomorrow for old master dealers: such is the preference in the market to buy the art of Today: so new the poster paint is still wet, the neon still bright.

Although the desire of old master dealers to get some of the action is understandable, what Frieze Masters amounts to is an admission that the value of art produced before 2000 is second-ary to, and dependent on, the value of art produced since the millennium. While appearing cheap by comparison may boost sales of Pre-Contemporary art in the short-term, the long-term effect can only be to further devalue and demean the value of art that admits it is parasitical on the contemporary art market. Frieze Masters logically ends up treating the past as a bargain basement. More disturbingly, as soon as the old starts to gain value by reference to the new, then even this simple opposition breaks down: partly because the arbitrary nature of the division is so transparent, mainly because the juxtaposition of the two

pulls the old into the orbit of the new and vice versa. As one contemporary art collector put it: 'To see megalithic axeheads alongside Kurt Schwitters collages just made my day. Newness is old, and oldness is being reconsidered.'[29] When everything has to be new, then the new gets tired pretty quickly and even the old can become new again: lift itself up for another reunion tour as it were, strut its stuff with the sexagenarian Stones at Glastonbury. Making the old disco dance with the young is precisely the exercise in humiliating bad taste that Victoria Siddall, director of Frieze Masters, intended:

> The idea is to create a space in which ancient and modern can be seen side-by-side. We don't want visitors to be distracted by thinking about when something was made. When you juxtapose different things from lots of different periods it makes for a rich way of looking.[30]

A 'rich way of looking' is an interesting turn of phrase. Siddall might mean that it is the way the rich look: that rich buyers undistracted by any knowledge of what it is they are looking at might find their wallets easier to find. Or she might mean that it is a full and varied perspective without the irritating restrictions and limits that the exercise of judgement and discrimination brings to one's perspective. Certainly the end result has all the order and sense of a car-boot sale.

The Performative Moment

On one level it is true that the new does indeed get tired very quickly. Artists have been sensitive for many years to the continuing expansion of the present—the here and now—and have responded to that in a variety of ways. One is to represent the feeling of impermanence through the use of perishable and non-

29 Charlotte Higgins, 'Shock of the old: Frieze Masters art fair puts contemporary sibling in the shade', *Guardian*, 10 October 2012.
30 Quoted in 'Back to the future', Rachel Campbell-Johnston, *RA Magazine*, Autumn 2012.

traditional materials such as flowers (Jeff Koons' *Puppy* topiary sculpture), acrylic paints (Warhol and Rothko) or rotting sharks (Damien Hirst's *The Physical Impossibility of Death in the Mind of Someone Living*), not to mention candles, light bulbs, video tape and computer disks.[31] This is the representation of the here and now through the medium of the here today, gone tomorrow.

Arguably though the zeitgeist art is performance, experiential and 'live' art. American art historian Peggy Phelan famously described performance art as 'the art of the present tense'. In a recent article, Catherine Wood, Tate Modern's curator of contemporary art and performance, argues that performance art has been relatively quiet since the '60s (notable for 'Carolee Schneeman's *Meat Joy*—a performance in New York in 1964 in which naked dancers rolled, improvising movement and interaction amongst a pile of chicken carcasses') and '70s, but argues for a performative 'turn in art-making that has occurred in the past decade'.[32] Part of the appeal lies in the idea that performance art is somehow resistant to what is imagined as the desire of collectors, patrons and curators to possess and own, to catalogue and display:

> [T]he very nature of the work—its ephemerality, its sound and movement and number of participants—fundamentally goes against the grain of the museum's set-up.

And, of course, live actions like mass feminist quilting (Suzanne Lacy's *The Crystal Quilt*, 1985-7), or dance pieces involving passers-by, or mixing video with theatre ('without being constrained by the conventions that a director might face') all serve as ways of breaking down the barriers between different art forms and between art and reality, artist and audience. Perform-

[31] M.P. McQueen, 'Perishable art: investing in works that may not last', *WSJ Europe*, 16 May 2007.
[32] Catherine Wood, 'Art in the present tense', *Art Quarterly*, Autumn 2012, pp. 45-6.

ance art in this way is *the* art form of total culture.[33] Wood spells this out, albeit approvingly:

> Performance is not a strict format with designated elements (seating, a stage, darkness, silence and so on). Rather it is sometimes thought of by artists as an attitude, or simply a crystallisation of people's attention, often with heightened critical awareness, towards something happening.[34]

If performance is just 'attitude' or 'awareness' then, with all its lack of form, and content, it is surely every bit the essence of the non-judgemental or total approach to art. A messy *something* that has no barriers to getting involved. Performance too puts the artist centre stage, as the performer, not in his own right, but effectively as someone else.[35] The artist can disclaim responsibility for a performance in a way not open to an artist who signs his name on a finished work.[36] It also partakes of the character of myth to an important extent ('were you there on that magic night when?'). It often actually takes the form of a rite or practice led by a shaman figure who tries to lead us into an imaginary world rooted in memory and fantasy.

Dancing in Peckham (1994) by the British conceptual artist and Royal Academician, Gillian Wearing, is a well-known example: a video piece showing the artist dancing in Aylesham Shopping Centre to an imagined and unheard soundtrack; quite oblivious to and in apparent narcissistic disregard for the

[33] Compare director of Tate Modern, Chris Dercon: 'I think we want to have an experience of the art of "with"… to be with something. That kind of new form of interconnectivity is what performance is providing. We are a little bit fed up with people and organisations doing things at us', as quoted in 'Tate Modern's "The Tanks" to showcase "non-marketable" live art', Nick Clark, *Independent*, 16 July 2012.

[34] Catherine Wood, 'Art in the present tense', *Art Quarterly*, Autumn 2012, p. 45.

[35] Examples are Cindy Sherman's work and Gillian Wearing, *Self Portrait of Me Now In Mask*.

[36] To the extent that modern artists even *are* individuals: consider Gilbert & George, Bob and Roberta Smith, the Chapman brothers. Or are known individuals: Banksy.

shoppers around her. *Dancing in Peckham* has now (2012) been taken to ten South London estates by the South London Gallery's 'SLG Local' project. SLG Local takes work 'off-site', out of collections, into a 'whole range of different social contexts' as part of a 'rich mix' of 'socially engaged practices'.[37] It is also used by the South London Gallery to help school children 'explore issues such as peer pressure and self-confidence', as part of the 'Start programme funded by the Prince's Foundation for Children & the Arts, ensuring access to the arts for children who currently receive little or no arts provision' and are, presumably, much in need of exposure to a 25-minute video of a woman dancing on her own, soundlessly, in a shopping centre.[38] Wearing's performance thus exemplifies the instrumental approach to art, the imagined need of the public for art, and also demonstrates the magical thinking behind the idea that a strange ritualistic dance can work wonders of personal and social regeneration on those who witness it.

Other areas of culture, too, are increasingly taking on the character of performance: immersive theatre, improv music, art 'happenings', the pop-up phenomenon. Oreet Ashery's *Party for Freedom* (2013), for example, is described as being somewhere

> between a travelling cinema and theatre troupe, a kiss-a-gram and a takeaway delivery service... an itinerant work that combines live performance with moving-image and an original album soundtrack.

It sets itself to combat the Dutch far-right politician Geert Wilders with 'performances of liberation and political nakedness.'[39]

[37] South London Gallery Director Margot Heller and Head of Education Frances Williams answer the question 'What is SLG Local?' http://www.recreativeuk.com/resource/slg-local

[38] 'Dancing in Peckham', http://www.southlondongallery.org/page/3051/Dancing-in-Peckham/529

[39] 'Oreet Ashery: Party for Freedom', http://www.artangel.org.uk//projects/2013/party_for_freedom/about_the_project/about_the_project

There is immersive opera: like the performance of *The Duchess of Malfi* by the English National Opera and Punchdrunk, in an abandoned building in the East End London docks.

> Four hundred people at a time watched the show, let loose across three floors to guide themselves through the action. Immersion means you choose your own route and construct your experience as you go. Elements are wilfully scrambled up for you to curate.

The director wanted 'to give an audience the freedom to construct their experience of the music for themselves'.[40] Is this liberating the audience or not having anything to say? Sadler's Wells and The Old Vic have both mounted site-specific hits: *Electric Hotel, Tunnel 228* and *You Me Bum Bum Train* which was 2012's fastest-selling show for the Barbican: pushed around in a wheelchair, *you* become the star of various unscripted situations.

The logic of here today, gone tomorrow is obviously hostile to the desire for permanence, even immortality, that drove the creation of culture in the West and created a tradition which was built up, developed and cared for over the last two thousand years. As the late American pianist and music critic Charles Rosen has argued, the art music tradition was based on the 'opposition of composition and realization': precisely what disappears in improvisation and in electronic music.[41] In the frozen moment of the live performance, the spontaneous happening, there is no cause and effect, no individual interpretation of score, nor text to judge, no chance for reasoned understanding or appreciation of art, and—in a funny way—no freedom. Despite the desire to liberate the audience, the effect of abandoning tradition—linear narrative, curatorial responsibility, artistic excellence in all its forms—is to not give the

[40] Emma Pomfret, 'The brave new world of immersive opera', *The Times*, 6 August 2010.
[41] Rosen (2012), p. 36.

audience anything much at all. It is left for them to make the art and, since they are not, after all, artists, they might have a bit of fun—wandering in the dark of old warehouses—but sooner or later will tire of the game and find something else to do. If we go along with treating the arts as having magic powers and justify them on that basis, what happens should the children grow up and stop believing in fairies? Do the arts shrivel and die before our eyes? Or will we have already become indifferent to them?

Impermanent Revolution

Along with the cult of the contemporary comes an attack on the notion of chronology as such. In her editorial to the Frieze Masters *Magazine* 2012, Jennifer Higgie argued it is

> easy to forget that all art was once contemporary; to walk through a gallery of paintings from the last few hundred years is, in a sense, to witness a continual present.[42]

Arguably, in another sense, this is not true because much art was always traditional and was produced more to the demands and within the limitations of that tradition than it was to an ephemeral need to 'respond to the here and now'. Higgie, although nodding dismissively at the 'long relationship to patronage or religion' (tradition, in other words) chooses instead to emphasise the importance of 'ever-changing variables'—of cultural, social and personal context—on artistic production. In a non-linear world where nothing is predictable and everything is always changing, then there is, of course, no tradition, and, in a sense, everything is always, and already, contemporary. Attempts to produce and explain art then have to fall back on 'memory, intuition, empathy and instinct'.[43] Which is to abandon reasoned judgement, conversation and a shared tradition—history—for the sharing of feelings. It is

[42] Jennifier Higgie, Frieze Masters *Magazine*, 2012, p. 11.
[43] Jennifier Higgie, Frieze Masters *Magazine*, 2012, p. 11.

effectively to replace tradition with the much shorter-lived, unreliable, selective and subjective faculty of memory. If that is indeed the basis for understanding art then she is right: walking through a gallery of paintings will be, for most people, just a matter of what is felt 'here and now'. Every time you stand in front of a painting is effectively the first time, given how every aspect of the 'cultural and social contexts' is ever-changing; not to mention the vagaries and fluctuations of your own subjective response. It also becomes hard to understand why any particular work of art might not do just as well as any other if it is really only your mood that matters. It is aesthetic groundhog day.

It is not unusual now to hear the phrase 'linear time' used in the tone of voice that marks something out as just *so* old-fashioned. In another article in Frieze Masters *Magazine*, this time in praise of anachronism, allegorical medieval philosophy, the indiscriminate collecting of André Breton 'in its overt disregard for the conventions of cultural and historical context', Nietzsche's 'unhistorical' thinking and Jorge Luis Borges' hostility to the 'illusions of individuality', Amelia Groom praises the fusty discipline of art history for finally appearing to be 'tentatively adjusting to new thinking on non-linear time'.[44] There is nothing wrong with non-linear narratives in the arts: after all, they strive to surpass the limits of the here and now. They have been around for a good while in film (*Citizen Kane, Memento, Walkabout, Pulp Fiction, The Constant Gardener, Trainspotting*) and forever in literature (from the *Iliad* to *Ulysses*), while arguably all 'graphic novels' (comic strips) are non-linear given the licence they give the eye to hop and pop around the page. But much *history* teaching in the UK over the last twenty to thirty years has also become largely non-linear: consisting instead of modules that offer snapshots of history bereft of any

[44] Amelia Groom, 'This is so contemporary!', Frieze Masters *Magazine*, 2012, p. 64.

narrative thread to tie the story together.[45] Breaking with an idea of time that only goes forward is the demand of Groom's article, a demand which justifies the

> inclusion of things in displays of contemporary art that are neither strictly 'contemporary' nor 'art'… [as] part of a growing awareness of the anachronism inherent in all time. After the failed productive-progressivism of modernity we're dealing with the fact that *then* and *now* and *later* aren't proceeding along a flat line; they're synchronized and woven through each other.[46]

Her real target is any idea of hierarchy, tradition or historical progress in which better things may come. All is equal in a non-linear world. In any case, the reaction against understanding culture in any chronological or traditional sense (a matter of *you* trying to grasp its meaning) supports the idea of displaying art in such a way as to maximise its impact *on* you. Higgie remarks how in 'recent years, more and more exhibitions have shown new work alongside the art of different eras'.[47] Disrupting, thereby, attempts to understand the development of art within the timeframe of a movement, or the lifespan of an artist and his contemporaries.

Leading this trend must be the Museum of Old and New Art (MONA) in Australia which holds the collection of Tasmanian gambling millionaire David Walsh in what he calls a 'subversive adult Disneyland' but in reality is more of a contemporary art underground hell; housing the likes of the *Cloaca Professional* already mentioned and Chris Ofili's notorious, and childishly profane, *The Holy Virgin Mary*.

[45] On this and the furious reaction provoked by the attempts of Michael Gove in the UK to reform the history curriculum, see Frank Furedi, 'The use and abuse of history', *spiked*, 25 February 2013.

[46] Amelia Groom, 'This is so contemporary!', Frieze Masters *Magazine*, 2012, p. 70.

[47] Jennifier Higgie, Frieze Masters *Magazine*, 2012, p. 11.

Satish Padiyar, lecturer in 19th-century art at the Courtauld Institute of Art, has written about how the cult of the contemporary is banishing older art to a new Dark Ages as reflected in the

ceiling-shattering Modern and contemporary sales in international auction houses… hand-in-hand with scholarly study of older art fast becoming a minority interest within the discipline of art history.[48]

He notes 'there is no longer a chair in the art of Classical Antiquity' at the Courtauld but that Modernism itself has already specialised, or rather fragmented, into Eastern European and Russian Modernisms. What lies behind this fashion for the contemporary?

The cult of contemporaneity rises out of the felt social experience of new lives that are predicated on change, instantaneity and novelty, while many of the fundamental older forms of social binding and human togetherness are no longer operative or well-functioning. If church attendance, family structure, social and political stability are eroded, or drastically experienced as 'other', then the older forms of art that picture these lost worlds and once rendered them enduring, daily lose their meaning.[49]

Padiyar is correct to identify the symptoms of the cult of the contemporary as arising from the breakdown of the traditional. The causes of that breakdown are due to that assault on and collapse of individual discrimination that this book attempts to delineate. They also involve the breakdown of borders in a globalised and increasingly homogeneous world: the European Union's flattening of national borders under an unaccountable bureaucracy being the best example of a widespread intellectual

48 Satish Padiyar, 'Out with the old, in with the newest', *The Art Newspaper*, Number 244, March 2013.
49 Satish Padiyar, 'Out with the old, in with the newest', *The Art Newspaper*, Number 244, March 2013.

identification of nationalism with war and racism. Yet, as Padiyar also observes,

> nationalisms have their cognates in the study of national schools, and so the very categories through which we study an older art, and our ways of demarcating it, begin to seem antiquated and to feel unreal.[50]

What is striking here is how fast meaning evaporates once tradition is eroded. And how far the thread unravels. This process is not something that limits itself to 'older forms of art' but extends to what are already 'Modernisms' and beyond. The speed of this process is remarkable. Sales figures for Christie's and Sotheby's New York rooms for November 2012 show that post-war and contemporary art sales netted them more than double that achieved at their Impressionist and Modern sales just a week before.[51] At a record breaking $526 million sale at Christie's in the spring of 2013, Lichtenstein's *Woman With Flowered Hat* went for $56 million while Jean-Michel Basquiat's *Dustheads* reached $49 million.[52] Insofar as we can use market values to take a snapshot of trends, then pre-war art already seems to suit contemporary tastes much less than does Rothko, Bacon or Warhol.

When chronology is still adhered to, it is often undercut by the tendency to show the very old and the very new together or through the wilful juxtaposition of different traditions. The new outpost of the Louvre at Lens, to take a recent example, has cherry-picked the existing 200-year-old collection in Paris,

[50] Satish Padiyar, 'Out with the old, in with the newest', *The Art Newspaper*, Number 244, March 2013.

[51] Christie's Impressionist and Modern Auction 7 November 2012 $204.8 million, 80 per cent sold by value; Sotheby's 8 November $163 million, 79 per cent sold by value; Christie's post-war and contemporary 14 November $412 million, 93 per cent sold by value; Sotheby's 13 November $375 million, 95 per cent sold by value; source, *The Art Newspaper*, Number 241, December 2012.

[52] Will Pavia, 'Christie's boasts biggest art auction in history', *The Times*, 16 May 2013.

taking a Raphael and a Botticelli here, a Mantegna and a Cranach there, to create La Galerie du Temps which aims to 'take the public, both new and informed, on a journey through the history of art from antiquity until 1848'.[53] Which, if one didn't mind the Louvre-Paris losing its heart and soul— Delacroix's *Liberty Leading the People*—to Lens (where it was promptly defaced by a lunatic with a marker pen), might sound laudable enough, until one realises this journey is *informed* with a mere 200 works arranged into fully 28 thematic sections. A bit like the British Museum's attempt to tell *A History of the World in 100 Objects*: punctuated by 20 thematic stops over what claims to be two million years of human history. Hi-speed 'journeys' like these move so fast that history and tradition become a blur at best. All that can be seen through the window of this train are a few assumed constants of human nature: we eat, shit, fuck and die. What this approach to the long artistic tradition, especially that of the West, amounts to is, in essence, a denial of culture in the name of an eternal nature. Xavier Dectot, director of the Louvre-Lens, is pleased to report he

> can overcome the constraints of the Louvre in Paris where the collection displays don't allow works of the same period, made by different civilisations and with diverse techniques to enter into a dialogue with each other.[54]

It may be that not allowing the mutually incomprehensible into 'dialogue' with each other is a 'constraint'. Though what Raphael's *Portrait of Baldassare Castiglione* has to 'dialogue with' 10th-century Iranian pottery I am not sure: although I *am* sure I will be told the failure is completely down to my lack of imagination. But is it not, as Julian Spalding has argued,

53 Vicent Pomarède, chief curator of paintings, quoted in *The Art News-paper*, Number 241, December 2012.
54 Quoted in 'The Louvre conquers the north', *Art Quarterly*, Winter 2012.

the job of a museum to provide its visitors with opportunities to develop their critical judgement by comparing the achievements of artists with their contemporaries and predecessors?[55]

Louvre-Lens would seem to be designed to disrupt rather than develop critical judgement, in the same way it seems set to disrupt (and damage in transport) the meaning, stability and safety of the Louvre-Paris collection. Lens will refresh 20 per cent of its display every year at the expense of visitors to both museums: no reliance on, or even getting to know old favourites, here.

The level of contempt and disdain to the labour involved in creating the institution and the collection of the Louvre-Paris — declared overnight to have been somehow lacking — is noteworthy. Not to mention the assumption that everyone who has only been to the *old* Louvre, the stone and marble aristocratic-palace Louvre, has not been keeping up, is not à la mode, is behind the times with the new. That's the thing about the continual present: you just have to be there.

Another 'curatorial revolution' has been underway a little farther north, as Amsterdam's Rijksmusuem has finally emerged from a ten-year makeover that took longer than Pierre Cuyper's original construction. The intent there — or at least the effect — of Taco Dibbits, director of collections, and general-director Wim Pijbes, has again been to disrupt and scatter the existing chronological fine and decorative art collections. Placing pictures, like Cornelis van Haarlem's *Massacre of the Innocents*, in a new context of period furniture and weaponry: what historian Simon Schama termed 'an active dialogue between pictures and artefacts, the material world and the cultural imagination'.[56]

[55] Spalding (2003), p. 93.
[56] Simon Schama, 'Simon Schama: the Rijksmuseum reopens', *Financial Times*, 29 March 2013.

Schama's review of the re-opening credited this 'unending inebriation of stuff' and the people who 'haunt this place' with magic powers:

> [Y]ou look at the hats, you hear the sailor's shouts, the creak of ice-trapped timber, you smell the blubber vats and you commune with your ancestry. Which may not be Fine Art but which is all the more enthrallingly potent for it.[57]

It may not be Fine Art indeed and it is perilously close to historical re-enactment or Disney Land for that matter. And it is, despite its very best of intentions, actually expressive of a contemptuous attitude towards the imaginative capacities of museum-goers. Do we really need to see an actual sword next to a painting of a Dutch gentleman wearing one so as to somehow 'get it'? What about the sword? Is it reciprocally illuminated by the picture or has it just become a stage-prop? Will any sword do or does it have to be a fine sword? Is there a danger in this 'associative curation' of contempt for both audience and objects? What, after all, does the sword-connoisseur do now that one of the swords from the collection is missing and can't be compared with the others?

The real aim of this new approach to curation is the breaking down—how many times must they be broken down?—of what Schama calls those 'invidious distinctions between "high" and "low" adopted in Renaissance Italy'. Schama turns from the art of 'the church and the aristocracy' to that 'of the people': embracing—not devotional transcendence—but 'the earthy entirety of human existence'; we are back in the land of 'the real'. I have no objection at all to Dutch genre painting. This should not be about preferring Vermeer, ter Borch and Pieter de Hooch to Michelangelo, Raphael and Titian. That is not the point. Or, if it is, it is a silly one. My objection is rather to the idea that Rembrandt needs to be rescued from 'some rarefied

57 Simon Schama, 'Simon Schama: the Rijksmuseum reopens', *Financial Times*, 29 March 2013.

realm of the canon' and restored to the context of 'an art that mirrored the life of the ordinary people of the Netherlands'. Schama can't have it both ways: either the art takes the every-day as its subject and raises it up — to somewhere we might call 'rarefied' — or it just mirrors life and, in that case, we should be honest: most ordinary life is no picture postcard. Nor is there any inherent virtue in the existence of a servant girl as opposed to that of an aristocrat, and to imagine there is puts a distinctly aristocratic premium on the circumstances of one's birth. It is to flirt, too, with an idea that an 'ordinary life' is good *because* it is ordinary, and that any form of elevated life must be bad. There is, in short, something completely different between an artist making the ordinary extraordinary (say the depiction of the 'seemingly everyday' in Pieter de Hooch's *Die Mutter* in Berlin's Gemäldegalerie, in which the mother's child stands transfixed in the golden light spilling from the kitchen door: pausing on the threshold between one world and another) and praising the ordinary as such. It would certainly be a shame should the idea take hold that all the art of the High Renaissance in Italy is somehow just churchy and posh, rigidly hierarchical, a slavish art dictated by authoritarian princes, rather than the highpoint of a humanist worldview without which the Dutch Golden Age might never have existed.

Freedom: the motor of history

Art critic David Hopkins may be right, at the end of his *After Modern Art*, to identify the work of Louise Bourgeois and Matthew Barney as a fair guide to what may be the art of tomorrow: the former looking backwards and 'asserting the irreducible, ongoing primacy of human memory and the uncon-scious'; the latter looking 'forward ambivalently, conjuring up futuristic technological fantasies' of human-animal hybridity and the transcendence of human givens in 'bio-mechanical syn-theses'.[58] I hope not.

[58] Hopkins (2000), p. 245.

Yet it is certainly a fair bet that tomorrow's art will be an art hostile to what it derides as the constrictive illusions of history, tradition, individuality, reason, space, time, human perspective and freedom itself. Unless, unless, we can restart the motor of history. Which, as Hegel reminds us in his short *Introduction to the Philosophy of History*, is freedom itself: history begins when we have freedom and it ends, or rather never does end, but finds its end, and its beginning, in freedom.

Once upon a time Karl Marx said the 'tradition of all the generations of the dead weighs like a nightmare on the brain of the living'.[59] Today it appears that we have freed ourselves from this 'burden' and float above it all, unconcerned and indifferent. At other times we feel uncomfortable, unsettled, all at sea and at the mercy of the elements. And, when we are uncomfortable and unsettled, it is always good advice to reassure oneself of where one has come from. So, if we want to move forward again with confidence, our first task is an historical one. The movement of history depends on our initiation of our own freedom.

...

The earth performs a double revolution. Around its axis (every day) and around the sun (every year). We perceive this as the sun going round the earth and as the sun moving closer and farther away. Sometimes what appears to be so natural is anything but.

At this moment in history we are standing still so we imagine that everything is changing. If we were to start to move, to act on the world, then we would see the world slow down. It's the difference between piloting a plane and standing beneath a low-flying one.

[59] Marx (1978), p. 9.

...

In terms of the arts the rejection of tradition has effectively naturalised culture: denuding it of meaning and making it into an object of use. What we need to do is remind ourselves that culture is far from being natural but is historical. Great works of art do retain beauty for us despite being from very different periods of history. But they do that precisely because they are *historical*, which is to say, they speak to us of our freedom to make history.

So one way to approach our historical task is analogous to what we do when we decide to take that risky step and declare in public where we stand with relation to a work of art. When we risk ridicule by saying something is beautiful. That is a rite of passage and has a transformative effect on the relationship between you and me and on me. It speaks to my spirit, not just my material nature.

Culture:
it's just not natural

Culture is all that has been created, built, assimilated and achieved by man throughout the course of his entire history, in contrast with what has been given by nature, including the natural history of man himself as an animal species. — Leon Trotsky, *Culture and Socialism.*

Opera, next to Gothic architecture, is one of the strangest inventions of western man. It could not have been foreseen by any logical process. — Kenneth Clark, *Civilisation.*

Human nature is deeper and broader than the artificial contrivance of any existing culture. — Edward O. Wilson, *The Creation: an appeal to save life on Earth.*

When Homer invokes his Muse in the opening line of the *Iliad* — 'Sing, goddess, the wrath of Peleus' son Achilles' — he attributed the poem to a supernatural source. Nearly two-and-a-half thousand years later Vasari opened his biography of Michelangelo with a contrast between the 'fervid but fruitless studies' of those artists equipped only with what the accident of birth and natural talent had given them — 'the benevolence of the stars and the proportionate mixture of their humours' — and the spirit that the 'most benevolent Ruler of Heaven' sent in his mercy

> to demonstrate in every art and every profession the meaning of perfection… so that the world would admire and prefer him for the wholly singular example of his life, his work, the holiness of

his habits, and all his human undertakings, and so that we would call him something divine rather than mortal.[1]

Michelangelo, at the high point of the Renaissance, was instrumental in creating an idea of *human* genius, one full of invention and the unexpected, restless in its pursuit of originality by any means: one that through its very success demonstrated the tension between man's mortality and the potential immortality of the art and culture he leaves behind him. No finer testament to this, maybe, than *The Creation of Adam* on the Sistine Chapel ceiling where, it is worth remembering, Michelangelo created both Adam *and* God for the world to admire. For a long time high culture was seen as expressing something uniquely human —even more than human—something setting man apart from animals and nature: expressive of how our subjectivity can transcend our objectivity. The increasingly influential idea, therefore, that culture might be something *natural*, something in our genes, is a relatively new departure and one that has accelerated over the last two decades.

Today science hopes to be able to make increasingly large elements of human life and experience explicable. Neuroscience, and its many branches, is often claimed to be on the way—armed with MRI brain imaging equipment—to reducing man to what is happening in his neurons: making him nothing more than a biological organism. A recent book by neurocriminologist Adrian Raine, *The Anatomy of Violence: the biological roots of crime*, to take one example, claims: 'revolutionary advances in brain imaging are opening a new window into the biological basis of crime.'[2] His argument that a low resting heart rate is a predictor of antisocial behaviour leads him to entertain the possibility of a 'future of screening programmes in which those

[1] Vasari (1991), p. 414.

[2] Raine (2013), p. 8. Raine's book is the result of experiencing the instinct of self-preservation against an intruder. While no doubt we have a strong survival instinct it cannot explain a conscious decision to break the law.

at high risk of committing violent crime are pre-emptively detained and treated'.[3] The danger of such 'biologism' as philosopher Raymond Tallis calls it, is of course that it pushes the question of consciousness to one side (let alone the recurring question of self-consciousness), along with notions of free will and personal responsibility, and, taken to extreme, would wire our brain activity and the actions it triggers into an 'endless causal net, extending from the Big Bang to the Big Crunch... Our destiny, like that of pebbles and waterfalls, is to be pre-destined'.[4] Or, as the English mathematician and philosopher Alfred North Whitehead put it, either 'the bodily molecules blindly run, or they do not. If they do blindly run, the mental states are irrelevant in discussing the bodily actions'.[5] Despite this danger of determinism (whether environmental or infant or cultural), the claims of neuroscience, evolutionary biology and psychology, and various forms of neo-Darwinism, often come dressed as arguments to *liberate* us from the grip of religious delusion and stupidity: they speak the language of science and reason. *The God Delusion* by Richard Dawkins — patron saint of such thinking — is a good example of the genre: religion was a product of unconscious evolution until, presumably, some genetic enhancement allowed some of us to tell the rest just how stupid we had all been being. It is a good example too of how neuroscience is often misused in the support of contemporary misanthropy: the feeling that man, that greedy, destructive, violent, polluting creature, is indeed more beast than human, deserving of standing on no pedestal: meat, not mind; synapse, not soul. Biological reductionism, after all, is an attempt to *reduce* man: to make less, not more, of him. In the context,

[3] Julian Baggini, 'Criminal minds', *Financial Times*, 17 May 2013.

[4] Tallis (2011), p. 51.

[5] Whitehead (1925), p. 79. His own response was 'the theory of *organic mechanism*. In this theory, the molecules may blindly run in accordance with the general laws, but the molecules differ in their intrinsic characters according to the general organic plans of the situations in which they find themselves'. *Op. cit.*, p. 80.

therefore, of this new phrenology, it should be no surprise that art—traditionally seen as one of the highest expressions of human spirit—should be having its bumps felt by neuro-aestheticians and by theories that explain art and culture in terms of natural adaptation and sexual selection. No surprise either that contemporary art also reflects the *zeitgeist*: consider Marc Quinn's frozen sculpture portrait head, *Self 2*, made from nine pints of his own blood, which nearly melted recently when the cooling unit within the display case failed.[6] This is art so focussed on man's mortality that it is not made to outlast him, let alone last.

Against this biological turn which threatens to *identify* man with his biology, even searching for a 'moral molecule',[7] to simplify him through equating mind with brain, emotion with chemical reaction, reducing him to a social insect, it is necessary to restate the case for man's *exceptional* nature. Of course we are natural beings—blood, brain and sinew. And we are mortal. Yet these facts, our natural situation, do not *determine* the course of our lives let alone give them any meaning. Rather we are natural *human* beings and it is the human that is the subject of culture and of freedom. To that extent, I want to argue, it helps us to understand culture as being unnatural.

My argument is a simple one: culture is not natural. That distinction—and the understanding that grew from it—was central to the development of Western civilisation from its very beginning. It was expressed in the distinction between *phusis* (nature) and *nomos* (convention), as well as *logos* (reason), so central to ancient Greek philosophy. For the Greeks what was natural existed in a cycle of death and rebirth. Culture and the arts escape that cycle which is why Achilles in the *Iliad* (9.410–416) can choose between a natural but inglorious death of old

6 'A bloody mess averted', *The Art Newspaper*, Number 242, January 2013, p. 39.

7 Cf. Zak, P.J. (2012) *The Moral Molecule: the new science of what makes us good or evil*, London: Random House.

age or death in battle with a glory that is never wilting (*aphthiton*). Flowers bloom and wilt and bloom again but Achilles' fame — and that of the *Iliad* — is evergreen, undying and eternal. Since Homer we have built up, as each generation gave way to the next, a tradition of our greatest artistic achievements that stands witness to our humanity. In this sense then, that it does not perish, culture is a break with nature. Another way of making this same point is the approach the art historian Ernst Gombrich takes in his well-known *The Story of Art*. An artist will work and rework his raw material until it looks 'right'. When he succeeds, 'we all feel that he has achieved something to which nothing could be added, something which is right — an example of perfection in our very imperfect world'.[8]

There is also a more powerful underlying sense, which will be developed further in these final chapters, in which culture is not natural and that is because all culture is rooted in, and expressive of, human freedom. We owe the story of the *Iliad*, after all, to Achilles' choice of death and glory: the choice to be a hero or a coward. That kind of choice, of what *sort* of person we want to be, a moral choice, is not one reducible to natural causes. If it was, it would be determined and, therefore, unfree. If it is unfree, then there is no choice and thus no story to tell: nor would any audience find it moving or even intelligible. But first we have to examine the arguments for a biological basis to culture.

Is Art an Instinct?

Part of the appeal of evolutionary psychology is that it attempts to account for the reality of man: explain him in terms of science, remove some of our worries about what we are and what we might be for. As such it appeals as much to conservatives looking to find a gene for the traditional family as it does to liberals who seek to use science to show that conservatives

8 Gombrich (1995), p. 33.

are naturally stupid.[9] Where society today is not confident in its own judgements, it reaches for science as a crutch. When it comes to art there is an appeal, too, in the idea that art might be a natural human universal because that would constitute a strong argument against the social elitism that often surrounds the high arts. So, the late philosopher Denis Dutton in his book *The Art Instinct* was not out to deny human freedom but rather to liberate art from both cultural elitism and from the abyss of postmodern cultural relativism through making a case for art as a human universal rooted in nature. As he asks, do we

> need to be reminded that Chopin is loved in Korea, that Spaniards collect Japanese prints, or that Cervantes is read in Chicago and Shakespeare enjoyed in China?[10]

Dutton's motivation is to combat undeserved expressions of national chauvinism in the arts (as in 'but they don't have our concept of art…') and to construct, based on his acceptance that there is an 'innate human nature', a 'naturalistic, cross-cultural definition of the concept of art' as an instinct, as something we *need*.[11] And as something great and important: there's more to it, in other words, than just what you *feel*. He aims to ground art in scientific objectivity as a way of combatting the anything-goes (as long as it is not traditional…) tendency in cultural theory of the second half of the twentieth century. The fundamental plank in his essentialist argument is his belief that our

> modern intellectual constitution was *probably* achieved in this period [the Pleistocene] by about fifty thousand years ago, fully forty thousand years before the founding of the first cities and the invention of writing.

9 On the former, for example, see Murray (2012) and, for the latter, see Hodson, G. & Busserl, M.A., 'Bright minds and dark attitudes: lower cognitive ability predicts greater prejudice through right-wing ideology and low intergroup contact', *Psychological Science*, July 2011.

10 Dutton (2009), p. 11.

11 Dutton (2009), p. 4.

My emphasis. It is this long view that leads him to the claim that the 'unity of the arts emerges from the unity of mankind'.[12]

The exercise of judgement in the arts today is something of a minefield, and discriminating between art produced in the Western tradition and that produced in its Other (i.e. what used to be called primitive art or, more accurately, craft) is a particularly dangerous route to take. Dutton's intentions in combatting a certain kind of cultural imperialism (although it was always more about imperialism than it was about culture) are noble enough, and the idea that Beauty is not just for the Great and the Good, the Rich and the Western, is not only attractive but also contains a large degree of truth. We can all potentially enjoy culture and we can all enjoy it more if we take the trouble to learn more about it and, crucially, get better at judging it, become more discriminating about it. That is, if we have the time and leisure, the *freedom*, to do so. (One way, of course, of getting that sort of freedom is to become wealthier and more 'Western'…) Turning art into an instinct, however, even in the spirit of democracy, making it into our genetic birth right, is a false move. It is to remove it from the realm of freedom and rationality and make it into something we need, which is to say, something we *depend* on. When we are dependent on something we are not free: as a child, say, is dependent on its parents. Art becomes something that determines us rather than something that expresses our freedom. Something we receive rather than pursue. One way of seeing the problem is to ask yourself if you really believe that Shakespeare says the *same* thing to all Chinese, let alone to all of humanity. As Tallis argues, neuro-evolutionary aesthetics 'bypasses everything that art criticism is about. It doesn't even distinguish aesthetic from other forms of pleasure, or indeed many forms of visual experience'.[13]

The other price Dutton pays for pitting a democracy of nature against an aristocracy of culture is to be forced to con-

[12] Dutton (2009), p. 42, p. 248.
[13] Tallis (2011), p. 287.

sider a levelling down of what we mean by art to a lowest common denominator in two important and related ways. Firstly, in his desire to prove that we all 'do art' by nature, he has to define art to be just what we do:

> [Recasting] art and aesthetic experience as a broad category that encompasses the mass arts (popular forms such as Attic tragedy, Victorian novels, or tonight's television offerings), historical expressions of religious or political belief, the history of music and dance, and the immense variety of design traditions for furniture, practical implements, and architecture.[14]

He believes this fits our broad pre-theoretical understanding of what art is, although I suspect the man on the Clapham omnibus knows the difference between his practical implements — his knife and fork — and his Nureyev.

The second result of the art-instinct approach is the need to deny that artistic talent is anything particularly special: that, if it is a natural gift, it is a profoundly rare one. Michelangelo worked and worked at his art, yes, but, again, do we really believe (when we being are honest) that we are *all* potential Michelangelos even with any amount of work? Dutton could accept this and still argue that we can all *appreciate* art equally, even if we cannot produce it equally. But how then to account for those people — and they are by far the majority, now and throughout history — who do *not* need the arts to lead full and rich lives? Who are born, have families and die without learning to read and write: let alone see a Raphael? Are we comfortable in saying that they are lesser human beings as a result? Does anyone really think they would be better off if they were *compelled* to appreciate art? Equally — the flipside of this argument — it is by no means assured that those who have a better appreciation of the arts than most have happier lives as a result: too aware perhaps of *lacrimae rerum*; touched by our mortality as was Aeneas, gazing on the murals of the Trojan war.

[14] Dutton (2009), p. 66.

Is Culture Genetic?

E.O. Wilson, the American sociobiologist, environmentalist and arguably the world's leading authority on ants, describes human nature as:

> the hereditary rules of mental development... expressed in the molecular pathways that create cells and tissue, particularly those of the sensory and nervous systems... prescribed in the cells and tissues that generate mind and behaviour.[15]

In his explanation, art, love and war are all the products of the interaction of instinct—that is, human nature—and environment. In his book *Wired for Culture* the English zoologist and evolutionary biologist Mark Pagel reports a story about Picasso's reaction on seeing the 13,000-year-old cave paintings in Lascaux in France of deer, birds, horses, bison and other animals. Picasso said: 'We have invented nothing.'[16] Maybe he was just being charitable or maybe he was claiming some sort of validation for his own style of art, but whatever he meant by the remark it raises the central problem for theories like Wilson's and Pagel's: how do we account for change without naturalising it? Why is it that—unlike ant colonies—humans have history and human societies have taken many forms? And why, crucially, are individual human beings not wholly determined by the societies in which they live?

Pagel believes that hundreds of thousands of years ago 'culture became our species' biological strategy', we are instruments for its propagation, we are 'still being tamed by culture'. He sees man as determined in a double sense: by his nature *and* by his culture, which is involved in an ongoing process of sorting him by his talents. He attempts to answer the old nature–nurture debate by arguing that it is our *nature* that propels us into the very environments that will *nurture* us. Artists are pushed into art schools, in other words, by arty genes. Pagel

15 Wilson (2007), p. 64.
16 Pagel (2012), p. 111.

radically inverts the traditional view of culture as expressive of our humanity and sees it rather as something installed in us like a software operating system, something that 'imprints' us like ducklings.[17] Rather than culture being something we leave behind as testament to our existence and significance, culture is nothing more than the 'most successful way there has ever been of making more people'. The human species consists of 'cultural survival vehicles', ways of propagating cultural 'memes', or 'mind-genes', in a fashion analogous to the way in which the physical body propagates genes. What is sacrificed in this account is the individual in favour of the survival of the group, a *'hyper-* or *ultra-sociality'*.[18] The idea that we are self-determining autonomous individuals with our own personal identity is dismissed as a 'tenuous' fiction, our perceptions and memories nothing more than 'stories our brain concocts to prop up our egos'.[19] Pagel in fact concludes by advising us to get over free will and stop trying to 'rebel against the dictates of our genes'.[20] The greatest danger, as he sees it, to our shared future in a happy One State is the illusion of the self, and of individual self-interest in particular.

In such accounts, the individual and his freedom are seen as a danger to the group, to society, rather than, as used to be the case, as constitutive of society. Everything uniquely human is explained away in terms of survival and we become subject to an iron law of natural selection, objectified in the name of an evolutionary teleology which is slowly domesticating mankind. It is a remarkable irony that religion—anathema to so many contemporary scientists—never determined man to such a degree as would Pagel: arguing our genes are 'the truly eternal players that our minds will have had to answer to'.[21] It is maybe

[17] I draw here on arguments first published as 'A braindead approach to free will', *spiked review of books*, 27 December 2012.

[18] Pagel (2012), pp. 26, 73.

[19] Pagel (2012), p. 308.

[20] Pagel (2012), p. 369.

[21] Pagel (2012), p. 308.

a provocative question to consider if religion—especially Christianity—is such a target precisely because of its recognition —with its promise of human transcendence of our materiality— of our freedom. In any event, as one recent account by philosopher Jesse J. Prinz argues, humanity has been able to transcend nature through history. It is worth remembering that, precisely as we discover more of what our biology has in common with other species, the more 'the search for what makes us human leads directly to what makes us less constrained by nature than any other species'. And worth remembering too that supposed human universals like art are not actually that universal:

> Some cultures have music and dance, but not paintings and sculptures, for instance, and cultures that have paintings and sculptures may use them for radically different purposes… [Art] is only universal in recent millennia, and that suggests it is not a human instinct.[22]

Taking on the central argument of the neo-Darwinians, sexual selection, Prinz argues that while sex is of course natural, culture and custom make it more unnatural in the different ways we regard it than anything else:

> Biology can help explain why we are more likely to flirt with a person than a potato, but that's just where the story begins… The story of sex is the story of our species. Here as elsewhere, we are always moving beyond human nature.[23]

The Miracle of Culture

Toward the end of the *Art Instinct* a different Denis Dutton emerges as his position starts to acknowledge more of the complexity—and humanity—of art. He does explain art in terms of human universals and, in particular, the theory of evolution as

22 Prinz (2012), p. 366.
23 Prinz (2012), p. 363.

natural selection and adaptation.[24] But he admits that, if art is a way 'that human beings achieve pleasure by catering to cognitive preferences that were adaptive in the ancestral environment', then it 'should be as easy to explain as the pleasures of sex and food'.[25] Dutton, unlike Pinker, acknowledges that, no, it is not that easy. He knows he is dealing here with a *human* art instinct and that no similar instinct exists in the animal kingdom. Dutton, as observed earlier, was driven by a desire to combat cultural relativism and reached for the heavy guns of scientific objectivity to try and win the day. His intellectual honesty, however, could not blind him to the fact that the greatest art is overwhelmingly about *subjectivity*. He notes that the arts are often a very solitary activity — rather than anything to the evolutionary advantage of the species — and do not always 'create warm communities'. Arts are not the same as crafts: they do not have a functional end point in mind. He quotes Kant: 'beautiful objects possess "purposiveness without purpose".' And he continues — examining the individuality expressed in high-art traditions — with the surprising (for an evolutionary psychologist) statement that 'the work of art is another human mind incarnate'. The human universal he finds in the end is that authenticity — 'as a truth of *personal expression*' — is found in the highest art everywhere: in the 'spirituality of artistic masterpieces'.[26] Which is no doubt true, but does not constitute an *objective* basis for anything we might call an art instinct. The strongest argument Dutton can manage is, not that there is a natural explanation for the soul or spirit, after all we 'are no

[24] Cf. Pinker (2002), p. 405: art 'is a by-product of three other adaptations: the hunger for status, the aesthetic pleasure of experiencing adaptive objects and environments, and the ability to design artifacts to achieve desired ends… [A]rt is a pleasure technology, like drugs, erotica, or fine cuisine'.

[25] Dutton (2009), pp. 99–100.

[26] Dutton (2009), pp. 228–9, 240, 243.

longer nomadic hunters' — history has intervened — but that today we 'still have the souls of those ancient nomads'.[27]

Dutton's slip into the language of spirituality, communion, genius and transcendence, is a far cry from his talk of evolutionary adaptation and sexual selection. So too is his introduction of normative terms like 'high', 'low', 'greatness', 'masterpiece', and his dismissal of Broadway productions as mere kitsch: opera-lite. It is a welcome turn but not a natural one. Evolutionary psychology, even at its most rigorous, cannot account for the sense we mentioned earlier of a work of art getting it 'right'. That 'rightness' is an appeal to moral sensibility not to genetic 'fitness'. As one recent critic writes:

> [this] moral dimension is one of the distinctive characteristics of human art. The feelings it produces are reactions not merely to what we find desirable or undesirable but to *ideas* that make certain claims about what is right or wrong, good or evil, beautiful or grotesque.[28]

Now, this is not to say that art is to be viewed as a set of morally improving lessons. Rather it is to say that art makes moral 'claims' upon us, claims you are free to accept, be indifferent or insensible to, or to reject, as you like. What great art definitely does do, however, is express a view of what the world *could* be like. It is not a statement of what *is*. In that sense, great art represents the miraculous leap that is involved in the transition from beast to man. Like human consciousness, like freedom, it is something that, try as you might, you cannot explain in terms of its origin.

The Origin of Man

Michelangelo, to go back to where we started this chapter, was a very poor advert for the evolutionary advantages of art for the

27 Dutton (2009), p. 27.
28 M. Mattix, 'Portrait of the artist as a caveman', *The New Atlantis*, Number 38, Winter/Spring 2013, pp. 128–39.

species: cranky, working in solitude, never married. But there is no doubt as to his originality in sculpture, painting and architecture. What shines through his work from the *David*, to the *Last Judgement*, to the Laurentian Library in Florence, is the expression not of any natural instinct but of human freedom: of man's capacity to be an *originator*. Every human being, artist or not, is, in that sense, a point of departure rather than an evolutionary end point. Insofar as man is an origin, capable of creating something new, then he stands outside, or at least on the edge, of the natural, the determined, world. He is *unnatural* in the sense that freedom is his birthright: the arrival of each human into the world represents the appearance of something new, and something irreducibly unique. I follow here Arendt's argument in *The Human Condition*:

> [M]en, though they must die, are not born in order to die but in order to begin… action, seen from the viewpoint of the automatic processes which seem to determine the course of the world, looks like a miracle… The miracle that saves the world, the realm of human affairs, from its normal, 'natural' ruin is ultimately the fact of natality, in which the faculty of action is ontologically rooted. It is, in other words, the birth of new men and the new beginning, the action they are capable of by virtue of being born.[29]

Birth is the origin of an originator: the miraculous creation of a being with the ability to create new things. With the freedom to act in the world. What is special about great art is that it makes us aware of that capacity — reflects it back to us — in a way that few other of our activities in the course of a normal life are likely to. Which is why we treasure it so highly and seek to preserve it.

The special quality of human freedom, as the philosopher Luc Ferry explains it in the course of commenting on Sartre's lecture *Existentialism is a Humanism*, is that 'man is the anti-natural being par excellence, the only one capable of not being

[29] Arendt (1958), pp. 246–7.

fully determined by the natural conditions allotted him at birth'. There is no 'human nature' as such. We have bodies, yes, we die, yes, but

> unlike an animal, which is subject to the natural code of instinct particular to its species more than to its individuality, human beings have the possibility of emancipating themselves, even of revolting against their own nature.[30]

It is in this revolt against instinct that 'one gives proof of an authentic humanity and simultaneously accesses the realms of ethics and culture'. Ferry concludes: 'Nothing could be less natural than rules of law just as nothing could be less natural than the history of civilization: both are unknown among plants and animals.'[31]

It is worth reflecting for a moment on what the absence of law and history from nature means. Obviously this is true at an empirical level. The only rules of law we know of and the only history we are aware of are *human* rules of law and *human* history.[32] The source and explanation for human law and history is to be found in man himself. The real insight here, therefore, is that, when we look, man is *absent* from nature: he *is not* to be found in nature, there is no evidence for oneself. Instead, man is present in his self-consciousness: that is, where he presents himself to himself, as himself. So the source of law and history is to be found in our self-consciousness, in our exercise of reason and in our capacity for self-reflection. We are autonomous (literally 'self-lawing') and, as originators, we inquire (*historein* in Greek) into the origins of things. That activity, which we call history, finds, of course, in the end, that man is both the subject and the object of his own inquiry.

30 Ferry (1995), p. 115.
31 Ferry (1995), p. 115.
32 We do, of course, discuss the concept of 'natural law' but we mean by that laws discoverable by human *reason* — the cardinal virtues of justice, wisdom, courage and moderation for example — in opposition to particular institutions of *civil* law.

Looking at the miracle of 'antinatural' man in this way, we can apply the same argument about law and history to culture: as an expression of man's being in history and of his freedom. Art of course requires freedom and originality. We talk about creativity, originality, restlessness, the desire to shock. We dismiss as derivative — as kitsch or pastiche — art that fails to 'make it new'. Art though just as much relies on discipline, study and hard work if it is to be as serious and enduring as befits its subject. The relationship between tradition and originality in culture is worth considering here as analogous to that between necessity and freedom. Writing on this subject, Scruton argues the 'encounter with the individual is what makes art so supremely interesting... A work is original to the extent that it *originates* in its creator'. It shows us the perspective of another human being and reminds us too of our own originality. Yet originality 'is not an attempt to capture attention come what may, or to shock and disturb in order to shut out competition from the world'. Originality works as a surprise or inflexion within the context of a tradition:

> Without tradition, originality cannot exist: for it is only against a tradition that it becomes perceivable. Tradition and originality are two components of a single process, whereby the individual makes himself known through his membership of the historical group.[33]

Artists always stand in a tradition, not in order to be traditional but in order to be original.

Kant argued we are most free in our thinking. Obviously in the sense that no law — except that of reason (we are not free to be irrational) — can stop you thinking whatever you want. But more deeply — and this is what is germane to our discussion — in his location of freedom in our voluntary and conscious obedience to the 'law of freedom': a law of which we ourselves are the author. This is his famous categorical imperative: 'Act only

[33] Scruton (2000), p. 45.

according to that maxim whereby you can, at the same time, will that it should become a universal law.' For Kant the meaning of autonomy is that man is his own legislator. And it is in this sense that we should understand Sartre when he says 'man is freedom'.[34] Freedom is on the side of law rather than on the side of nature. We have a duty of freedom, we are bound to freedom or we are, again with Sartre, 'condemned' to be free.[35] And none of this is natural. In the sense that it is *human* but not vegetable, animal or mineral. When we exercise our reason consciously we are *overriding* our natural instincts. When we exercise a degree of free will to that very extent we are not being natural.[36] Although we are very much being *human*. Doing what comes naturally is clearly not a conscious choice. It is easy and thoughtless by definition. It is about going with the flow. Choosing what does *not* come naturally is making use of one's free will. It is difficult and requires mental effort and, insofar as it involves going against the grain, it is original (and originating).[37] Freedom is an unnatural choice, then. And it is a choice *of* the unnatural (the cooked, not the raw) *by* the unnatural: that being that is man. To act *naturally* (to take food to eat because you are hungry) is at best a hypothetical imperative, a utilitarian

[34] It is fair to say that is an atypical reading of Sartre—there are at least two Sartres and one of them thinks choice can be ungrounded, indeterminate —but he would approve of me choosing that Sartre which most closely represents his best self.

[35] And cf. Bergson (1911), p. 270: 'consciousness is essentially free; it is freedom itself; but it cannot pass through matter without settling on it… [It] will always therefore perceive freedom in the form of necessity.'

[36] Which is to say that reason and freedom are the same thing under different aspects: we use reason to overcome instinct which would otherwise determine us. In Hegel's terms: thinking is free but has a rational content, namely truth.

[37] Obviously not all free will has this character. We freely choose all manner of things on a daily basis without great soul-searching or danger. But we see freedom most clearly expressed in those situations where one freely chooses a course that runs counter to one's natural instincts, for survival say, or when one chooses something useless. The relevance to the case of culture is clear.

means–end calculation. The categorical imperative, however, is an unconditional requirement that is always necessary: both required and justified as an end in itself.

Hegel, although responding to Kant and disagreeing with him in many ways, not least that Kant paid insufficient attention to the reality of society and the state and their demands on the individual, shared much the same position when it came to freedom and autonomy. Hegel, firstly, would agree that culture is unnatural because he argues that the world in which we live is *our* world. Mind, reason or soul finds itself in the world through acting in the world. And mind is freedom: from that essential freedom springs our ability to think and to act. While Hegel thinks that art *finds* meaning out there, in the world, he lays the stress of his argument on how we *impose* meaning on the world, and here I agree with him. Through taking the raw material of the world (and the materials of art are raw indeed: coloured earth, wood and stone) and working it up into objects of beauty which we leave behind us, marked with our name, we demonstrate that it is *us* who are essential and the world inessential.[38] All art works upon the natural material to hand. What distinguishes art from labour, from the sphere of biological necessity, the production of consumer goods, is that it works up that raw material into something 'useless' and artificial: at least in an immediate means–end sense. Art works possess a 'potential immortality' because

> [not] only are they not consumed like consumer goods and not used up like use objects; they are deliberately removed from the processes of consumption and usage and isolated against the sphere of human life necessities.[39]

As Arendt goes on to argue, we need a certain *distance* from art: works made solely for their appearance and judged by the

[38] Drama is an edge case here because its material is free men—and, as such, not left behind—but, in the sense that it lasts, it is ink on paper.

[39] Arendt (1968), p. 206.

criterion of beauty, not functionality. This distance requires a certain freedom from the struggle to survive: a freedom that allows us what Kant called the 'disinterested joy' of aesthetic judgement. Or as Hegel puts it:

> [A]rt is nevertheless a withdrawal of man into himself, a descent into his own breast, whereby art strips away from itself all fixed restriction to a specific range of content and treatment, and makes *Humanus* its new holy of holies: i.e. the depths and heights of the human heart as such, mankind in its joys and sorrows, its strivings, deeds and fates. Herewith the artist acquires his subject-matter in himself and is the human spirit actually self-determining and considering, mediating, and expressing the infinity of its feelings and situations: nothing that can be living in the human breast is alien to that spirit any more.[40]

Culture is a mediation of our necessity, and the distance it creates from immediacy a measure of our freedom.

Freedom is autonomy: we are free if we obey ourselves and our own rules. When we make a work of art, or a poem or play, it is a realisation of that imaginative freedom that constitutes man. The work of art is more than a mere demonstration or exhibition of our freedom, however, since it gives meaning to what would otherwise be meaningless things. It is in our possession of the world that it is our world. And it is in this sense that we should understand the signature on a work of art: a stamping of human right to be in the world. As Hegel argued in the *Philosophy of Right*, the most emphatic mode of taking possession of something is to put my mark on it. A point he had earlier made in the *Phenomenology of Spirit*:

> It is therefore through culture that the individual acquires standing and actuality... individuality *moulds* itself by culture into what it intrinsically is, and only by so doing is it an intrinsic

40 Hegel (1975), p. 607.

being that has an actual existence; the measure of its culture is the measure of its actuality and power.[41]

Culture in this sense can be taken as an expression of our right to occupy this world. It is the mark of the history of human civilisation.

Art and History

When we discussed Dutton's theory of an art instinct earlier we noted that, in his account, 'modern' man emerged some forty-thousand years before the first city. A 2013 exhibition at the British Museum in London, *Ice Age Art: arrival of the modern mind*, sought to demonstrate the truth of this claim with pre-historic ivory carvings of bison, female forms and even a flute made from a vulture's wing bone. Curator Jill Cook argued there was no distinction between 'prehistoric' and more recent art: instead there is a 'deep history of art' affirming a funda-mental human unity.[42] If such a unity exists, it could only, I imagine, be plausibly located in the material stuff of man: in the brain rather than the spirit. The problem with such a thoroughly ahistorical approach, as sociologist Tiffany Jenkins argued on *spiked*, is that the very human activity of art becomes fully deter-mined by neural activity and there is no place for self-aware-ness: for 'changes in human society', let alone changes in art forms.[43] If art is art because it acts in a particular way on the brain, which is somehow pleasing to us, then why would it ever change? Why do we no longer listen to Ice-age flutes? Let alone harpsichords. And why, fundamentally, should we look at Ice-age flutes rather than any other flutes?

One fine carving in the exhibition, found in the south-west of Germany, stands 30cm high and has human legs but the head

[41] Hegel (1977), p. 298.
[42] Marek Kohn, 'Ice Age Art: arrival of the modern mind, British Museum, London', *Financial Times*, 6 February 2013.
[43] Tiffany Jenkins, 'Human creativity is not frozen in time', *spiked*, 26 February 2013.

of a lion. *Der Löwenmensch* was made some 40,000 years ago and should be direct evidence for Dutton's argument that an art instinct is to be found somewhere in our prefrontal cortex. To make the point, the exhibition included works by Matisse, Moore and Mondrian. Surely nothing has changed? But as art critic Jonathan Jones pointed out,

> avant-garde work of the 20th century echoes ice-age art — not to mention African masks and Oceanian statues — because artists like Picasso chose to emulate whatever freed their minds from western realism.

Attempts to say that art has not changed speak to a loss of perspective and reveal more about contemporary feelings of discomfort with the achievements of human history, and the Western tradition, than anything else: 'These ice-age humans may have been like us biologically, but they had ideas we can only guess at.'[44] The pieces on display, notably, shy away from representing the human form at all. Statues of women express only their child-bearing function (all hips and breasts: headless) but nothing that could be called a personality. Ice-age artists could draw bison and deer (food) with great realism. They were unable to draw themselves. They had no capacity for self-reflection.[45] It is in this sense that it is a mistake to find the emergence of the modern mind 40,000 years ago. These were savages with axes no matter how abstract their carvings may appear to us now. I mean it as no slight to call them savages: they simply lived *before* civilisation and before history. To think otherwise is to read history backwards.

Art emerges with human history and it is no accident that some of the greatest art we have coincides with some of our most historical moments: in ancient Greece, in Rome, the

44 Jonathan Jones, 'Ice Age Art at the British Museum: "Not even Leonardo surpassed this"', *Guardian*, 5 February 2013.

45 Consider William Blake: 'Nature has no outline; but Imagination has, Nature has no tune; but Imagination has!'

Renaissance and the Enlightenment. In 1435 Alberti wrote a treatise called *De Pictura* (*On Painting*). In it he developed a theory of 'historia': paintings of historical scenes with lots of human figures were the noblest form of art because, visualising history, they had the greatest potential to move us. The point is not to fixate on a particular art form but to realise that human history is the story of the exercise of man's freedom against the circumstances in which he finds himself. Culture is the trace we leave behind of what that meant. It requires a sense of being in history for us to be cultural: that we are neither the first nor the last. Vasari tells a story of how Pope Julius II, Michelangelo's patron, thought the Sistine Chapel wanting, saying, 'Let the chapel be embellished with colours and gold, for it looks too plain'. And Michelangelo would reply: 'Holy Father, in those days men did not wear gold, and those who are painted there never were rich, for they were holy men who despised wealth.'[46] The other moral to this story, of course, is that of the confident sense of his own worth and freedom that allowed Michelangelo to say no to a Pope.

Culture is unnatural in that it is made to last. It is a product that is meant to be durable through time. It aspires to the condition of immortality. And what could be less natural than immortality? Nature is the sphere of birth and death where our destinies are biological. Culture, on the contrary, although it often takes our transient nature as its subject matter, is a marker of our ability to leave a trace on the world. Now it could be objected that it is only a survival mechanism. We make buildings that last so our children don't have to make them anew and have a better chance of surviving. Maybe, but why do we make cathedrals? As Hegel lectured on architecture, a 'house is an entirely purposeful structure' but

46 Vasari (1991), p. 442.

> the freest purpose is that of religion, i.e. the construction of a temple to be an enclosure for a person who himself belongs to fine art and is set up by sculpture as a statue of the god.[47]

Why, at some times, do we make paintings that cannot be reduced to sex and power? If architecture is 'frozen music' then culture is frozen freedom: freedom distilled. Art, to let Hegel have the last word, deals with

> an unfolding of the truth which is not exhausted in natural history but revealed in world-history. Art itself is the most beautiful side of that history and it is the best compensation for hard work in the world and the bitter labour for knowledge.[48]

Coming of Age

Culture is no magic potion or restorative medicine that will cure a sick mind, nor an ailing economy or corrupt society, no matter how deep a draught you drink. The very idea of culture as having any regenerative effect is one taken from the sphere of nature. Rather than considering the benefits that culture might give to the human species, we should consider the question the other way around. That is to say, man creates and conserves culture for its sake: not for his own. If there is a sense — and that possibility is what I am going to touch on briefly — in which culture can benefit us, then it happens indirectly at best. No amount of standing in front of Raphael's *Madonna del Prato* or reading Wordsworth's *Prelude* is *necessarily* going to have any morally improving effect on one. Through, however, the study of art, responding seriously to the moral claims it makes upon us — as a gift of freedom insistent that we earn it — we can learn to exercise our own freedom. Not in the sense of being at liberty to do whatever we feel like, but rather in learning self-discipline. For some this is the only thing that has ever mattered. Cicero, in the *Tusculan Disputations*, puts it like this: *totum in eo est, ut tibi*

47 Hegel (1975), pp. 662–4.
48 Hegel (1975), pp. 1236–7.

imperes ('the whole thing comes down to this, that you rule yourself'). For German thinkers around the end of the 18th century and beginning of the 19th, this insight was taken up into the process of aesthetic self-formation — the moulding of a character — what in German is called *Bildung*. The poet Friedrich Schiller in his letters, *On the Aesthetic Education of Man*, can be taken as a representative of this approach. He echoes Kant:

> [I]ndifference towards reality and interest in appearance are a real enlargement of humanity and a decisive step towards culture... The reality of things is the work of things; the appearance of things is the work of Man.[49]

There is no moral or didactic art. Rather Beauty is our

> second creator. For although she only makes humanity possible for us, and for the rest leaves it to our own free will to what extent we wish to make it actual, she has this in common with our original creator Nature, who similarly conferred on us nothing beyond the capacity for humanity, but left its exercise to our own volition.[50]

Man is his own ground, which is to say that man is his own cause, is his own freedom. *Bildung* took that approach seriously and urged man to *self*-cultivate, to struggle through the angst involved in transforming one's brute nature into a harmonious individuality. It was a theory of education that in its insistence of becoming a mature individual mirrored Enlightenment thinking, like that of Kant, which said it was time to put the immaturity of man behind us and dare to know, dare to be cultured.

Coming of age — that fraught transition — also partakes of the character of a struggle, a *rebellion*. Accepting the responsibilities that come with the various stages of life such as adulthood, citizenship, parenthood and so on can often have the appear-

49 Schiller (1954), p. 125.
50 Schiller (1954), p. 102.

ance of being a submission to the way things are or must be. From a different, maybe more mature, perspective, on the other side of what Joseph Conrad called the 'shadow-line', this process can be equally usefully seen, without I hope too much exaggeration, as a rebellion against instinct, against what Hegel termed 'natural consciousness'. When one determines what one will be, one exercises one's freedom in a way that is not present in a childish refusal to grow up. John Locke expressed it better:

> Is it worth the name of *freedom* to be at liberty to play the fool, and draw shame and misery upon a man's self? If to break loose from the conduct of reason, and to want that restraint of examination and judgement, which keeps us from choosing or doing the worse, be *liberty*, true liberty, mad men and fools are the only free men: But yet, I think, nobody would choose to be mad for the sake of such *liberty*, but he that is mad already.[51]

Freedom being a question of a freedom to act against your instinct is fully exemplified in cases of genuine altruism: laying down your life, say, for someone you don't know. Interestingly altruism poses a major problem for evolutionary accounts of human behaviour. It is usually explained in terms of 'kin selection' (if you die for your children then copies of your genes survive) or through a process known as 'reciprocal altruism': or you scratch my back, I'll scratch yours. But the former cannot account for altruism to strangers and the latter presumes a society already advanced enough to keep a tally of favours exchanged. The other explanation, 'group selection' theory as favoured by E.O. Wilson in his recent book *The Social Conquest of Earth*, argues that 'groups of altruists beat groups of selfish individuals', but this theory is widely discredited. In a review of the book Jerry A. Coyne pointed out that there is no evidence for even 'one evolved behaviour in any species that is harmful to individuals and their genes but good for their social

51 Locke (1997), p. 244.

groups'.[52] But if we turn to man's freedom to rebel against the natural instinct for self-preservation, then we have an explanation for altruism that tells us why we value it so highly: why we revere Socrates' self-sacrifice, why it was the basis of Christianity, and why it is the subject of much great art. There can be no more dramatic representation of the extent to which man is freedom than when man exercises his freedom unto death.

The Nature of Art

Culture (and the human for that matter) is actually entirely *unnatural*. It is the product of humans living for the world they create. Its value is adjudged insofar as it may aspire to immortality: be durable and outlast the natural lifecycle (of man and beast).

The more leisure we are afforded by advances in civilisation, the more free time we have for the production and the enjoyment of the arts and, by the same token, so are we less subject to evolutionary pressures like survival. So explaining it in those terms, if there is anything still natural in man today, it is at best the remnants of attenuated 'instincts', which we are increasingly free to override. If there were any universals of human nature, which operated when we did cave painting, then millennia of civilisation, and the gifts of Prometheus, have weakened their grip. As Allan Bloom puts it: 'Culture is the unity of man's brutish nature and all the arts and sciences he acquired in his movement from the state of nature to civil society.'[53] As we have evolved we have moved from the simple to the complex, from the determined to indeterminacy, from instinct to intellect, from survival to freedom.[54] To the extent that art *was* an instinct it would be the case that our freedom consisted in resisting it.

[52] J.A. Coyne, 'Genes first', *Times Literary Supplement*, February 2013.

[53] Bloom (1987), p. 185.

[54] Cf. Nagel, T. (2012) *Mind and Cosmos: why the materialist neo-Darwinian conception of nature is almost certainly false.*

In this sense we can understand Hegel's argument that art does not imitate nature. Art tries to represent our own, unnatural, freedom. Mark Wallinger's *White Horse* which now stands outside the British Council offices on the Mall in London is not art because it, as the British Council website reported it, is a

> life-size representation of a thoroughbred racehorse created using state of the art technology in which a live horse has been scanned using a white light scanner in order to produce a faithfully accurate representation of the animal.

The only way we could consider it art is if we did not know how it had been constructed but imagined that Wallinger had sculpted it. As such it is a cheat. Nature, however, in a way, does imitate art. The landscape pictures of Claude had such an impact on 17th-century Englishmen that they created gardens to match his vision and started using the word 'picturesque' to describe nature they thought was good enough to be art.[55] Much of England's countryside in fact has been shaped by man —men like William Kent and Capability Brown—to look like art. It is the same process we apply to ourselves through *Bildung*: we try to make ourselves as beautiful and as good and as true as a *Bild*, a picture.

Relegating culture to scientific inquiry, even to 'cultural studies', we remove it from the sphere of human judgement. This trend works itself out in the absence of any deep commitment to Truth. Or Beauty. Or the Good. None of which are natural but represent what we can do in the world, what we should choose to commit ourselves to. When we commit ourselves to culture, we are not acting to subjugate nature, nor are we subject to it, but we tend to it, we ameliorate it, we care for and cultivate it.

[55] Cf. Scruton (2009), p. 76: 'Tourists in the eighteenth century would often travel with a "Claude Glass": a small tinted convex mirror, which helped them to appreciate the landscape by compressing it and composing it in a manner reminiscent of Claude.'

We aspire, as Goethe had it, not to make reality of our poetry but to make reality more poetic. To make the real a little more ideal. We aspire to *culture* being: in the sense of making beauty from nature. And doing that requires freedom in a way that science maybe does not.

And we aspire to *be* cultured. To be our better if not our best selves. We are not there yet. The reason why not is in part a question of our relationship to freedom and our perspective upon it.

The Subject of Freedom

In the beginning was the Word, and the Word was with God, and the Word was God. — *John* 1:1, *King James Bible.*

To write is thus both to disclose the world and to offer it as a task to the generosity of the reader. — Jean-Paul Sartre, *What is Literature.*

[Writing], by refusing to assign a 'secret', an ultimate meaning, to the text (and to the world as text), liberates what may be called an anti-theological activity, an activity that is truly revolutionary since to refuse to fix meaning is, in the end, to refuse God and his hypostases — reason, science, law. — Roland Barthes, 'The Death of the Author'.

Michelangelo, 'something divine' though he may well have been, was not God. As only the example of the unfinished tomb of Pope Julius II shows, he was not possessed of the absolute and unlimited freedom necessary to bring into being *whatever* he imagined. His freedom was relative to that of other men, his powers limited, and his perspective unique rather than total. We still hold his achievements in such high esteem because he was able — at the height of Renaissance humanism and liberty — to explore and expand the experience of artistic freedom as few before him or after. Great artists, writers, composers and poets, I would argue, flourish in freedom. Just as culture is something possible when we have leisure time enough to lift us from the daily grind, so too do artists wax and wane with liberty. It is as

if they need the license to be able to play God in order to most fully realise themselves as artists or authors. What novelist would not want that God's eye view, to be fully conscious of his intention, and fully capable of getting just that into just the right words? The writer, as Writer, aspires to the full plenitude of freedom that is God's. His failure—if we can call it that—to be God only makes his willingness to put the flawed beauty and partial truths of his work in our hands so much more demanding of our gratitude. At the other extreme, the automatic writing of the Surrealists as praised by Barthes, or the action painting of a de Kooning or a Pollock, its rejection of perspective, its 'thick, fuliginous flatness' so lauded by the American critic Clement Greenberg, are representative of a wider loss of faith in the idea or possibility of meaningful human authorship as such: through the wilful substitution of chance for intent and spontaneity for design.[1] Minimalist composer John Cage's *Music of Changes*— the first fully indeterminate musical work, composed using the I Ching—by deliberately undercutting authorial intent, undermines thereby the author's responsibility for his creation. Such works represent a demand not to have to make choices: an adolescent refusal of tradition and rules of harmony, narrative structure or grammar. A refusal, in the end, to make art.

The profound mistake of post-war bohemian radical theory —in its deep hostility to the bourgeois individual and so-called bourgeois freedoms—was to see a turn against authorship and authorial intent as liberatory and not, as Sartre argued, as an example of 'bad faith', of self-hatred, as a fearful revolt *against* our own freedom.[2] The artist's and the writer's aspiration to the perspective of God is not to be taken literally. The question of the reality of God has never been the issue in human life. He stands for that transcendent end to which our freedom

[1] On Greenberg and the spell of Flatness, see Wolfe (1975), p. 51.
[2] Sartre (1967), p. 308: Mathieu thinks of 'liberty—I sought it far away: it was so near that I can't touch it, it is, in fact myself. I am my own freedom'.

necessarily drives us, but to which we can never attain. To reject that, let alone reason, science and law, is to reject freedom itself in the sense of the freedom of the author to bring something new into being. The argument of deconstructionist, post-modern, literary theory — found in Barthes and his epigones — is that we can never faithfully determine what an author intended given the radically polysemous nature of any text: context, the particularity of the reader and 'the reading' all serving to cut us off from any shared understanding, and judgement, of a book. The author is not really responsible anymore (just consider the stress on 'play' in such theories): we might as well proclaim him dead. Instead, we can talk only of multiple, undetermined and always provisional readings. Barthes no doubt considered this as a liberation for readers (and, of course, we cannot blame him), but the idea that nothing really means anything actually ends up denying, or rendering futile, the freedom of the individual (as writer, as reader and in their relationship through the text) to make sense of the world. Readers and writers are now both rendered irresponsible: irrational and foolish. The terrible and tragic irony of this rejection of intent and of reason is that the freedom an individual artist requires to create is precisely what is dismissed. Against the backdrop of growing conformism in many Western societies — their willingness to trade individual liberty for collective security — 'bad faith' rejections of freedom and authorship can come to seem like the safest option. The grim outcome of the rejection of the individual may yet be the loss of freedom for large sections of society as a whole.[3]

The idea that artistic creation and appreciation both rest in the individual's free pursuit of beauty and truth, rather than being rooted in any natural instinct or innate ability, is one that involves consideration of questions of perspective, discrimina-

[3] See Arendt (1958), p. 45, on the victory of 'the social', the bureaucracy and especially the 'social sciences which, as "behavioral sciences," aim to reduce man as a whole, in all his activities, to the level of a conditioned and behaving animal'.

tion and aesthetic judgement. Artist, qua artists, are free sub-
jects: a subject of freedom. I mean, however, the title of this
chapter to also be taken to refer to the subject of freedom (man)
as being the *object* of culture: what it represents. Art is an
expression of the artist's freedom and it—the artwork, novel or
play—represents the freedom of its subject and its actors (man
or man's perspective on the world) and, in the third side of this
triangle of freedom, it is presented as a gift of freedom to you
the consumer of this vision. In a way, it is all about perspective,
which can equally be considered under three aspects: the artist's
point of view, the use of perspective in the arts as a technique,
and from the vantage point of the spectator.

How these three aspects work in respect of the freedom and
reason of the individual is the focus of this chapter: the artist as
originator or author of a gift of freedom, the human *in* art and
culture, and the judgement of the beholder. How individuals
relate to each other in terms of their aesthetic judgement is the
focus of the next, and final, chapter.

Man His Creator

As we have been discussing, the artist, as an originator, an
author, lacks the absolute freedom to make his dreams real. He
is not God. On the other hand, nor does man have a function.
As Sartre argued in his famous lecture *Existentialism & Human-
ism*, man is not a paperknife: he is not a tool created by an
artisan for a specific purpose. His existence is not modelled
against some essence of 'man' in the way that we might say that
this paperknife is a more or less good exemplar of Paperknife-
ness. Man is not, then, 'the realisation of a certain conception
which dwells in the divine understanding'. Man is that being
'whose existence comes before its essence, a being which exists
before it can be defined by any conception of it'.[4] Instead of
partaking of a universal human nature, man has a 'second
nature': that is his freedom, his self-consciousness. Man's start-

4 Sartre (1948), p. 29.

ing point is his own subjectivity: 'Man is nothing else but that which he makes of himself.'[5] As such man is responsible for himself and there are no excuses. If we start as nothing — as a not-thing, that is, a subject — then saying 'my genes or my god made me this way' explains nothing away. No amount of fashionable determinism can undercut a freedom and a responsibility grounded in our existence: our 'being there'.

Sartre is also at pains to stress — in a clear, if for him unusual, echo of Kant — that: 'when we say that man is responsible for himself, we do not mean that he is responsible only for his own individuality, but that he is responsible for all men.'[6] For, when man chooses (for) himself, he only chooses that which seems best for himself and suits his image of how he *ought* to be. The word 'ought' alerts us to the moral imperative of this choice: what is good for me must be good for you. If I judge Sartre's novel *The Age of Reason* to be 'good', then what argument can I stand up to say that it is not 'good' for you too? You may not agree, it may not be your sort of thing, but I certainly judge that you *should* like it.

When an artist paints a picture or an author writes a novel, they do not work to a predefined template of the Picture or the Book. Sartre takes as an example a canvas by Picasso:

> As everyone knows, there is no pre-defined picture for him to make; the artist applies himself to the composition of a picture, and the picture that ought to be made is precisely that which he will have made. As everyone knows, there are no aesthetic values *a priori*, but there are values which will appear in due course.

Just as Picasso's 'works are part and parcel of his entire life' so too with morality: 'in both we have to do with creation and invention.'[7] It is in this sense that we can talk about culture

5 Sartre (1948), p. 30.
6 Sartre (1948), p. 31.
7 Sartre (1948), pp. 62ff.

having a history or a tradition built up from the free choices of artists through the ages: some of whose choices and judgements and books and pictures were *better*, in due course, than others. And what 'better' means here can be nothing other than a matter of whether or not those artistic inventions were made in the name of freedom: that is to say, in good faith. Did the artist fully commit to his work, hold nothing back? Did he manage to be original over and against the constraints of tradition? Did he, in due course, succeed in realising his intention in a revelation of himself, his freedom, to us?

The other point that needs to be made about freedom from the perspective of the creator of culture is that of the freedom of the situation — and in particular the political situation — in which he may find himself. As George Orwell argued in his essay 'The Prevention of Literature', artists — writers in particular perhaps — need freedom in which to operate.[8] While scientists may find themselves useful to a totalitarian regime, writers are not writers without the possibility of free expression:

> Prose literature as we know it is the product of rationalism, of the Protestant centuries, of the autonomous individual. And the destruction of intellectual liberty cripples the journalist, the sociological writer, the historian, the novelist, the critic and the poet, in that order.[9]

Literary creation rests on the spontaneity of the individual because a 'bought mind is a spoiled mind'.[10] In other words, to the extent that the individual is not autonomous but determined by something other than himself, so too is the possibility of creating culture diminished and impaired. Today's total culture with its bipartisan enthusiasm for the collective rather than the

[8] This is certainly logically true: if no self-expression is allowed at all — only propaganda — then there is no writing. Of course, our unfreedom is never total, so there are always exceptions and maybe even exceptional writers under totalitarian regimes. The record, however, is not good.

[9] Orwell (1984), p. 337.

[10] Orwell (1984), p. 340.

individual—just consider how left and right unite in their support for the fashion of 'nudge' and 'behavioural insight' teams—should give us pause. Societies, on the other hand, that have historically afforded the individual the greatest liberty have been those in which culture has flourished. Those moments—as fate would have it—have largely been in the West: really because—through the miracle of the Persian defeat at Salamis—when freedom got started in ancient Greece, there was no turning back the clock; even if, at times, its hands might turn more slowly than at others. The democracy that was created in Athens was grounded in and realised the freedom of its citizens: 'it was the only political system that enabled the freeman to develop and realize his potential to the fullest.'[11] Freedom, as another German classicist has argued, became a motor of yet more freedom because free men and free city states were 'challenged to secure and expand their free way of life against all encroachments'.[12] The Greeks and the Athenians in particular—those most radical and tempestuous of innovators —show us

> the imprints of a culture formed for freedom's sake, of a grand experiment in living life, under difficult circumstances, without a single ruling force... If the nineteenth-century French philosopher Ernest Renan called this the 'Greek miracle', this means only that what happened was completely exceptional.[13]

Their situation created a desire to understand and to find the right measure of things: they found it in man and in, what is the same thing, freedom. Freedom is the measure of all things. Although artists

> gained great freedom with the alternatives that opened up in the political realm... everything remained connected to a human dimension, to an image of humanity that was essentially

11 Raaflaub (2004), p. 276.
12 Meier (2001), p. 286.
13 Meier (2001), p. 14.

an ideal to be distilled out of what seemed to be the basis of all phenomena.[14]

The Order of Appearance

Sometime around 500 BC, the ancient Greek vase painter Euthymiades painted a warrior on a red-figure vase. What was unusual, particularly when compared to black-figure pottery, was that this figure—Hector arming himself—was shown turned to face out rather than to the side: one foreshortened foot pointing forward (out of the picture plane); his shield resting in profile. This change in the depiction of the human figure to be rather more as it appears to us and less in the fashion of a puppet show was greatly assisted by the change in technique which allowed the artist to depict the figure with a brush rather than scratching with a stylus. What really drove the development of this technique, however, was the context of the birth of democracy in Athens: which put the individual at the centre of things, and gave him the power to judge and determine how things should be. When man started to become the measure of things, then what counted as beautiful started to involve a greater degree of idealism: in the sense that the beautiful was more a matter of things needing to appear 'right' to *us*, to a human perspective, and less something intrinsic to the object.[15] The traditional stories of Greek myth were not discarded but this recognition of the freedom of both artists and audiences licensed their questioning, reinterpretation and even alteration. This mood of confident experimentation was reflected in the name 'The Pioneers' for the group of vase painters that included Euthymiades: surely the first self-conscious artistic movement in history. In this context it is worth noting too—in distant anticipation of the Renaissance—that Euthymiades himself

[14] Meier (2001), p. 284.
[15] Cf. Gombrich (1995), p. 81: 'the artist no longer aimed at including everything in the picture in its most clearly visible form, but took account of the angle from which *he* saw an object.' My emphasis.

emerged as a person, signing his own work and comparing himself to one of his fellow artists: '*this* no Euphronius could have made' as he wrote on one jar.

Euthymiades and his fellow painters displayed a practical knowledge of the technique of perspective: and soon 'artists drawing architectural forms employed a rudimentary perspective in the representation of planes and lines in depth'.[16] Thus the Parthenon was constructed so as to look 'right' to the human eye through the use of a range of optical refinements: such as pillars leaning slightly inwards and gradually tapering at their tops. The whole building is designed for dramatic effect upon the viewer and is built to a human perspective, while aiming to elevate that perspective towards the divine. At the same time, the famous frieze of the Panathenaic festival — the Elgin Marbles — shows the spectator yet another human drama: that of his fellow Athenian citizens acting out their roles in the great procession. While these examples of the use of perspective in the arts are relatively well known, perspective also features in theatre itself where, once again we find man and his viewpoint (in both the literal and metaphoric senses) being used as the measure of culture.

From Aristotle's *Poetics* we know a little about the development of the form of tragedy in Athens in the 5th century BC: from its early beginnings in choral performance, until that moment when an individual stepped forward from the crowd and *acted*. An actor whose actions were explained by his distinctive and individual thought and character: that is to say, his personality.[17] Aristotle tells us that Aeschylus added a second

[16] Brigstocke (2001), p. 562.

[17] Aristotle, *Poetics,* 1449b. There is an attractive if contested theory of the etymology of 'personality' being based on the masks worn by ancient actors: the mouthpiece of which was shaped like a tube to project the voice by letting it sound through (*per-sonare*). Maybe it is the case that our concept of a person emerges *through* play-acting, that through the representation of the human we create the human? Another example of nature imitating art?

actor to the stage, and Sophocles 'a third and indeed *skenographia'*.[18] The addition of the third actor, as many have argued, allowed for the fuller dramatic conflict of the kind we find in the Oedipus plays. Adding additional actors is of course a matter of making the drama more human: both literally, and in the sense of introducing more points of view. Sophocles' innovation of *skenographia*, or scene painting, is less remarked upon but certainly no less remarkable.[19] Painted scenery backdrops to the action occurring on stage had to be constructed with a view to the spectator's line of sight. In that sense they represent an ordering of appearance in space with reference to the subjectivity of the perceiver. Aristotle says that since tragedy is a representation (*mimesis*) of human action, it necessarily follows from this that the foremost part of it is, literally: 'the order of sight' (ὁ τῆς ὄψεως κόσμος).[20] He means that what strikes us most immediately in the representation of action is its visual form: with 'poetry and dialogue' playing second fiddle. For maybe the first time, then, there is a recognition that the perspective of the free citizen in the audience determines the appearance of the world.[21] And the plays themselves, performed in the annual festival of Dionysus, were submitted as part of a *competition* in which the assembled audience of free citizens voted on which of those they had seen were the best. Most of the plays that have survived through the ages are those that were judged to be the winners. In this sense, then, Athenian drama is the representation, above all, of the unique political freedom of the Athenian polis.

[18] Aristotle, *Poetics*, 1449a.
[19] Vitruvius has an account that 'Agatharchus of Samos was the inventor of scenography' around 430 BC (cited in Brigstocke, 2001, p. 562) although Aristotle's is the more contemporary account.
[20] Aristotle, *Poetics*, 1449b: κόσμος ('kosmos') being the Greek for 'order'.
[21] The recognition finds expression in Kant's argument that at the very least we interpret the world as ordered so that we can judge it: even if it is not, in fact, so ordered.

It is worth reflecting for a moment on Aristotle's choice of the word *kosmos*: it means 'order' but also 'good order', 'good behaviour', 'the order of government' (as in *cosmopolitan*), 'fashion', 'ornament' and—because of its perfect arrangement and order—'the world'. The human world is what we create through the exercise of our individual judgement—and through the inevitable contestation of that judgement—as we think it ought to appear to us. Arguably, therefore, perspective in the arts (in the broadest sense) is deeply intertwined with democracy: perspective is allowing individuals to decide what is good, and what is not, through presenting a vision of the human to them; a recognition of subjectivity. Tyranny is when your point of view has no weight, does not *count* against only one fixed viewpoint. It is only democracy that treats each individual perspective as valid despite its (logical) difference from every other perspective. No accident then that discrimination comes from the Latin *dis-cerno*: to pick out, to separate on the basis of distance, to make distinguished. Perspective—as a technique in the arts—serves to mediate the relationship between artist and audience through expressing the distance (through the illusion of depth as opposed to the flatness of ancient Egyptian, say, or pop art), and the freedom, that is the prerequisite to aesthetic judgement. This truth goes a good way to explaining why Plato chose to end his *Republic* with an—at first sight surprising—attack on the arts. He singles out perspective in particular ('an object seen at a distance does not, of course, look the same size as when it is close at hand') as a problem in the sense that we can be deceived as to the actual size of the object. And he attacks the arts in general on the basis that they 'by many tricks of illusion, like scene painting (*skiagraphia*) and conjuring' misrepresent the true nature of reality to the spectator.[22] The dramatic poet

[22] See Fowler (1989), p. 169: she argues *skiagraphia* is strictly 'the illusion of a play of light upon surfaces of varying quality and depth' while *skenographia* was 'drawing or painting in perspective'.

gratifies that senseless part [of the soul] which cannot distinguish great and small, but regards the same things as now one, now the other; and he is an image-maker whose images are phantoms far removed from reality.[23]

Plato objects to culture because it relies on the exercise of subjective judgement, on individual freedom, rather than the use of objective methods like measuring, counting and weighing. The danger of culture lies in the possibility that the people, the little people, might decide for themselves what is best, might even decide on whom should rule, rather than it being the case that rulers are rulers because they are Rulers, that is to say: are just, and with no argument, the 'right sort' of people.

Perspective, then, was certainly not unknown in antiquity and not just in scene painting. Wall paintings have not survived from 5th-century BC Athens but we have examples from the end of the Roman Republic four hundred years later. The walls of the bedroom in the Villa of P. Fannius Synistor in Boscoreale feature illusionistic architectural cityscapes—stacked, receding towers and balconies—that remind one of Carlo Crivelli's *Annunciation*: painted as an altarpiece in 1486 to celebrate the town of Ascoli's achievement of a degree of self-government and now in the National Gallery. The painter of these frescoes had awareness (albeit empirical rather than theoretical) of central perspective: that is, 'seeing through a transparent plane on which the scene is traced from a single fixed eye-point' or, as Leonardo put it, 'nothing else than seeing a *place* (*sito*) behind a pane of glass, quite transparent, on the surface of which the objects which lie behind the glass are to be drawn'.[24] It may just be the chance of their survival but these frescoes are from the 1st century BC: the period which saw the greatest flourishing of the Roman arts, from Lucretius to Cicero to Virgil and including, of course, Vitruvius, whose *De Architectura* was popularised by

[23] Plato (1941), pp. 326–9.
[24] Brigstocke (2001), p. 553.

Alberti in the 1450s and who placed man — Vitruvian man as immortalised by Leonardo — at the centre of the cosmic order, as the measure of all things.

And it is in the Renaissance that perspective is rediscovered and developed after nearly a thousand years in which it was lost in the collapse of the Western Roman Empire, and with it the desire and ability to represent a human natural world, as opposed to the abstract patterned visions of barbarian invaders or the transcendental idols of Christianity. Where it had the best chance of survival, in the Eastern Byzantine half of the Empire, it existed to the letter at best: never the spirit.[25]

Yet perspective re-emerges in Florence with a bang. The east doors of the Baptistery by Ghiberti were, as he put it, designed 'with all the perspective I could produce to have excellent compositions rich with many figures'.[26] They are also pure *skenographia*. Ghiberti's great rival, Brunelleschi, who constructed the dome of Florence Cathedral, had worked out the basic principles of linear perspective as early as 1413.[27] He cut a single eyehole in a painting, which one could then hold up and look through the back of, to see the picture reflected in a mirror held in front of the painting in the other hand: 'what the viewer saw was not the thing itself but the appearance that thing had shed onto another surface.'[28] But Donatello's *David* (circa 1440s) is equally testament to the new perspective of Renaissance humanism. It is a virtuoso demonstration of technique (the first

[25] Its late re-emergence in, for example, the frescoes of St. Savior in Chora, the Kariye Camii, in Istanbul, under the influence of trade with the West in the early 14th century, was a false dawn given the fall of Constantinople to the Turks in 1453, although this latter and the resulting flight of its intellectuals and libraries west was, of course, a great fillip to the Italian Renaissance.

[26] Campbell & Cole (2012), p. 93.

[27] Though they were not empirically codified until Alberti in 1435, and only scientifically demonstrated by Piero della Francesca in 1480: see Raymond, D. 'Optics and perspective prior to Alberti' in Strozzi & Bormand (2013), p. 165.

[28] Campbell & Cole (2012), p. 95.

free-standing bronze cast) and an example of the rebirth of the classical (the first free-standing, life-size male nude since antiquity).[29] David – political symbol of the resistance of the independent Florentine republic against the Goliath that was the Holy Roman Empire – also symbolises a spirit that is willing to step forth as unashamedly, and brazenly, human. What a contrast it is to Donatello's first *David* – now also in the Bargello – but executed in marble maybe 30 years before for the pious Overseers of Works of Florence Cathedral. It is Gothic Bland at best and quite traditional. His later work for the Medici is certainly inspired by the Greek statues Donatello had excavated, studied and measured in Rome (while Brunelleschi meticulously measured the dome of the Pantheon during their four years together there at the beginning of the 15th century) but the statue is something new. What I think it represents is not Donatello's homosexuality, as some have alleged, or even that of the Medici or of Florentine society more broadly. The *David*, of course, does speak to us of what Mary McCarthy called 'a transvestite's and fetishist's dream of alluring ambiguity', but it also has the 'springy vitality of the terrestrial', the defiant resistance of the masculine principle of action.[30] In Clark's distinction in *The Nude* between the antique curve of the hip and the Gothic curve of the stomach, it is the former that is an 'image of energy and control' while the latter 'does not take its shape from the will but from the unconscious biological process which gives shape to all hidden organisms'.[31] With the second *David* stood in the courtyard of their palace, the Medici were laying claim to the political spirit of Florence by association – like Obama having Bob Dylan play at the White House – but I think they were at the same time stating their artistic and philosophical credo. There is no doubt that the *David* has something of the

[29] Avery (1970), p. 82.
[30] McCarthy (1956), p. 135.
[31] Clark (1956), p. 312.

Hermes — the messenger of the Gods — about him,[32] which makes the statue express the arrival of the new symbolically as well as literally through its unconventional pose, detail and technique. It is more than a rebirth of the ancient though it has all the shock value that Sophocles' introduction of the third actor must have had. Donatello would of course continue to innovate and in that sense it is worth remembering his equally ground-breaking *Magdalene Penitent*: executed with astonishing realism in yet another medium, white poplar, some twenty years later for the Baptistery of Florence.

Donatello was just as revolutionary in bas-relief, another area where he could demonstrate advances in perspectival illusionism and show man occupying space in depth: one of the best examples being the *Miracle of the Irascible Son* commissioned for the altar of the Basilica of Saint Anthony in Padua which — with its crowded drama presented as if on a stage, wings raised on either side for spectators, the sun illuminating the action from behind — is nothing if not *skenographia*. But I think it is his work in the free-standing human figure — on the subject of man standing in freedom — that epitomises this great artist of the Italian Renaissance: the first artist to be celebrated as an artist in the modern sense of possessing a

> devotion to the inventive powers of his craft combined with a
> disregard for accepted standards of behaviour which patrons
> had to accept if they wished to employ this genius.[33]

The spirit of humanism of the time, in that moment of freedom, led to the emergence of the individual onto the stage of history and the representation of the 'individuality of the personality' through the originality of artists such as Donatello.[34] Through the pursuit of *virtù*, through 'our diligence, our interest', men

[32] The feather in Goliath's helmet seeming to spring from David's foot
 reminding us of Hermes' winged sandals.

[33] Holmes (1996), p. 40.

[34] Holmes (1996), p. 36.

like Alberti aimed to limit the effects of *fortuna* and increase the degree of control they exercised over their lives.[35] Such virtuosity, as a heightened sense of an expanded subjectivity, went hand in hand with a revolution in perspective that allowed artists to turn their gaze upon themselves (as in the emergence of self-portraiture as a genre in this period)[36] and fostered a sense that the viewpoint of one's fellow subjects actually mattered. Alberti, after all, ends his treatise *On Painting* with the advice to 'please the public', 'to ask and to listen to everybody's opinion', and not to fear their 'criticism and judgement'.[37]

The Discriminating Perspective

Perspective — in which the human stands out as discriminate and discriminating — is a constituent of freedom. It is in light of his freedom, subjectivity and personality that man is a creator, an artist, and he is an artist insofar as he creates representations of human freedom. It is through the recognition of our fellows that we become ourselves. The confidence the artist must have in his own freedom to create — despite his particular limitations — mirrors the Hegelian freedom of self-consciousness that emerges through the Master–Slave dialectic and the awareness of the absurdity of despairing at the infinite gulf between the real and the ideal.[38] What then of the spectator? What does he do as the recipient of what the artist has created, what the author or composer has brought into being?

Art that is constructed with an eye to a human point of view invites a human response to it: it solicits assent to the vision of

[35] Alberti (1972), p. 4.
[36] Notably Masaccio's self-portrait with Masolino, Brunelleschi and Leon Battista Alberti (1427), Van Eyck (1433), Jean Fouquet (1450), Mantegna (1474) and, above all, Dürer's wonderful self-imaging as Christ (1500).
[37] Alberti (1972), p. 95.
[38] Hegel (1977), pp. 111–138. In general much of my concluding argument, especially as regarding the connections between freedom, subjectivity and recognition, derives substantially from the *Phenomenology of Spirit*: particularly the sections on culture, morality and religion.

its creator. When one perceives art (whether a painting or a piece of music or a book) there is of course a set of physical processes involved – the senses – but these passively enable and underpin the central process which is one of active interpretation: how do *I* perceive this? How do *I* take it in? How do I *feel* about it? Perception has an insistent and imperative character to it: the work of art demands a response. This is a question of taste, of discrimination. The relationship is akin to that charged moment when one unwraps a present under the eyes of its giver. Artists hope their work will be liked and we will be grateful. The judgement that one makes of the work of art (good, bad or indifferent) is one that relies on the recognition of our freedom to make it possible. In the sense that if I am not free to dissent then my assent is worthless. But also in my independence of – and distance from – the object being appreciated. To ask myself if this is beautiful or not I must self-reflect: must stand apart from myself and try to be as impartial a judge as I can. This means choosing to rise above my natural instincts and exercise self-discipline and reason: taking a view.

I stand apart from – above – myself and pass judgement on the object in itself as impartially as I can: it as object; I as subject. To the degree I am successful in this, then I experience what Kant in the *Critique of Judgement* calls 'the pure disinterested delight which appears in the judgement of taste'.[39] Scruton glosses this as an *intentional* pleasure, a pleasure of reason *in* the object, as opposed to any desire to *self*-pleasure, as it were.[40] This standing apart in disinterested delight is of course also what is referred to as *transcendence*: the passing over and surmounting of the material. The other form of out of body experience we associate with the arts is *ecstasy*: from the Greek, a being put out-of-its-place. It is the state achieved through drink and

[39] Kant (2007), p. 37.
[40] Scruton (2009), p. 30. Cf. also p. 31: 'My pleasure in beauty is therefore like a gift offered to the object, which is in turn a gift offered to me. In this respect it resembles the pleasure that people experience in the company of their friends.'

dance by those Bacchantes who in their passion ripped the head — the seat of reason — from the body of Orpheus. The two states are symbolised in Greek thought by the eternal opposition between Apollo and Dionysus and we humans partake of both: we are spirit as well as flesh. We are one thing, but as a matter of perspective, and whenever we overcome our material nature ('interest' in Kant's terminology, desire or need) we experience and find a freedom *in ourselves* that is not present in the state of ecstasy, which is a matter of *losing oneself*.

Aesthetic judgements are always made about *particular* works of art. They are made by individuals — fallible individuals — who can only say what *they* think. As Arendt poses the problem that confronted Kant:

> No one can define Beauty; and when I say that this particular tulip is beautiful, I don't mean, all tulips are beautiful, therefore this one is too, nor do I apply a concept of beauty valid for all objects.[41]

Is there, then, any validity to my judgements? We could duck the question and say that there is nothing more to the question of beauty than how *this* appears now, to *me*. Such is the temptation expressed by contemporary relativism and total culture: the feeling that those who express strong value judgements are guilty of some kind of essentialist error, of imagining that beauty is objective, and showing no respect for the opinions of others. This, however, is not to judge at all: to give up on the possibility of gaining the assent of others to your view that *this* is beautiful and to give up on the possibility of any community of interest. There should be some way of communicating the beauty of something to others: of gaining their assent. Surely we should be able to have a 'common sense' of what this beauty consists in? A subjective universality?

Kant's answer (and I draw on Arendt's exposition of the problem in her mid-1960s lecture series *Some Questions of Moral*

[41] Arendt (2003), p. 138.

Philosophy) in terms of a 'common sense' is that our ability to imagine what other people think — to think 'communally' rather than 'commonly' as it were — allows us to take the view of others into account when we make a judgement. Kant calls this an 'enlarged mentality' but it can be put simply as the process of going through in your mind what others may think *before* arriving at your judgement. This is why the judge 'hopes that his judgments will carry a certain general, though perhaps not universal, validity'.[42] Obviously, the greater the number of different perspectives one is able to take into account the greater one's hopes of arriving at a valid judgement. If one is to be confident in one's judgement it is common sense to examine the work of art from all the angles one can. How can one hope to take all these different points of view into account? Through thinking hard — and with all due study — and crucially through reliance on an inherited tradition of judgement: on the precedent set by the canon. Reliance on precedent does not mean that one's judgement is blindly *determined* by previous judgements: if only for the reason that every situation and every work of art is unique. Precedent demands reasoned *application* to the case in hand: this is the process by which the body of precedent grows as we all add to it. And it is in this sense of judgement — as this common sense — that those who jeer at 'traditional judgements' as being old fashioned and elitist, actually reveal themselves to be profoundly hostile to any idea of being part of a community of others.[43] Those who say — 'who are you to judge' — express their indifference to your reasoned opinion and to your freedom to dissent from orthodoxy. At heart they operate with an assumption that their own opinions are above judgement. One can tag along and be part of the 'in' crowd but the

42 Arendt (2003), p. 140.
43 Cf. Baudet (2012), p. 189: 'a judge is not so much supposed to be "objective" as to be "authoritative": and that can only be the case when he is part of a large whole, of which the conflicting parties are also members.'

price is a more or less explicit endorsement of received opinion, conformism and dogma.

Those willing to judge are interested in what they *themselves* think about the object: what they *reason* about the object. Being disinterested in the object—but interested in what their reason says—means that judgement is in an important sense not *determined* by the object: that is to say, it is not objective, but reasoned, and free. If the object was such as to appear beautiful at all times to all men, then it would be a Platonic ideal of Beauty and not something in the human world. The important thing here is that we have the freedom to be wrong, and to be right. Both make sense to us: aesthetics is not a science like physics. This does not mean, however, that judgement is only subjective. Good judgement, we understand, is a matter of getting it 'right', and we should try, as individuals, to learn how to do this more reliably. To do so involves learning from experts —connoisseurs—and, crucially, from tradition. The fact that some works of culture—from the *Iliad* to the Pantheon to Beethoven's Choral Symphony—have stood the test of time for so long in the Western tradition is precisely why their greatness is more than a matter of mere subjective opinion: something, rather, that generation after generation has failed to displace with anything better, giving us what Harold Bloom terms 'the list of survivors of a three-thousand-year-old cosmological war'.[44] We can rely on such works as touchstones of beauty and truth that can help us judge new works against the standard they set. And we can appeal to them to enable conversation with each other. The canon, 'despite the limitless idealism of those who would open it up, exists precisely in order to impose limits, to set a standard of measurement'.[45]

[44] Bloom (1995), p. 36.
[45] Bloom (1995), p. 33.

Who am I to Judge?

If there is one thing that seems to have near universal assent today it must be the idea that no one person has the right to judge. Even the new Pope steps back from condemning gay priests with the words: 'Who am I (Vicar of Christ though I may be) to judge?' With the breakdown of the authority of the Western tradition there seems to be little more involved in aesthetic judgement than just whatever one happens to think. Or the idea that taste is rooted in specific cultural identities: the only validity of judgement resting in the exclusion and denial of different, yet equally valid, traditions. Or it is argued that in a world without God there is nothing to underpin the concepts of Beauty and Truth: at least in the absence of sufficient faith in humanity to find their foundation in our reason and free will. What is missed in such critiques is that judgement involves qualities of self-questioning and reflection: it relies on experience, the accumulated wisdom of tradition and impartiality, on our reason and our freedom. And that these are shared and *shareable* qualities.

When I judge a work of art to be Good (i.e. beautiful and true) I assume you too could assent to the judgement. It is not a take it or leave it sort of thing to say, and, if it is, then it is not an aesthetic judgement. It is a normative judgement with moral force on you who ought to get it too. It is my judgement but precisely because it is mine I want it to have universal force. This is of course why arguments over taste in art, literature and music can be so personal and so bitter. As Kant argued (in his famous Antinomy of Taste) the fact that we have a saying 'there is no arguing about taste' (*de gustibus non disputandum est*) means of course that there is indeed arguing about taste. And that it matters. In his words:

> The judgement of taste expects agreement from everyone; and a person who describes something as beautiful insists that everyone *ought* to give the object in question his approval and follow suit in describing it as beautiful.

We judge and in so doing we present that judgement to the world in the hope of assent and of making friends with those who concur: we are 'suitors for agreement from everyone else, because we are fortified with a ground common to all'. That ground is reason, freedom and self-consciousness which constitute perspective and in which we all share: 'the effect arising from the free play of our powers of cognition.'[46]

What matters in culture is that you judge. There is no avoiding judging appearances, so it behoves us to judge as well as we can to avoid the risk of confusing books with covers. To judge well is to exercise our freedom through the recognition of the freedom of the artist. There is a model, in other words, for the task of human self-fashioning in the process of artistic creation. The former creates unique individuals and human history; the latter, unique works of culture and a tradition which is itself, as Hegel would argue, nothing less than the expression of man's spiritual freedom. It is man that is responsible for his own history: not nature; nor God.

Judging as a critical individual is, then, at root constitutive of society. It is the process by which we disclose ourselves to others. We should, therefore, choose our friends — and our loved ones — carefully, in the light of the kind of person we want to become and with a view to the sort of society we want to live in. We must be able to choose our friends freely otherwise they are just people forced upon us by circumstance. I think this truth is why Arendt was so fond of quoting, as an example of his *humanitas*, this line from Cicero: 'I prefer before heaven to go astray with Plato rather than hold true views with his opponents.'[47] She argued he was claiming freedom as our foundational norm. Judgement must be free *even* to the extent that it is not determined by evidence, by truth itself, even by beauty. When we judge, our judgement is not *determined* by the evi-

[46] Kant (2007), pp. 68–9.
[47] Arendt (1968), p. 221.

dence but by our conscience. Arendt concludes, for the Romans as well as us:

> [A] cultivated person ought to be: one who knows how to choose his company among men, among things, among thoughts, in the present as well as in the past.[48]

It is the loss of this understanding that concerns us today. 'Evidence-based culture' would be a contradiction in terms since it denies the freedom that culture relies on.[49] In making judgements we can take courage from J.S. Mill:

> Truth gains more even by the errors of one who, with due study and preparation, thinks for himself, than by the true opinions of those who only hold them because they do not suffer themselves to think.[50]

In similar vein, Kant is said to have argued 'the death of dogma is the birth of morality'. He saw it was in the public use of man's reason—in the making of judgements rather than the blind following of accepted wisdom—that enlightenment would be most advanced:

> For enlightenment of this kind, all that is needed is freedom. And the freedom in question is the most innocuous form of all —freedom to make *public use* of one's reason in all matters. But I hear on all sides the cry: *Don't argue!* The officer says: Don't argue, get on parade! The tax-official: Don't argue, pay! The clergyman: Don't argue, believe![51]

48 Arendt (1968), p. 222.
49 As a check that I was not making this up, a quick Google search on 'evidence-based art', 31 May 2013, gave results like 'Art and Health— Therapeutic Landscapes Network... art in the healthcare setting has healing potential... the artwork chosen should be based on evidence rather than solely on the opinions or aesthetics of designers, administrators, or curators'. Only a matter of time before the first Evidence-Based Museum opens its non-curated doors...
50 Mill (1991), p. 39.
51 Kant (2009), p. 3.

Don't judge, respect! Today, too, we are forced into 'roles', into uniform, rather than being vouchsafed the freedom to be ourselves. The project of being cultured is not an optional part of a politics of emancipation, of maturity, nor of freedom. To discriminate requires the ability to judge as one's conscience dictates. To do so is to step forward in relation to our fellow human beings. Disinterested delight, Kant knew, is just half the story: 'Only in society is it *interesting* to have taste.'[52]

[52] Kant (2007), p. 37

Nine

Being Cultured

Constant revolutionising of production, uninterrupted disturbance of all social conditions, everlasting uncertainty and agitation distinguish the bourgeois epoch from all earlier ones. All fixed, fast-frozen relations, with their train of ancient and venerable prejudices and opinions, are swept away, all new-formed ones become antiquated before they can ossify. All that is solid melts into air, all that is holy is profaned, and man is at last compelled to face with sober senses his real conditions of life, and his relations with his kind. — K. Marx & F. Engels, *The Communist Manifesto.*

It is only by unremitting effort that we can persist in being individuals in a society, instead of merely members of a disciplined crowd. — T.S. Eliot, *Notes towards the Definition of Culture.*

We should find the way to exalt our world and to endow it with a more than worldly significance. — Roger Scruton, *On Defending Beauty.*

The State of Culture

In his classic exposition of liberalism, J.S. Mill argued a strong society was made up of strong individuals: 'when there is more life in the units there is more in the mass.' He, like Kant, opposed the idea that we should mould ourselves to society's dictate or submit to the 'despotism of custom'. Instead we should cultivate whatever is individual in ourselves. In this way 'human beings become a noble and beautiful object of contemplation'. And such individuals create a human world that is

rich, diversified, and animating, furnishing more abundant aliment to high thoughts and elevating feelings, and strengthening the tie which binds every individual to the race, by making the race infinitely better worth belonging to.[1]

Mill wrote *On Liberty* in 1859, just ten years before Arnold's *Culture and Anarchy*, and both aimed at an increase in the general level of culture. The two books, however, took radically different views of the role of the state in society. Arnold feared that culture ('which simply means trying to perfect oneself') was not attainable by individuals unaided because 'the strong feudal habits of subordination and deference' which used to keep the working classes in line had been dissolved by the modern age and 'the anarchical tendency of our worship of freedom in and for itself' had become expressed in the idea of the individual's 'right to do what he likes'.[2] Not finding the pursuit of one's best self – or culture – to be in the interests of any one section of society, he had to assign that authority to the state because:

> [A] State in which law is authoritative and sovereign, a firm and settled course of public order, is requisite if man is to bring to maturity anything precious and lasting now, or to found anything precious and lasting for the future.[3]

That is to identify the state with our best selves and with right reason: to empower it over our ordinary selves to the loss of our liberty. Whereas Mill, in the ringing conclusion to his pamphlet, argued that 'mischief begins when, instead of calling forth the activity and powers of individuals and bodies, it [the state] substitutes its own activity for theirs'. The result is that 'a State which dwarfs its men... will find that with small men no great thing can really be accomplished'.[4] As we have seen, he felt that

1 Mill (1991), p. 70.
2 Arnold (2006), pp. 57–61.
3 Arnold (2006), p. 149.
4 Mill (1991), pp. 127–8.

even our mistakes moved us forward so long as they were *our* mistakes: the result of thinking for ourselves.

It is certainly true there is always a balance to be struck between the individual and society, between freedom and order, reason and passion. Striking that balance is a matter of right judgement — what Aristotle termed *phronesis* — and it is the political quality par excellence. The difference between Mill and Arnold represents this very tension. Since their time, however, there has been a slow but steady increase in the role of the state in all areas of life (the economy, education, welfare, security and so on) and a concomitant decrease in the latitude and freedom afforded to individuals and private institutions. We have seen the role of the state in funding culture and its enthusiasm for using it as an instrument to achieve its various bureaucratic social and political goals. Every increase in official oversight into, for example, our choices of what to eat or drink is justified by the supposed risk the uncontrolled individual poses to society: in terms of setting a bad example to others or in costs to the state. From what styles itself as the Left comes the accusation that individuals are naturally (indeed genetically) greedy and selfish and that it is the job of society to retrain and restrain them for the common good. Documentary filmmaker Ken Loach's nostalgic paean to collectivism — *The Spirit of '45* — identifies capitalism (moribund though it appears to be) with rampant individuality, while populist attacks on the excesses of risk and greed in finance find support from the *Guardian* to the *Financial Times*. Above all, contemporary hostility to the individual finds expression in demands for a degraded form of equality: the removal of meaningful differences between people; and in hostility to meritocracy.

Christopher Lasch observed nearly twenty years ago that democracy had been replaced by the 'democratization of "self-esteem"'. The idea that everyone — and in particular the disadvantaged and marginalized — would benefit from workplace and university speech codes, from compassion and redress, came at the expense of the truth that democracy 'works best when men and women do things for themselves, with the

help of their friends and neighbours, instead of depending on the state'.[5] Indeed it was always informal bonds of cooperation such as peer groups and clubs that mattered most, as Richard Sennett argues in *Together: the rituals, pleasures & politics of cooperation*, making the point that the role of ritual 'in all human cultures is to relieve and resolve anxiety, by turning people outward in shared, symbolic acts'. So far secular replacements for religious ritual have 'proved too feeble to provide that support'.[6] Nor have attempts to use culture in this way, *as if* it was religion, been successful: high culture is subject to the same pressures that have dissolved the bonds of religion, and its priesthood (the critics) have found that it is impossible to hold a shared sense of what matters, what is good and what is not, against the dominance of contemporary non-judgementalism and hostility to the exercise of discrimination. With the erosion of self-reliance and subjectivity more broadly has come the rise of a therapeutic state which—despite its no doubt worthy intentions—only reliably serves to further enfeeble individuals through placing them in a relationship of dependence to itself. A relationship itself on which it is all too easy to become dependent. In culture the danger is that the public becomes the relatively passive recipient of culture as government largesse or doled out on prescription. The most likely outcome is an entirely healthy reaction *against* culture or at least deep indifference to it when it becomes obvious that any amount of 'bibliotherapy' is no proof against reality.

Against this situation—marked by dependence and indifference—those who care about culture must find ways to assert their independence and difference. By takings risks, trying new things and being originators, but also by discriminating in favour of what they love and through establishing institutions of their own to support and further the interests of communities of taste. We suffer too much from the increasing professionalisa-

5 Lasch (1995), pp. 7–8.
6 Sennett (2012), p. 280.

tion, formalisation and legalisation of areas of life best left self-regulated and where common sense, tradition and instinct are the surest guides. Above all, it is through experiments in freedom we may hope to restart the engines of history. We have to decide between witnessing the increasing erosion of the authority of culture or making a commitment to the pursuit of being cultured. In conclusion I will look briefly at each of these points in turn.

Discrimination: it's in our interests

There is more to this world than individuals making judgements in isolation. That is not even possible. Judgements are made to others, in public, and establish relationships with others who can be supportive, indifferent or hostile to your view. When I judge that something is beautiful or true I am making an appeal (if not directly or consciously, at least it is logically implicit in the nature of judging) to your freedom to judge and to agree (or disagree) with me. You are bound to me by my judgement: even if you refuse to respond to it you are responding to it, at least in the sense of letting it stand without comment. And you are bound to me in the sense that we are like each other: we are self-conscious, free, rational beings. So my judgement of value (although expressive of my subjectivity) compels the assent (or dissent) of other beings in common with me and, therefore, provides the basis of the potential universality of judgement. This way of looking at judgement is in marked contrast to the contemporary dominance of the idea that there is a real particularity of judgement whereby whatever I think creates no necessary relationship to you since you are different to me (black, LGBT, young, working class...). In a nutshell discrimination, as I have argued it, is ideally non-discriminatory whereas non-discrimination is really discriminatory.

Culture is a matter of discriminating judgements, expressions of taste that are necessarily exclusive and elitist: as expressive of a particular selection or choice. That, for example, Giulini's Bruckner's Ninth symphony is better than the record-

ing by Georg Tintner. When I express such a judgement, I am gratified if you share my view and I may feel that I have found a friend. If we find many such judgements in common, we may be sure of it. If you disagree, I am unsettled to one degree or another. If you are openly hostile to my judgement and criticise me severely, I may revise my views or keep quiet about them, or go in search of new friends. So, both senses of discrimination are involved here. I discriminate between things (the Giulini and the Tintner recordings), and as a result I discriminate between people, at least on the question of taste in Bruckner's Ninth.

This relationship of discrimination—between things and between people—is in fact the foundation and the very possibility of association. In Arendt's words: 'without discrimination of some sort, society would simply cease to exist and very important possibilities of free association and group formation would disappear.'[7] Judgement has a two-fold character: as it includes X; it excludes Y. It relies on my freedom and on yours. This makes it the building block of society in the sense that it is what underpins the foundation of associations of discrimination, to coin a phrase. Societies, clubs, membership organisations, communities of interest and so on. Some of these associations of discrimination may take institutional form with articles, rules, dues paid, annual meetings and so on and so forth. Others may be virtual communities with members who never meet as such but who share a set of judgements to some degree: a shared understanding of what an educated human being is; or a sense of Britishness, for example, although that is a case in point given hardly anyone can agree on just what it means to be British today. Indeed, one of the effects of what I have been terming total culture is that, in a very real sense, society has indeed ceased to exist and our life as individuals is increasingly defined by nothing more than our loneliness.

7 Arendt (2003), p. 205.

In this situation the formation of *societies* by individuals in pursuit of their interests should very much be the order of the day. It is increasingly the case that the existing cultural institutions have been hollowed out in the name of accessibility and openness. Artist and critic J.J. Charlesworth has noted how traditional institutions no longer hold a line in the name of 'tradition, national culture, respectable moral values or craft skills' and, on the other hand, what were once 'radical institutions' have now triumphed in the culture wars. The result is that contemporary cultural institutions (whether art galleries, fairs, museums, concert halls or libraries) have become so 'liberal, tolerant, pluralist, inclusive, nonpartisan' and open that there is no longer any struggle to get in nor any reason for artists to create their own new institutions.[8] Nor is it easy for artists to mount any challenge to an orthodoxy whose guiding principle is not to judge. Yesterday's outsiders find themselves in new roles advertising the inside-out transformation of august institutions: Mark Ravenhill as writer in residence at the Royal Shakespeare Company, Carol Ann Duffy as Poet Laureate, Tracey Emin as Professor of Drawing at the RA, Marin Alsop conducting the Last Night of the Proms. Those who believe we have inherited a unique cultural tradition may increasingly find it necessary to create new institutions dedicated to its preservation.

The Re-sacralisation of the World

The case of Michael Landy, artist in residence at the National Gallery, is a clear expression of a key imperative within culture today: that nothing should be sacred, everything hidden should be dragged into the light, every foundation rocked or at least mocked. Landy's exhibition there in 2013, *Saints Alive*, featured an animated St. Thomas made of junkyard materials, poking his finger, robotically, into the headless torso of a Christ mounted

8 J.J. Charlesworth, 'Diamond skulls in discursive spaces', *Art Review*, November 2011.

on a spring: like something from *Toy Story*. Other saints whirred and crashed and lit up like crazed slot machines as the public stamped them into motion. One art critic justified this torture room for the human spirit on the grounds that Landy was asking us to

> reconsider the gruesome strangeness, the sadistic violence, the self-sacrificing conviction or motivational purity of the stories upon which have been built up a Christian faith.[9]

Whether or not Landy's irreverence towards Christianity is to your taste (although it is terribly fashionable in certain circles), the idea that the National needs to prick its own pretensions and out-modern the Tate Modern is the shortest route to losing what is unique and distinctive about it as an institution. For the National to stay true to its foundational principles it must maintain a high seriousness about great art and about itself: it should act as a temple of freedom, elevating art and us from the mundane and day-to-day. Not all institutions need to be academic, austere and august. But nor do all institutions have to be accessible nor aspire to the condition of Alton Towers. Daniel Bell wrote that human 'culture is a creation of men, the construction of a world to maintain *continuity*, to maintain the "un-animal" life'.[10] What matters is the attitude we take towards this culture. If we choose to accept our inheritance, say the canonical Great Books, then, as Bell goes on to argue, we owe a duty to those who handed it down: that of upholding the shared values of society. What we need is to take ourselves as humans, as originators and authors, more seriously: with a bit less irony, a bit more distance and perspective, and a little more effort to stand above ourselves.

Bell also had this to say about religion:

9 Rachel Campbell-Johnston, 'Michael Landy at the National Gallery', *The Times*, 23 May 2013.

10 Bell (1996), p. 170.

> It is a constitutive part of man's consciousness: the cognitive
> search for the pattern of the 'general order' of existence; the
> affective need to establish rituals and to make such conceptions
> sacred; the primordial need for relatedness to some others, or to
> a set of meanings which will establish a transcendent response
> to the self; and the existential need to confront the finalities of
> suffering and death.[11]

Religion is a limit, something that ties you back (*re-ligare*), some-
thing that obliges you to do the right thing, your duty, without
question. As such it is precisely religion, I would venture to say
—or maybe it is better to call it a religious *attitude*—that we need
in society today. That is not a call for superstitious belief. It is a
call for being able to self-limit, to bind oneself to one's own free-
dom, to discriminate the sacred from the profane and, further-
more, for the establishment of rituals to mark the border
between the two: borders which serve to keep the Devil out. The
sacred and profane as Bell analyses them, himself following in
the footsteps of Durkheim, are the division of the world that
religion expresses. Religion is the 'means of gathering together,
in one overpowering vessel, the sense of the sacred—that which
is set apart as the collective conscience of a people'.[12] Religion in
this sense is the very model of an association of discrimination.

In a society obsessed, however, with change and the new,
the disruption of hierarchy and the denial of discrimination,
there is no such divide. Such a society will be better able to keep
the Devil out to the extent that it is made up of individuals who
are not afraid to say what is Good, what is canonical. To that
degree, therefore, the call for discrimination and judgement,
and maybe aesthetic judgement in particular, is of a religious
nature.

11 Bell (1996), p. 169.
12 Bell (1996), p. 154.

Being Cultured

In Thomas Mann's *Doctor Faustus* nothing is more chilling, and profoundly evil, than the threat of composer Adrian Leverkühn that he will 'take back' Beethoven's Ninth: it symbolises the idea that the Western tradition has become so hateful to us — through our failure to be cultured, to be original — that it might be better if that great gift of freedom was taken from us, and we were taken into the care of responsible guardians. The danger we face today is much more profound than that expressed by the *Kulturpessimismus* of Spengler in *The Decline of the West*, if for no other reason than that his central thesis — that cultures are organisms that are born and must die — is now an accepted commonplace. The idea that everything is natural in this sense means that nothing can be challenged and that nothing will last. To the extent that this mood of profound fatalism holds sway today then history is on hold and we remain very much in what Kant called our 'self-imposed minority', in the childhood of man. As such the possibility of going backwards is a real one and the death of civilisation imaginable.

In the last book of the *Georgics*, Virgil gives us an extended, light-hearted and lyrical account of the society of bees and how a beekeeper should care for them: we are treated to an idyllic picture of a hive prospering under proper care and cultivation. But fortune is fickle and sometimes bee society is prey to the whims of nature: disease can wipe them out. Virgil tells the story of Aristaeus (his name means 'the best'): a Greek culture hero who revealed to mankind many arts of cultivation including husbandry and bee keeping. Aristaeus' bees, however, sicken and die but he finds — through capturing and holding fast the ever-changing Proteus — the explanation in the tragedy of Orpheus: Aristaeus was himself to blame since, in his hot pursuit of Eurydice, she was bitten by a serpent and died. In atonement he sacrifices cattle and from their carcasses new swarms of bees miraculously emerge. Like all great poetry this works on many levels simultaneously. We can read it as speaking to the sickness of contemporary Roman society — riven by civil war — requiring the heroism of a great individual

(Augustus) to recreate it as whole and orderly. We can read it—and the story of Orpheus—as a moral warning of the consequences of unbridled passion and of surrender to animal instinct: the need to follow duty and reason instead. And we can read it as reminding us of how—despite our mortal fallibility and human weakness—we can, through culture—our self-knowledge—keep society alive: come what may. That we are bound to advance—despite our less than perfect reason, despite our relative unfreedom—by wrestling human truths from the eternal transience of reality: through the ongoing and never-resolved tension between the individual and society, freedom and security. Even though we die our song can echo in the future.

If we are not to regress but to stand out and step forward into history again then we must discriminate. Choosing, separating and relating, rejecting, setting standards and judging are all activities which are a prerequisite to the existence of a common cultural world. It is a task for individuals, and maybe we should take more heed, in these times of state interference on our behalf, of Voltaire's advice to tend and cultivate one's own garden. Certainly man was not born to be idle, but free to follow his own lights, and choose what he would become. The brave become individuals, which is to say, become noticeable: present themselves in the sight of others. As Camus said: 'Rebellion is the common ground on which every man bases his first values. I *rebel*—therefore we *exist*.'[13] In trying to be cultured too, if we bind ourselves to our freedom as a duty, we will find that we are not alone. We may rediscover our love for a cultural tradition that is no millstone but a springboard and the very possibility of the new. And we may find again that we are more capable of leaving something precious and lasting for the future than even we imagine.

13 Camus (1953), p. 28.

Bibliography

Adorno, T.W. (1991) *The Culture Industry: selected essays on mass culture*, London: Routledge

Alberti, L.B. (1972) *On Painting*, trans. C. Grayson, London: Penguin

Arendt, H. (1958) *The Human Condition*, London: University of Chicago Press

— (1968) *Between Past and Future*, London: Penguin

— (2003) *Responsibility and Judgment*, New York: Shocken Books

Armstrong, J. (2009) *In Search of Civilisation: remaking a tarnished idea*, London: Allen Lane

Arnold, M. (2006) *Culture and Anarchy*, Oxford: Oxford University Press

Arts Council England, and others (2010) *Cultural Capital: a manifesto for the future*

Avery, C. (1970) *Florentine Renaissance Sculpture*, London: John Murray

Baudet, T. (2012) *The Significance of Borders*, Leiden: Brill

Barthes, R. (1977) *Image Music Text*, trans. S. Heath, London: Fontana

Bell, D. (1996) *The Cultural Contradictions of Capitalism*, New York: BasicBooks

Benjamin, W. (1968) *Illuminations*, London: Pimlico

Berger, J. (1972) *Ways of Seeing*, London: Penguin

Bergson, H. (1911) *Creative Evolution*, trans. A. Mitchell, New York: Dover

Berman, M. (2001) *The Twilight of American Culture*, New York: Norton

Bloom, A. (1987) *The Closing of the American Mind*, New York: Simon & Schuster

Bloom, H. (1995) *The Western Canon*, New York: Riverhead Books

Bourdieu, P. (1984) *Distinction: a social critique of the judgment of taste*, London: Routledge

Brigstocke, H. (2001) *The Oxford Companion to Western Art*, Oxford: Oxford University Press

Burckhardt, J. (1990) *The Civilisation of the Renaissance in Italy*, trans. S.G.C. Middlemore, London: Penguin

Campbell, S.J. & Cole M.W. (2012) *A New History of Italian Renaissance Art*, London: Thames and Hudson

Camus, A. (1953) *The Rebel*, trans. A. Bower, London: Penguin

Carey, J. (1992) *The Intellectuals and the Masses*, London: Faber and Faber

Carr, E.H. (1961) *What is History?*, London: Palgrave Macmillan

Chipp, H.B. (1968) *Theories of Modern Art: a source book by artists and critics*, London: University of California Press

Clark, K. (1956) *The Nude*, London: Penguin

— (1969) *Civilisation: a personal view*, London: BBC

— (1973) *The Romantic Rebellion: Romantic versus Classic art*, London: John Murray

Coleman, J. (2000) *Political Thought: from the Middle Ages to the Renaissance*, Oxford: Blackwell

Cronin, V. (1967) *The Florentine Renaissance*, London: Pimlico

Dante, A. (1971) *The Divine Comedy Volume 1: Inferno*, trans. M. Musa, London: Penguin

Dennis, D.B. (2012) *Inhumanities: Nazi interpretations of Western Culture*, Cambridge: Cambridge University Press

Dudley Edwards, R. (2012) *Killing the Emperors*, London: Allison & Busby

Dutton, D. (2011) *The Art Instinct: beauty, pleasure, and human evolution*, Oxford: Oxford University Press

Eagleton, T. (2000) *The Idea of Culture*, Oxford: Blackwell

Eliot, T.S. (1948) *Notes Towards the Definition of Culture*, London: Faber & Faber

Ferry, L (1995) *The New Ecological Order*, London: University of Chicago Press

Fowler, B.H. (1989) *The Hellenistic Aesthetic*, Madison: University of Wisconsin Press

Furedi, F. (2004) *Where Have All The Intellectuals Gone?*, London: Continuum

— (2011) *On Tolerance: a defence of moral independence*, London: Continuum

Gombrich, E.H. (1995) *The Story of Art*, London: Phaidon

Greenberg, C. (1961) *Art and Culture: critical essays*, Boston: Beacon Press

Heartfield, J. (2006) *The 'Death of the Subject' Explained*, London: BookSurge Publishing

Hegel, G.W.F. (1896) *Philosophy of Right*, trans. S.W. Dyde, New York: Dover

— (1975) *Hegel's Aesthetics: lectures on fine art*, Vols. I & II, trans. T.M. Knox, Oxford: Oxford University Press

— (1977) *Hegel's Phenomenology of Spirit*, trans. A.V. Miller, Oxford: Oxford University Press

— (1988) *Introduction to The Philosophy of History*, trans. L. Rauch, Indianapolis: Hackett Publishing Company

Holden, J. (2004) *Capturing Cultural Value: how culture has become a tool of government policy*, London: Demos

— (2010) *Culture and Class*, London: British Council

Hoggart, R. (1957) *The Uses of Literary: aspects of working-class life*, London: Penguin

Holmes, G. (1996) *Renaissance*, London: Weidenfeld & Nicolson

Hopkins, D. (2000) *After Modern Art: 1945–2000*, Oxford: Oxford University Press

Hughes, R. (1993) *Culture of Complaint: the fraying of America*, New York: Oxford University Press

Israel, J. (2010) *A Revolution of the Mind: radical Enlightenment and the intellectual origins of modern democracy*, Princeton: Princeton University Press

James, C.L.R. (1980) 'The making of the Caribbean people', in *Spheres of Existence: selected writings*, London: Alison and Busby

Josipovici, G. (2010) *What Ever Happened to Modernism?*, London: Yale University Press

Kant, I. (2009) *An Answer to the Question: 'What is Enlightenment?'*, London: Penguin

—(2007) *Critique of Judgment*, trans. J.M. Creed, Oxford: Oxford University Press

Lasch, C. (1979) *The Culture of Narcissism: American life in an age of diminishing expectations*, New York: Norton

—(1995) *The Revolt of the Elites and the Betrayal of Democracy*, New York: Norton

Lessing, D. (1962) *The Golden Notebook*, London: Fourth Estate

Knell, J. & Taylor, M. (2011) *Arts Funding, Austerity and the Big Society: remaking the case for the arts*, London: RSA

Locke, J. (1997) *An Essay Concerning Human Understanding*, London: Penguin

Mamet, D. (2010) *Theatre*, London: Faber & Faber

Marx, K. & Engels, F. (1888) *The Communist Manifesto*, trans. S. Moore, London: Pluto Press

Marx, K. (1973) *Grundrisse*, trans. M. Nicolaus, London: Penguin

—(1978) *The Eighteenth Brumaire of Louis Bonaparte*, Peking: Foreign Languages Press

McCarthy, M. (1956) *The Stones of Florence* and *Venice Observed*, London: Penguin

McMaster, B. (2008) *Supporting Excellence in the Arts: from measurement to judgement*, Department for Culture, Media and Sport

Meier, C. (2011) *A Culture of Freedom*, trans. J. Chase, Oxford: Oxford University Press

Mill, J.S. (1991) *On Liberty and Other Essays*, Oxford: Oxford University Press

Millard, R. (2002) *The Tastemakers: UK art now*, London: Scribner

Mirandola, P. della (1965) *On the Dignity of Man*, trans. C.G. Wallis, Cambridge: Hackett

Mirza. M. ed. (2006) *Culture Vultures: is UK arts policy damaging the arts?*, London: Policy Exchange

Mumford, L. (1961) *The City in History*, London: Pelican

Murray, C. (2012) *Coming Apart: the state of white America, 1960–2010*, New York: Crown Publishing Group

Neudecker, R. (1988) *Die Skulpturenausstattung romischer Villen in Italien*, Darmstadt: Phillip von Zabern

Pagel, M. (2012) *Wired for Culture*, London: Allen Lane

Pater, W. (1986) *Studies in the History of the Renaissance*, Oxford: Oxford University Press

Pinker, S. (2002) *The Blank Slate: the modern denial of human nature*, London: Allen Lane

Plato (1941) *The Republic of Plato*, trans. F.M. Cornford, Oxford: Oxford University Press

— (1994) *Gorgias*, trans. R. Waterfield, Oxford: Oxford University Press

Prinz, J.J. (2012) *Beyond Human Nature: how culture and experience shape our lives*, London: Penguin

Ortega y Gasset, J. (1968) *The Dehumanization of Art and Other Essays on Art, Culture, and Literature*, trans. H. Weyl, Princeton: Princeton University Press

Orwell, G. (1984) *Essays*, London: Penguin

Raaflaub, K. (2004) *The Discovery of Freedom in Ancient Greece*, London: University of Chicago Press

Raine, A. (2013) *The Anatomy of Violence: the biological roots of crime*, London: Allen Lane

Read, H. (1963) *To Hell with Culture*, London: Routledge Classics

Rosen, C. (2012) *Freedom and the Arts: essays on music and literature*, Cambridge: Harvard University Press

Ross, A. (2007) *The Rest is Noise*, London: Fourth Estate

Russell, B. (1946) *History of Western Philosophy*, London: Routledge

Russolo, L. (1967) *The Art of Noise*, trans. R. Filliou, ubuclassics, available at: http://www.artype.de/Sammlung/pdf/russolo_noise.pdf

Sallust (2010) *Catiline's Conspiracy, The Jugurthine War, Histories*, trans. W.W. Batstone, Oxford: Oxford University Press

Sartre, J.-P. (1948) *Existentialism & Humanism*, trans. P. Mairet, London: Methuen

— (1950) *What is Literature?*, trans. B. Frechtman, London: Routledge

— (1963) *The Reprieve*, trans. E. Sutton, London: Penguin

Schiller, F. (1954) *On the Aesthetic Education of Man*, trans. R. Snell, New Haven: Yale University Press

Scruton, R. (2000) *Modern Culture*, London: Continuum

— (2007) *Culture Counts: faith and feeling in a world besieged*, New York: Encounter Books

— (2009) *Beauty*, Oxford: Oxford University Press

Sennett, R. (2012) *Together: the rituals, pleasures & politics of cooperation*, London: Penguin

Sidwell, M. (2009) *The Arts Council: managed to death*, London: Social Affairs Unit

Sierz, A. (2000) *In-Yer-Face Theatre: British drama today*, London: Faber and Faber

Sontag, S. (1966) *Against Interpretation and Other Essays*, London: Penguin Classics

Spalding, J. (2003) *The Eclipse of Art: tackling the crisis in art today*, London: Prestel

Spengler, O. (1961) *The Decline of the West*, trans. C.F. Atkinson, Oxford: Oxford University Press

Strozzi, B.P. and Bormand, M. (2013) *The Springtime of the Renaissance: sculpture and the arts in Florence 1400–1600*, Firenze: Mandragora

Tallis, R. (2011) *Aping Mankind: neuromania, Darwinitis and the misrepresentation of humanity*, London: Acumen

Todorov, T. (2006) *In Defence of Enlightenment*, trans. G. Walker, London: Atlantic Books

Tusa, J. (1999) *Art Matters: reflecting on culture*, London: Methuen

— (2007) *Engaged with the Arts: writings from the frontline*, London: I.B. Tauris

Vasari, G. (1991) *The Lives of the Artists*, trans J.C. & P. Bondanella, Oxford: Oxford University Press

Virgil (1983) *The Ecologues The Georgics*, trans. C.D. Lewis, Oxford: Oxford University Press

Watson, P. (2010) *The German Genius: Europe's third renaissance, the second scientific revolution and the twentieth century*, London: Simon & Schuster

Whitehead, A.N. (1925) *Science and the Modern World*, New York: The Free Press

Williams, R. (1961) *Culture and Society 1780–1950*, London: Penguin

— (1983) *Keywords*, London: Fontana

— (1986) *Culture*, London: Fontana

Wilson, E.O. (2007) *Creation: an appeal to save life on earth*, London: Norton

Witt, R.G. (2000) *In the Footsteps of the Ancients: the origins of humanism from Lovato to Bruni*, Leiden: Brill

Wolfe, T. (1975) *The Painted Word*, New York: Picador

Zamyatin, Y. (2006) *We*, trans. N.S. Randall, New York: Random House

Index